MASTERS OF WOOD SCULPTURE

MASTERS OF
WOOD SCULPTURE

BY NICHOLAS ROUKES

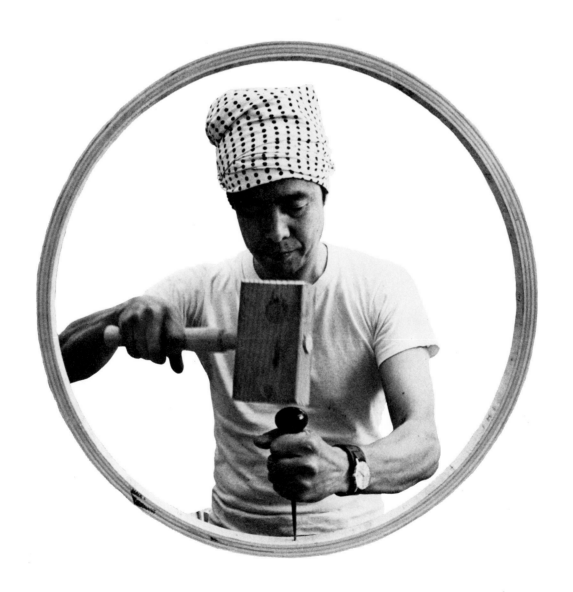

WATSON-GUPTILL PUBLICATIONS/NEW YORK
PITMAN HOUSE/LONDON

To Michael

Copyright © 1980 by Watson-Guptill Publications

First published 1980 in the United States and Canada by Watson-Guptill Publications,
a division of Billboard Publications, Inc.,
1515 Broadway, New York, N.Y. 10036

Published in Great Britain by Pitman House Ltd.,
39 Parker Street, London WC2B 5PB
ISBN 0-273-0515-X

Library of Congress Cataloging in Publication Data
Roukes, Nicholas.
 Masters of wood sculpture.
 Bibliography: p.
 Includes index.
 1. Sculpture, Modern—20th century. 2. Wood-
carving—History—20th century. I. Title.
NB1250.R63 1980 735'.237 79-26930
ISBN 0-8230-3019-9

Manufactured in U.S.A.

First Printing, 1980

On page II:
Specified excerpt from p. 72 in
A REVERENCE FOR WOOD by Eric Sloane
(Funk & Wagnalls). Copyright © 1965 by
Harper & Row, Publishers, Inc.
Used by permission of the publishers.

Editor's Note: In Great Britain, a *C*-clamp is known as a *G*-cramp.

The author thanks the many artists, museum personnel, galleries, manufacturers, and suppliers that have aided in the research and compilation of material for the production of this book.

Special thanks are extended to the following people and organizations: John Kelsey, Taunton Press; John Sainsbury; Record Ridgway Company; MacMillan Bloedel Company; California Redwood Association; American Forest Products Association; St. Regis Paper Company; Rockwell International; Woodcraft Supply Company; George F. Earle, College of Environmental Science and Forestry; Weyerhaeuser Company; Sculpture Associates, New York; Crafts Advisory Committee, London; The American Crafts Council, New York; George W. Staempfli; National Hardwood Lumber Association; Northeastern Lumber Manufacturer's Association; U.S. Department of Occupational Safety and Health Administration (OSHA); Art Hazards Information Center, New York; National Institute of Occupational Safety (NIOSH); and to Julianna Roukes.

To the editorial and production staff of Watson-Guptill Publications: Marsha Melnick, Editorial Director; Don Holden, Editorial Consultant; Michael McTwigan, Senior Editor; Bonnie Silverstein, Associate Editor; Hector Campbell, Production; and Jay Anning, Designer, a grateful acknowledgment and thanks for their splendid efforts.

And to Henry Moore, a special thanks for his inspiration, hospitality, and special contribution to this publication.

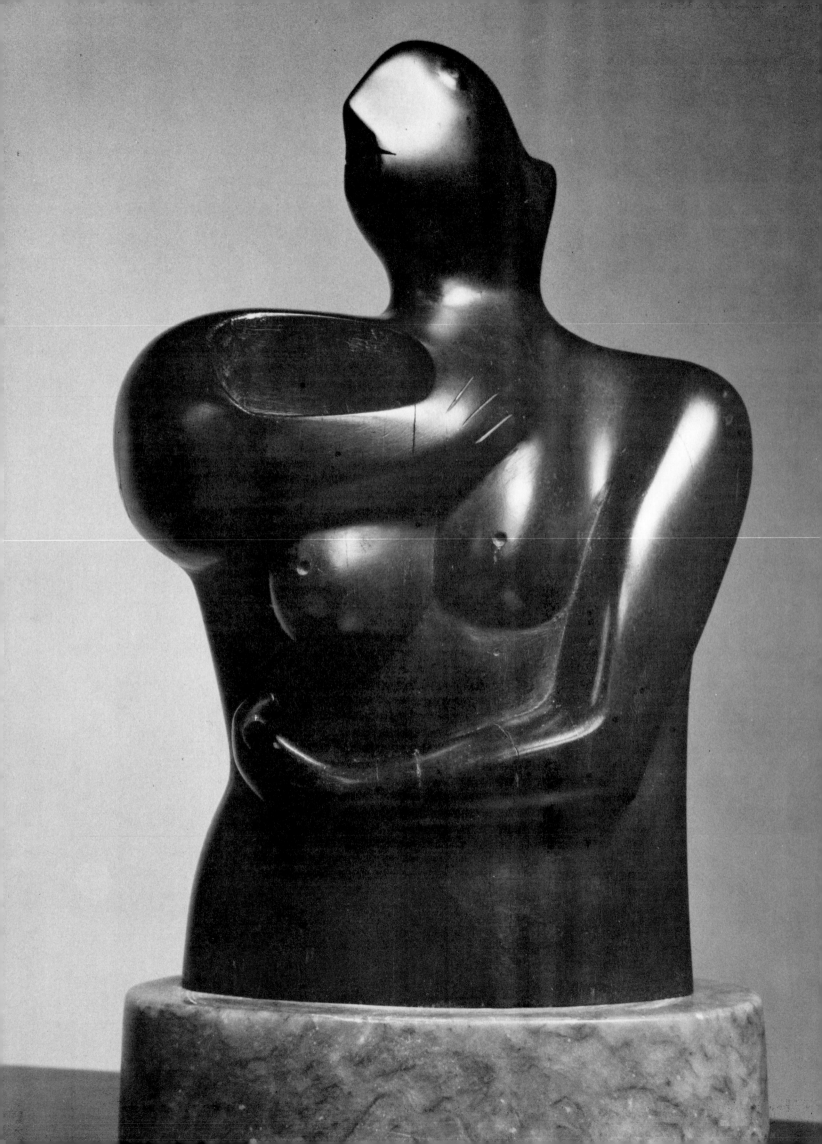

"Wood often appeals to artists who feel a close affinity with nature and organic growth. Many natural factors—the changing seasons; wind, sun, and rain; birth and death—are compressed within its fibers and year rings. Wood, too, contains symbolic values of ancient origin which rise, from time to time, to the conscious level of our minds. Certain groves and single trees were once the habitations of gods, and eventually themselves became godlike objects of worship and reverence. A tree trunk, a twisted root, a broken branch assumed mysterious importance, and became carriers of supernatural powers. There is a relationship between ceremonial wooden objects used by African tribes and splinters of the Holy Cross venerated in the Christian world. The miraculous change of Aaron's staff into a living snake proved to Pharaoh the power of Moses as a leader of his people. Structural beams from demolished old houses, impregnated for centuries by the happiness and sorrow of their inhabitants, were Brancusi's favorite material for carved sculptures. . . . Wood is a magic material, alive and working, organic, and never completely at rest."

George W. Staempfli

Henry Moore, *Figure*, 1930. Ebony, 10″ (25 cm) high.
Private collection, London.

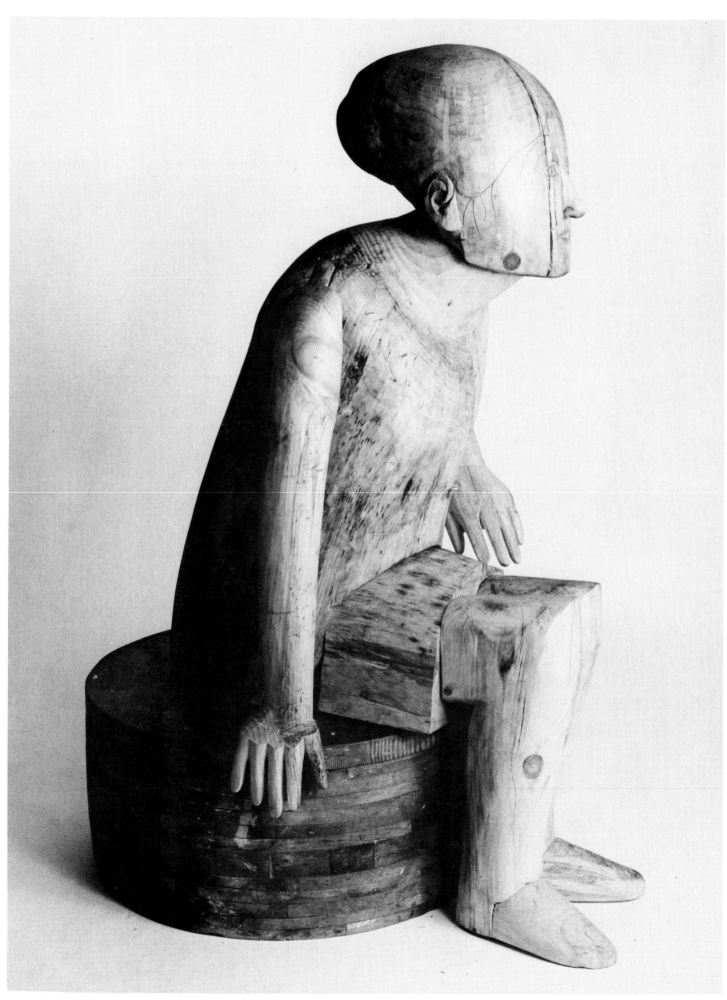

Louise Kruger, *Seated Woman*, 1973.
White pine, 4'6″ (1.4 m) high.

CONTENTS

THE LEGACY OF WOOD 10

PORTFOLIO: A WORLD SURVEY 12

WALTER DRIESBACH 28
Demonstration One: The Figure 31

DAVID HOSTETLER 36
Demonstration Two: The Head and Torso 39

PETER BOIGER 44
Demonstration Three: The Abstract Figure 47

HENRY MOORE 54
Demonstration Four: The Monumental Figure 57

NICHOLAS ROUKES 64
Demonstration Five: The Bas-Relief 67

PORTFOLIO: DIRECT CARVING 72

WOLFGANG BEHL 88
Demonstration Six: The Figure Group 91

PETER ROBBIE 102
Demonstration Seven: Lamination and Carving 105

FUMIO YOSHIMURA 108
Demonstration Eight: Bentwood Lamination 111

RAYMOND SELLS 116
Demonstration Nine: Plywood Lamination 119

CARROLL BARNES 124
Demonstration Ten: Sliding Lamination 127

PORTFOLIO: CONSTRUCTION AND LAMINATION 134

HAYDN DAVIES 154
Demonstration Eleven: Art in Architecture 157

MICHAEL COOPER 168
Demonstration Twelve: Wood Wizardry 170

PORTFOLIO: ACROSS BOUNDARIES 178

BIBLIOGRAPHY 190

INDEX 191

THE LEGACY OF WOOD

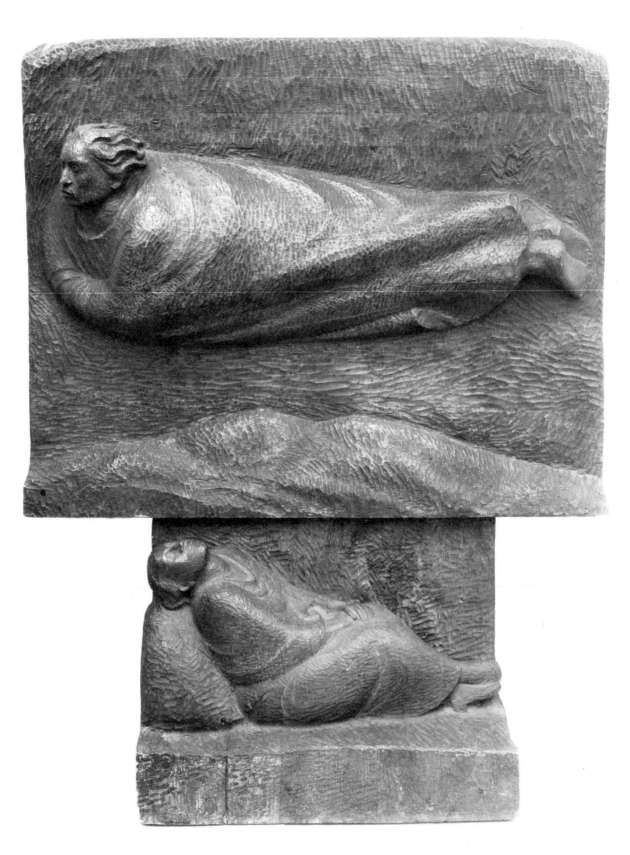

> "The century of magnificent awareness preceding the Civil War was the age of wood. Wood was not accepted simply as the material for building a new nation—it was an inspiration. Gentle to the touch, exquisite to contemplate, tractable in creative hands, stronger by weight than iron, wood was, as William Penn had said, 'a substance with a soul.' It spanned rivers for man; it built his home and heated it in the winter; man walked on wood, slept in it, sat on wooden chairs at wooden tables, drank and ate the fruits of trees from wooden cups and dishes. From cradle of wood to coffin of wood, the life of man was encircled by it."
>
> Eric Sloane
> *A Reverence for Wood*

There are countless relics and treasures in our museums from every historical epoch and world culture that serve as reminders of the important role that wood has played in past history. Wood has captured the respect and imagination of both the famous and the humble; throughout the annals of history, highly skilled artists and craftsmen, primitive carvers and folk artists alike have all been creatively motivated by wood.

In the days of our great grandparents, wood was in plentiful supply. Great virgin forests were to be found everywhere, and it seemed highly unlikely that our vast resources of timber would ever be depleted. Early New England immigrants and the pioneers that heeded the call "go west!" relied heavily on wood for their survival. Wherever they went, abundant supplies of wood were available to provide shelter, fuel, tools, and transportation. With the passing of time, however, and the ensuing demand for timber for construction purposes, widespread and indiscriminate cutting of trees occurred that threatened our forest reserves with almost complete extinction. Fortunately, this tendency has been curbed with present-day forest management and intelligent governmental controls. Wood is a renewable material and self-replenishing, but its future existence still rests largely on our continued concern for its survival.

Modern technology has created a vast number of new synthetic materials that have come to replace wood in the manufacture of utilitarian products. At times we even begin to wonder if the ubiquitous plastic products will completely overrun us and replace wood altogether. Somehow that prospect seems unlikely, however. The "wood consciousness" of our grandfathers' day still seems to persist, although it is often manifested in bizarre forms. (Why do we go to such extraordinary means to manufacture products made of plastic that look like wood?)

Man's reliance on wood dates back 5000 years, and the art of woodcarving is one of the oldest of crafts. Paradoxically, it is one that we seem to be re-learning. Many writers have observed that the present "wood revival" is symptomatic of our need to re-examine present-day values. Living as we do in a technologically oriented society proliferating in chemically produced products, we have, in fact, produced a sterile environment and regret the passing of wood from our surroundings. Noguchi has written that wood is a natural material, alive long before man, and as such, has a greater capacity to comfort us with the "reality of our being." The concurrent "back-to-wood boom" among artists and craftsmen is indicative of an emerging sensitivity and indignant reaction to the proliferation of cheap and artificial goods. Wood is the healer; it links man to nature, and rekindles the emotional satisfaction and joy of perceiving the well-crafted and one-of-a-kind object that feels friendly and good to touch.

In this book, we shall examine some of the time-honored as well as new and unorthodox means of working wood within the realm of the fine arts. In the demonstration chapters that follow, we'll look into the studios of many wood sculptors as they demonstrate their particular expertise. Varied techniques of creating wood sculpture will be described in detail, with special chapters devoted to carving the figure and the head, making reliefs, and creating laminations, constructions, and abstract forms out of wood. A gallery of exemplary world wood sculpture down through the ages is also included, as well as three other portfolios illustrating the range of contemporary techniques in wood, from direct carving, and construction and lamination techniques, to work that reaches beyond these horizons.

It is hoped that in perusing this book you'll discover new and useful information that will kindle enthusiasm and active participation in one of the oldest and yet newest of art forms, wood sculpture.

Ernst Barlach, *Die Vision*. Courtesy Nationalgalerie, Staatliche Museen, West Berlin. Photo: Jörg P. Anders.

A WORLD SURVEY

▶ *Mitry and His Wife*, Egypt, From his tomb at Sakkara, Fifth Dynasty, c. 2500 BC. The Metropolitan Museum of Art, Rogers Fund, 1926.

▼ *Statue of Senedem-ib-Mehy*, Giza, Old Kingdom, Fifth Dynasty. Courtesy Museum of Fine Arts, Boston.

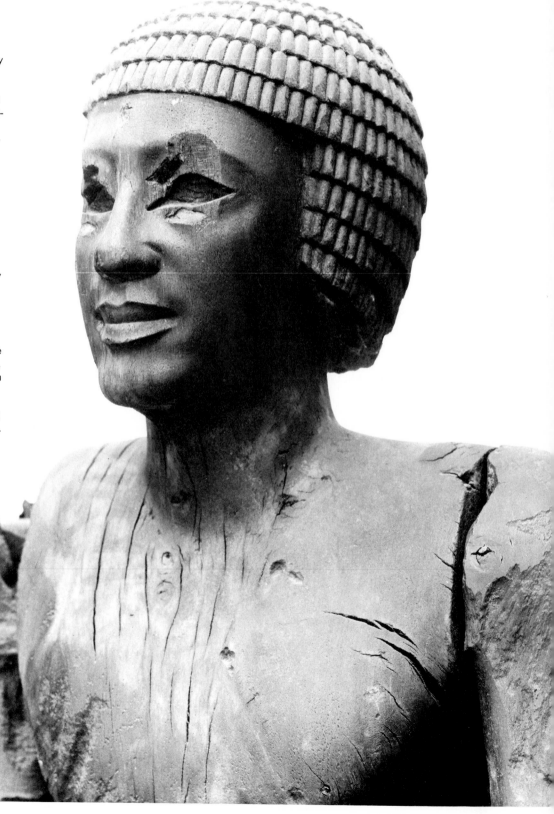

The art of woodcarving flourished in many of the old Egyptian dynasties. Some of the oldest artifacts date back beyond the Fifth Dynasty (2780–2280 BC), the epoch marking the construction of the great pyramids. Throughout the dynasties, artisans were commissioned primarily for one purpose: to document the "mortal" life of the great pharaohs through the creation of two- and three-dimensional artifacts and environments that were placed inside the tombs. Among the artifacts were small wooden statues for the pharaohs' spirits (the Ka) to dwell in the afterlife. Accordingly, woodcarvers made the statues as representational as possible. Lifelike features were painted on the wooden figures, and through the combined efforts of graphic work and statuary, the deceased ruler's earthly rank and status were depicted, thus preserving the "public persona," while also allowing for his "re-animation" in the spirit role of Osiris. Aside from the wooden statues and relief figures, many other types of wooden artifacts from ancient Egypt have survived the ages, including chairs, thrones, beds, and other types of furniture, as well as polychromed wooden coffins and miniature tableaus depicting the lifestyle of the great kings.

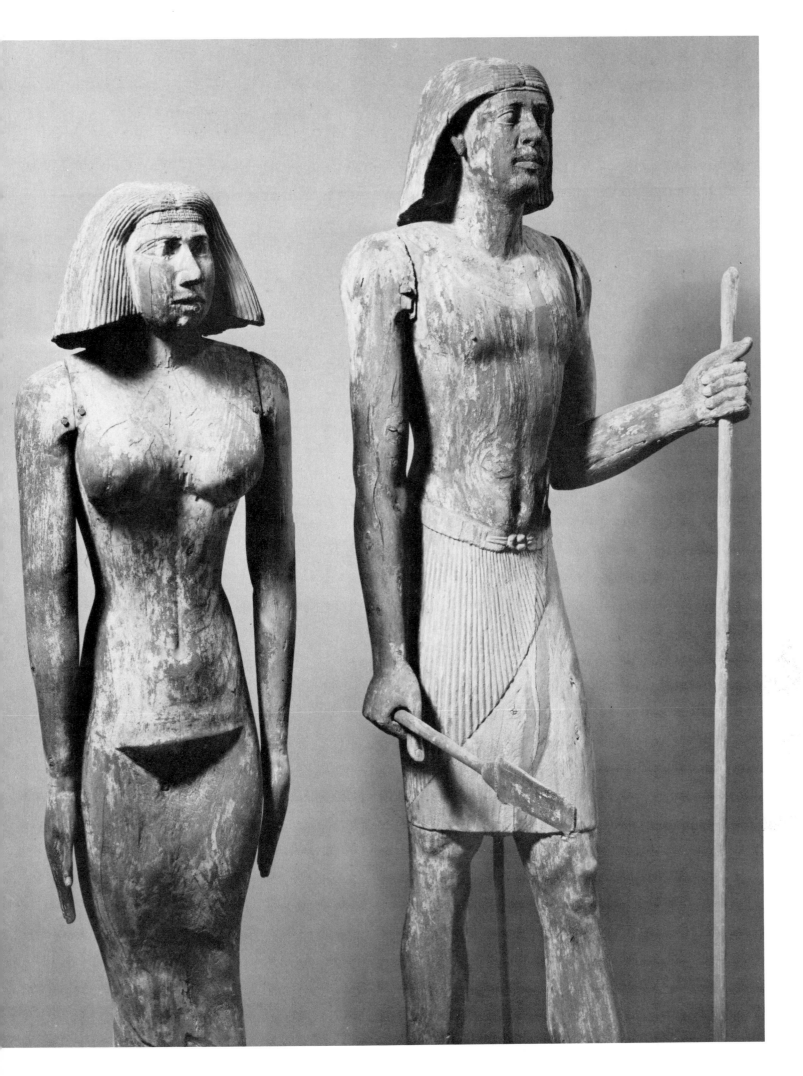

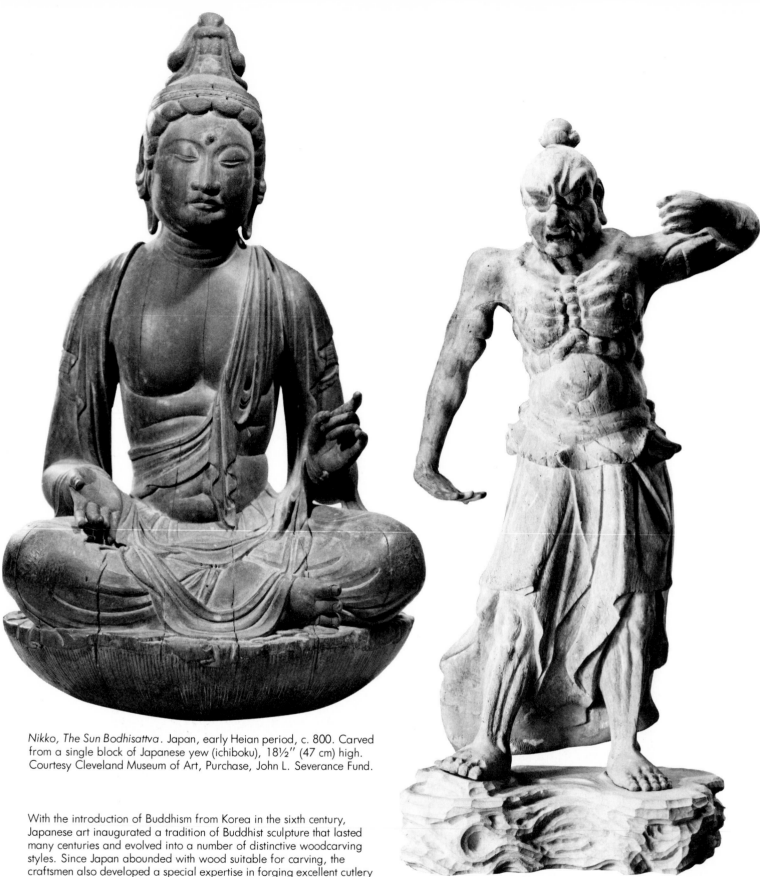

Nikko, The Sun Bodhisattva. Japan, early Heian period, c. 800. Carved from a single block of Japanese yew (ichiboku), 18½" (47 cm) high. Courtesy Cleveland Museum of Art, Purchase, John L. Severance Fund.

Guardian Figure. Japan, Kamakura period, from Shiga prefecture. Chestnut, 66½" (169 cm) high. Courtesy Cleveland Museum of Art,. Leonard C. Hanna Jr. Bequest.

With the introduction of Buddhism from Korea in the sixth century, Japanese art inaugurated a tradition of Buddhist sculpture that lasted many centuries and evolved into a number of distinctive woodcarving styles. Since Japan abounded with wood suitable for carving, the craftsmen also developed a special expertise in forging excellent cutlery and carving tools—two ingredients that contributed much to the emerging art of woodcarving. The late Nara and early Heian period (late eighth to early ninth century) produced exemplary wood sculptors who carved highly stylized monumental wooden figures, with lavish attention paid to facial details and drapery. From the seventh through eleventh centuries, *ichiboku*, a method of carving an object from a single block of wood, was a popular technique. It was eventually supplanted by the *yosegi* method, which involved the joining of many separately carved sections of a sculpture. With this method, the artist was not limited by the size and shape of the log, but could produce monumental-sized figures. In addition, the centers of each section were hollowed out, curbing the tendency of the wood to crack as it dried out. (The yosegi method also made it possible for master carvers to utilize many apprentices, each assigned to special tasks.)

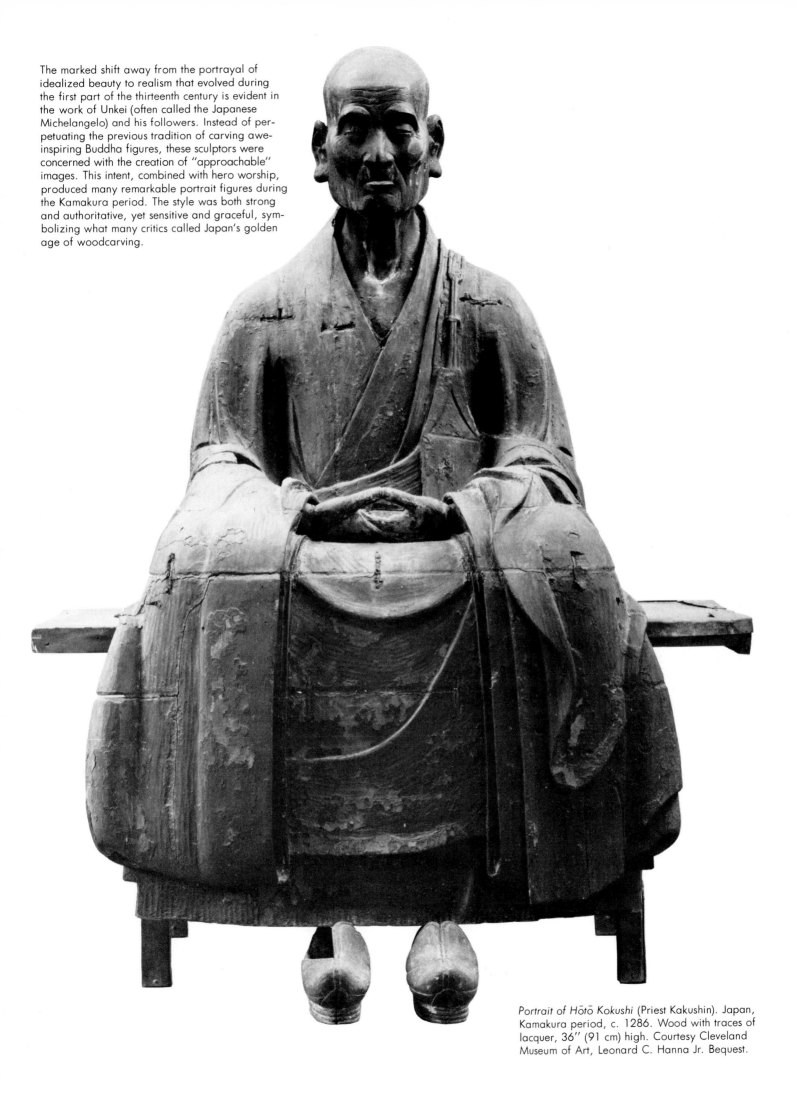

The marked shift away from the portrayal of idealized beauty to realism that evolved during the first part of the thirteenth century is evident in the work of Unkei (often called the Japanese Michelangelo) and his followers. Instead of perpetuating the previous tradition of carving awe-inspiring Buddha figures, these sculptors were concerned with the creation of "approachable" images. This intent, combined with hero worship, produced many remarkable portrait figures during the Kamakura period. The style was both strong and authoritative, yet sensitive and graceful, symbolizing what many critics called Japan's golden age of woodcarving.

Portrait of Hōtō Kokushi (Priest Kakushin). Japan, Kamakura period, c. 1286. Wood with traces of lacquer, 36" (91 cm) high. Courtesy Cleveland Museum of Art, Leonard C. Hanna Jr. Bequest.

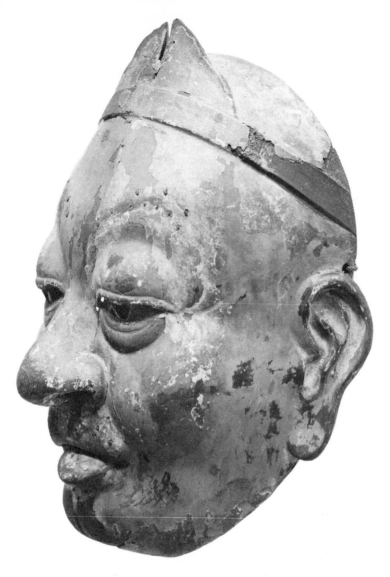

▲*Gigaku Mask.* Japan, Heian period, early 11th century. Polychromed wood, 10½″ (26 cm). Courtesy Museum of Fine Arts, Boston, William Sturgis Bigelow Collection.

Motivated by the import of Chinese sandalwood statues, the Japanese developed a great love of ornamentation, and the custom of carving highly detailed figures soon became a national tradition. The gigaku masks were used in Buddhist rituals and were noteworthy among the sculptures of the Nara temples.

▶*Kuan-Yin (Avalokiteśvara).* China, from a temple near Hung-tung Hsien, Sung period, 1195 AD Polychromed wood. Collection Royal Ontario Museum, Toronto, Ontario.

The Bodhisattvas Kuan-Yin and Ta-shih-chih were the favorite attendants of the great Buddha Amitābha and were usually shown flanking the Buddha in a tableau of three sculptures. The Kuan-Yin figure depicted divine compassion and mercy and was a particularly well-regarded figure. Kuan-Yin figures were carved lifesize of wood and hollowed out from the rear to lighten the sculpture and prevent subsequent splitting. A wooden tablet used to close the opening also provided pertinent information regarding the work. Sung Kuan-Yin statues were delicately carved in relaxed poses and were usually elaborately adorned with jewelry and flowing garments. Gold leaf and polychrome techniques were used extensively on the wooden figures of this period.

 In ancient China, wood was accorded the classification of an element, one of the basic irreducible components of the universe, along with fire, water, and earth. Although there are bronze pieces that date back to 1500 BC, the oldest wood artifacts from China appear to be tomb figures that date back to the late Chou period (771–221 BC). Like the Egyptians, the Chinese also buried statuary with their deceased. Tomb figures appear to have been used through the Han period (206–220 AD), the period of the Six Dynasties (220–589 AD), and the T'ang period (618–907 AD). The inception of Buddhism as a religion immediately following the Han period imposed a strong stylistic demand upon the sculptors. The fifth and sixth centuries in particular witnessed the blooming of Buddhist sculptural art. Many Buddha figures were carved in wood during this period, including large figures for public ceremonial use and smaller figures for private and personal service. During these periods as well as the Sung period (12th century AD) and the Yuan period (13th century AD), many exemplary wood pieces were produced.

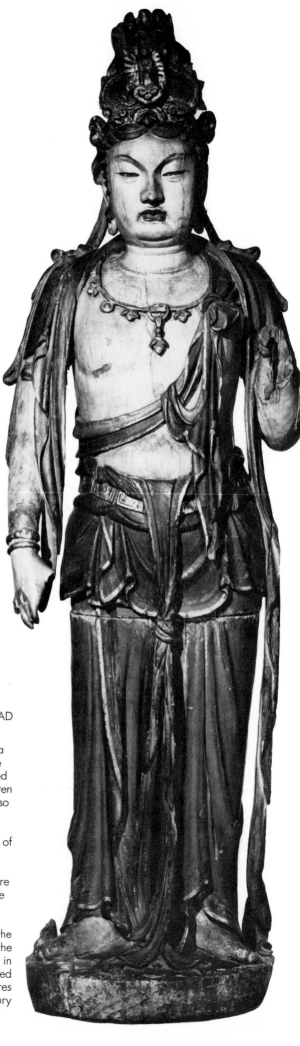

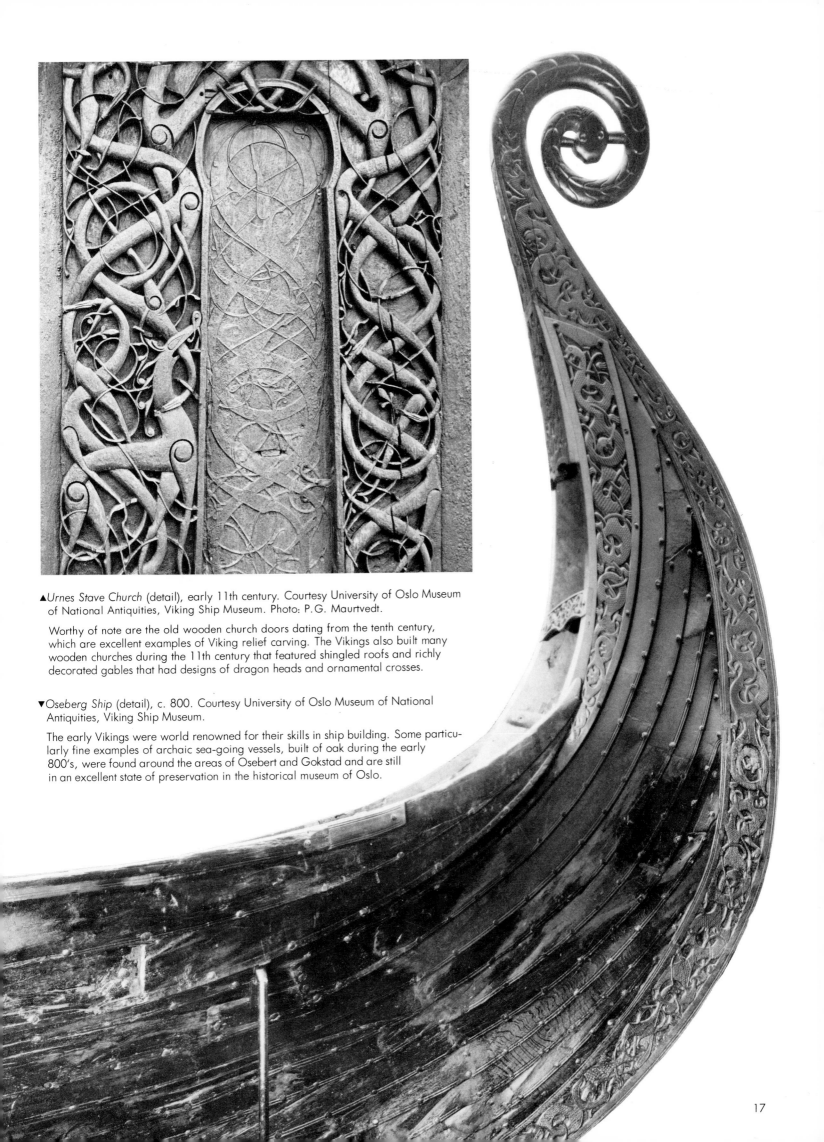

▲*Urnes Stave Church* (detail), early 11th century. Courtesy University of Oslo Museum of National Antiquities, Viking Ship Museum. Photo: P.G. Maurtvedt.

Worthy of note are the old wooden church doors dating from the tenth century, which are excellent examples of Viking relief carving. The Vikings also built many wooden churches during the 11th century that featured shingled roofs and richly decorated gables that had designs of dragon heads and ornamental crosses.

▼*Oseberg Ship* (detail), c. 800. Courtesy University of Oslo Museum of National Antiquities, Viking Ship Museum.

The early Vikings were world renowned for their skills in ship building. Some particularly fine examples of archaic sea-going vessels, built of oak during the early 800's, were found around the areas of Osebert and Gokstad and are still in an excellent state of preservation in the historical museum of Oslo.

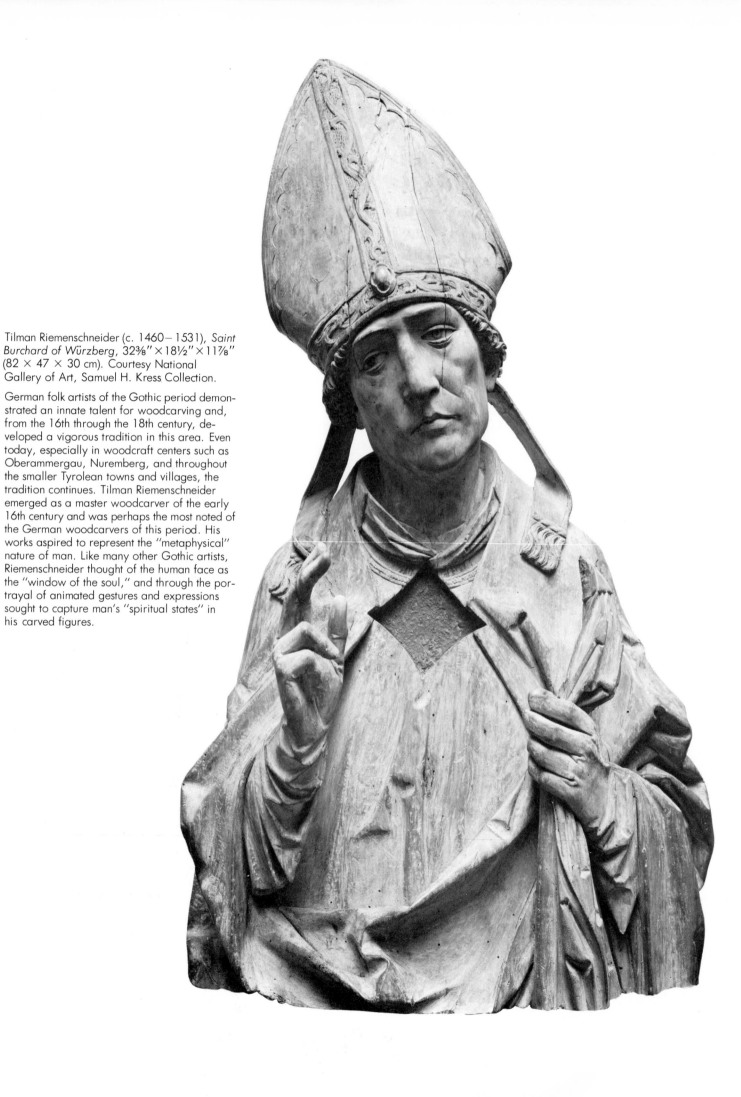

Tilman Riemenschneider (c. 1460–1531), *Saint Burchard of Würzberg*, 32⅜″×18½″×11⅞″ (82 × 47 × 30 cm). Courtesy National Gallery of Art, Samuel H. Kress Collection.

German folk artists of the Gothic period demonstrated an innate talent for woodcarving and, from the 16th through the 18th century, developed a vigorous tradition in this area. Even today, especially in woodcraft centers such as Oberammergau, Nuremberg, and throughout the smaller Tyrolean towns and villages, the tradition continues. Tilman Riemenschneider emerged as a master woodcarver of the early 16th century and was perhaps the most noted of the German woodcarvers of this period. His works aspired to represent the "metaphysical" nature of man. Like many other Gothic artists, Riemenschneider thought of the human face as the "window of the soul," and through the portrayal of animated gestures and expressions sought to capture man's "spiritual states" in his carved figures.

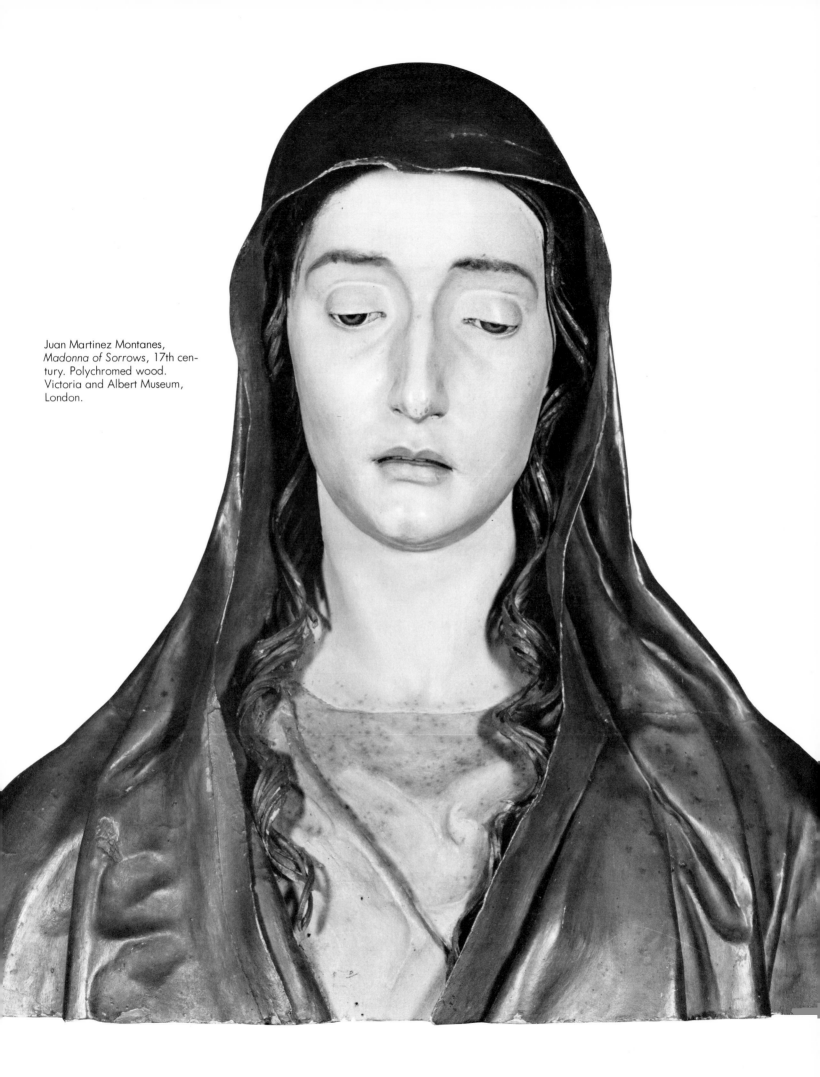

Juan Martinez Montanes,
Madonna of Sorrows, 17th cen-
tury. Polychromed wood.
Victoria and Albert Museum,
London.

▶*Male Figure*, Senufo Tribe, Ivory Coast. Wood, 49″ (124.5 cm) high. Courtesy Glenbow Foundation, Calgary, Alberta.

▼*Wooden Helmet* (*Nimba*), Baga tribe, Portuguese Guinea. Wood and raffia, 5″ (12.5 cm). Courtesy Glenbow Museum, Calgary, Alberta.

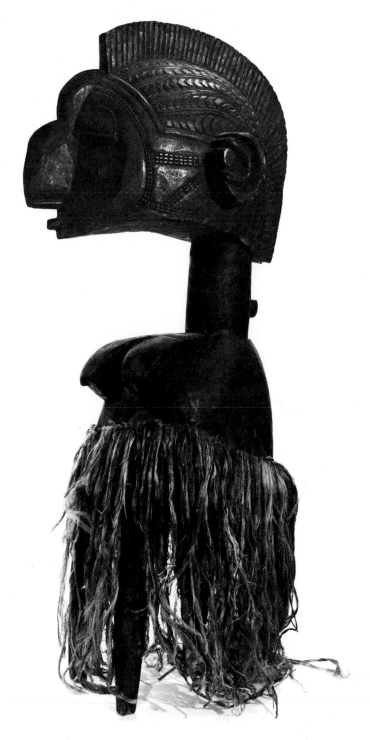

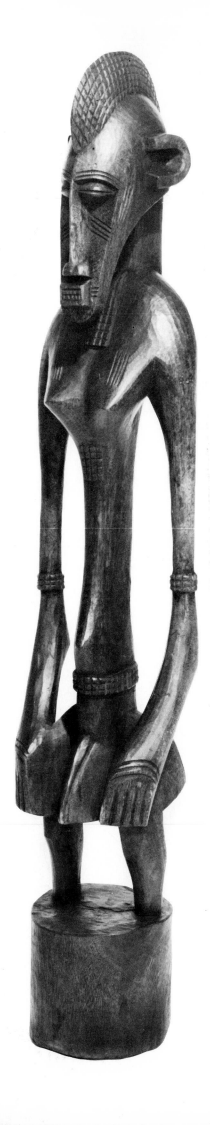

African Tribal art was not originally produced as an artform, but as means of creating images of power and magic. Made by very superstitious people who believed that the objects were endowed with a spirit more powerful than any human, various types of masks, figures and ceremonial objects were fashioned for the purpose of promoting the general welfare of the clan, insuring health and fertility, driving away evil spirits, or getting spirits to harm individuals who had "wronged" tribesmen in some way. (The Bakongo tribe of the Belgian Congo has produced some particularly fearsome nail fetishes for the latter purpose.) The general areas of Africa from which we have collected examples of tribal art include the Sudan, the Guinea Coast, Middle Africa, and the Congo. Some of the specific localities and tribes that have produced outstanding carved wooden artifacts are the following: Sudan: The Dogon, Bambara, Senufo, Bobo, and Moshi tribes. Guinea Coast: the Baga tribe. Serra Leone: the Mende. Ivory Coast: the Dan-Ngere, Guru, and Baule tribes. Ghana: Anyi and Ahsanti tribes. Nigeria: the Yoruba, Ibo, Ogoni, and Ibibio tribes. Gaboon: The Fang and Bakota tribes. Congo: the Bakongo, Bayaka, Babembe, Bajokwe, Lunda, Baluba, and Basikasingo tribes. Tanzania: the Makonde.

Mask with Twelve Faces, Tsimshian tribe, British Columbia. Courtesy Vancouver Centennial Museum, British Columbia.

Totem Post, Pacific Coast Indians. Red Cedar. Stanley Park, Vancouver, British Columbia.

Among the finest Totemic and heraldic art forms in North America are the works of the Northwest Coast Indians (the Tlingit, Haida, Tsimshian, Kwakiutl, and the Bella Coola tribes). These native people continue to live in areas ranging from southern Alaska to the state of Washington, including British Columbia and the offshore islands. Although isolated culturally from North American society, much of their work has found its way into private and public collections. The Haida, Kwakiutl, and the Tsimshian tribes in particular have carved outstanding masks, figures, and totem poles.

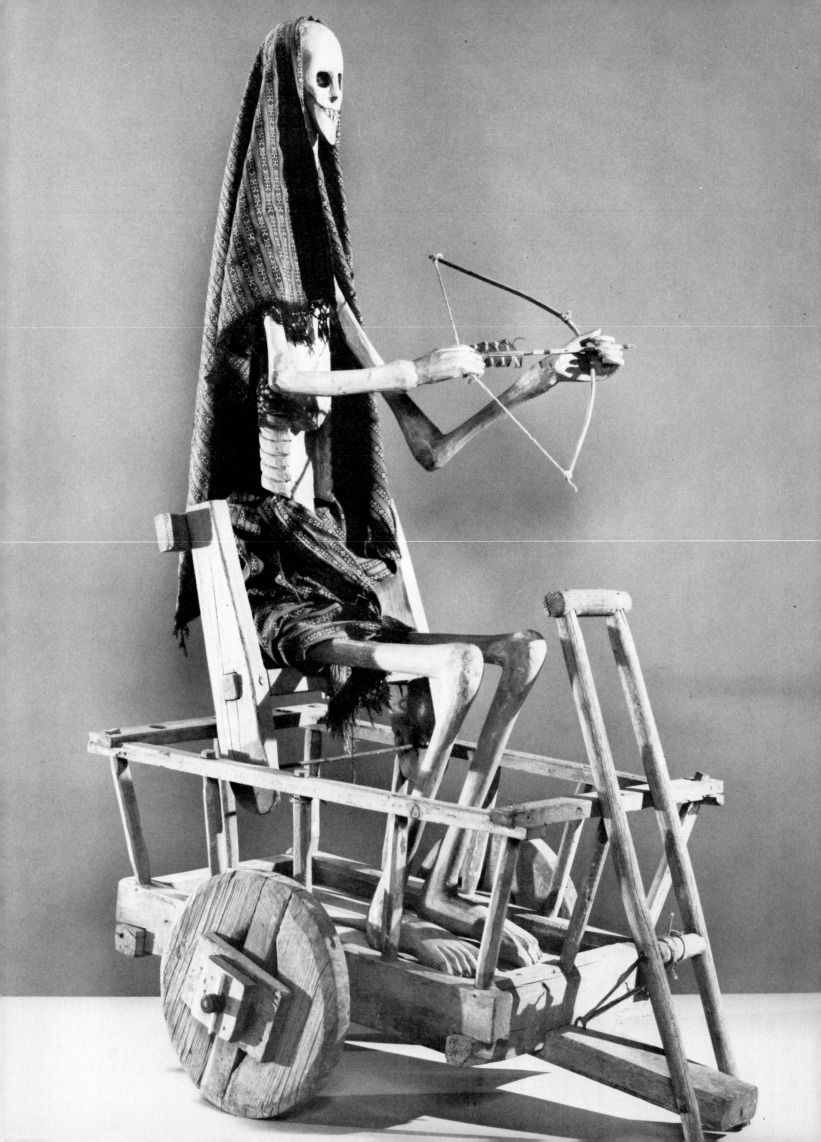

Woodcarving was a fairly widespread and vigorous activity in America by the late 18th and early 19th century; by the mid-1800's there were close to 2500 registered woodcarvers in the United States, many of whom specialized in particular types of carving, ranging from the creation of trade figures such as the cigar-store Indian, to ship figureheads, kitchen utensils, toys, clocks, furniture, whirligigs, (weathervanes), and circus wagons. Woodcarvers such as John and Simeon Skillon, Samuel McIntire, John Bellamy, William Rush, and Samuel A. Robb emerged as important craftsmen of their day.

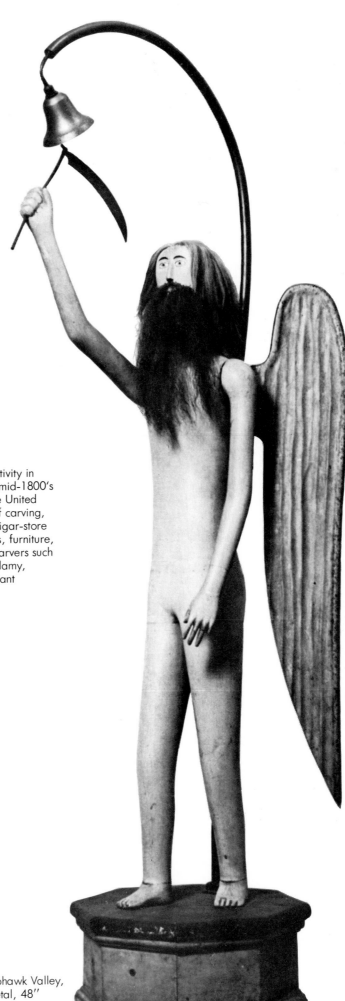

José Inez Herrera, *Death Cart*, New Mexico, 19th century. Courtesy Denver Art Museum, Anne Evans Collection.

Father Time, early American, Mohawk Valley, N.Y. Polychromed wood and metal, 48″ (122 cm) high. Courtesy Museum of American Folk Art, New York.

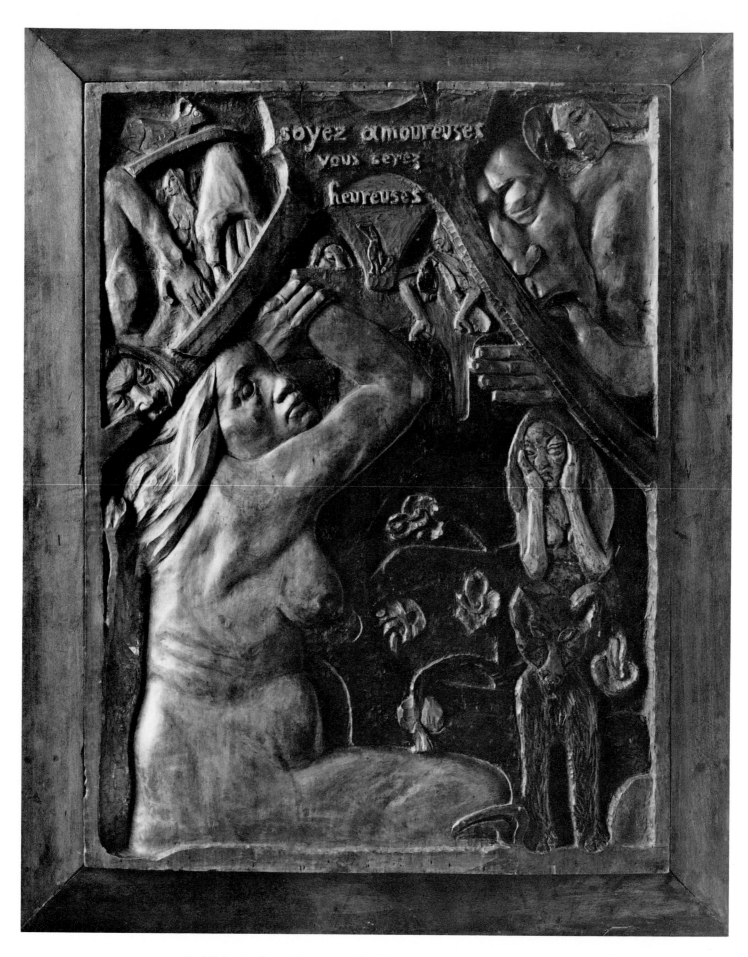

Paul Gauguin, *Soyez Amoureuses, Vous Serez Heureuses*. Polychromed wood relief. Courtesy Museum of Fine Arts, Boston, Arthur Tracy Cabot Fund.

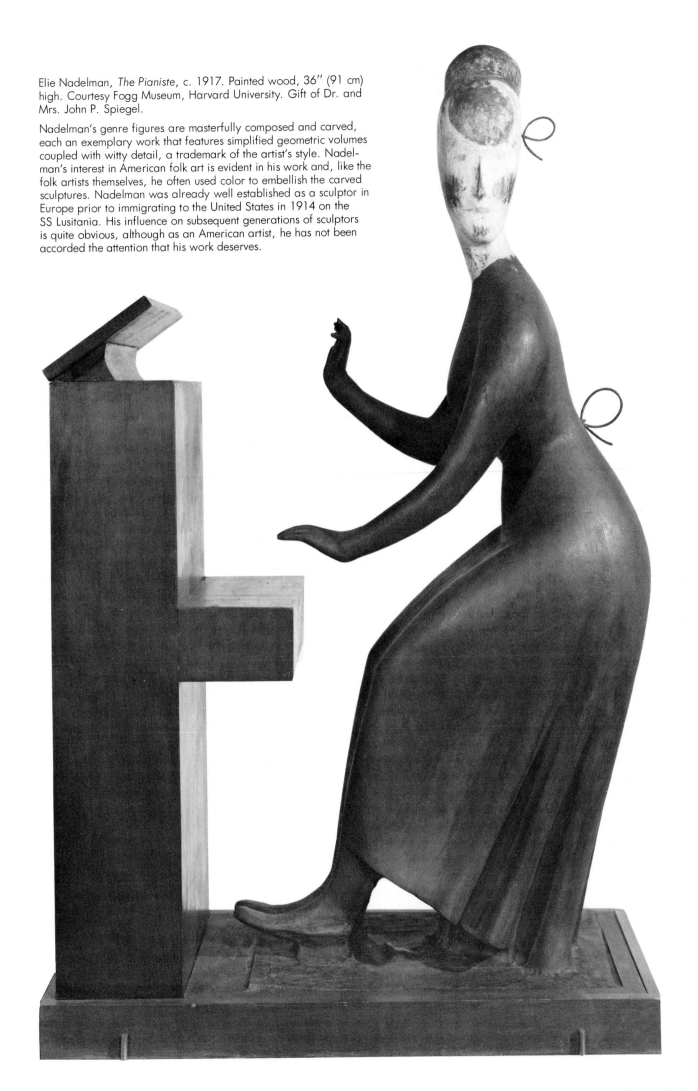

Elie Nadelman, *The Pianiste*, c. 1917. Painted wood, 36" (91 cm) high. Courtesy Fogg Museum, Harvard University. Gift of Dr. and Mrs. John P. Spiegel.

Nadelman's genre figures are masterfully composed and carved, each an exemplary work that features simplified geometric volumes coupled with witty detail, a trademark of the artist's style. Nadelman's interest in American folk art is evident in his work and, like the folk artists themselves, he often used color to embellish the carved sculptures. Nadelman was already well established as a sculptor in Europe prior to immigrating to the United States in 1914 on the SS Lusitania. His influence on subsequent generations of sculptors is quite obvious, although as an American artist, he has not been accorded the attention that his work deserves.

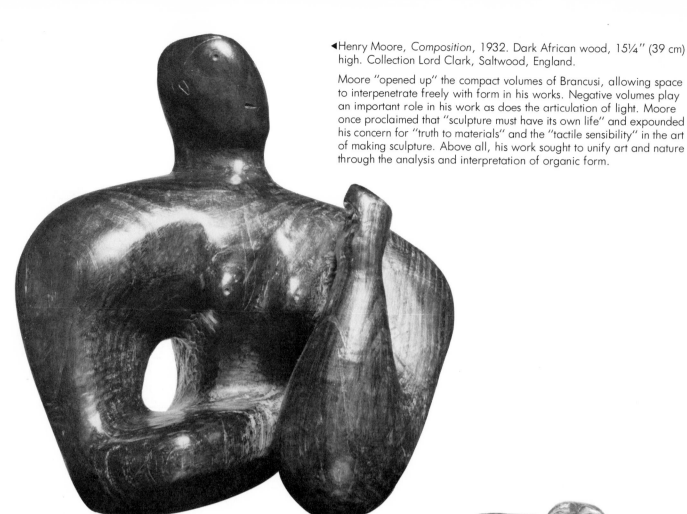

◀Henry Moore, *Composition*, 1932. Dark African wood, 15¼″ (39 cm) high. Collection Lord Clark, Saltwood, England.

Moore "opened up" the compact volumes of Brancusi, allowing space to interpenetrate freely with form in his works. Negative volumes play an important role in his work as does the articulation of light. Moore once proclaimed that "sculpture must have its own life" and expounded his concern for "truth to materials" and the "tactile sensibility" in the art of making sculpture. Above all, his work sought to unify art and nature through the analysis and interpretation of organic form.

▶Ernst Barlach, *Man in the Stocks*, 1918. Oak, 29″ × 18″ × 18″ (73 × 46 × 46 cm). Courtesy Kunsthalle, Hamburg.

Barlach produced more than 90 wood sculptures between the years of 1907 and 1937 and followed an expressionistic approach in his style. Heralded as the master wood sculptor of the century by many critics, he effectively combined woodgrain with the marks of the chisel. Barlach's work echoed a strong social consciousness and compassion for the plight of man, and the dynamic use of planes and volumes was one of its identifying characteristics.

▶▶Barbara Hepworth, *Icon*, 1957. Mahogany, 18″ (45.7 cm) high. Collection Arts Council of Great Britain.

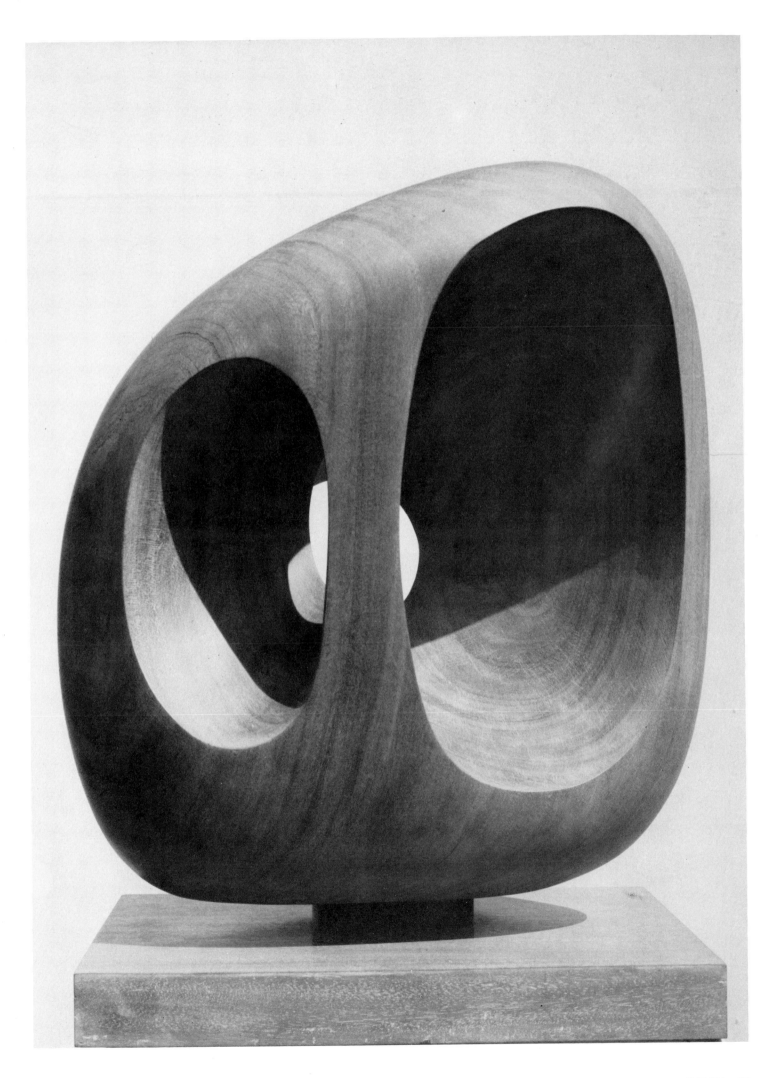

WALTER DRIESBACH

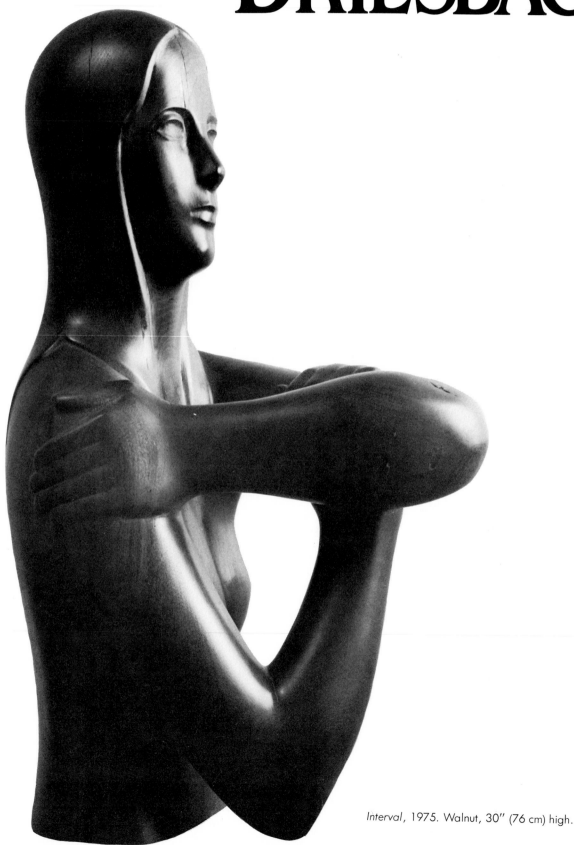

Interval, 1975. Walnut, 30″ (76 cm) high.

"Cutting through layers of wood is like turning back the years of time."

Walter Driesbach

In this chapter, Walter Driesbach, Jr., of Cincinnati, Ohio, demonstrates a traditional method of carving a figure in wood. Driesbach is a prolific woodcarver who often has several sculptures underway simultaneously. On this he writes: "Getting away from a piece for a short time is important, as it allows me to view the work objectively and in this way sense the changes that are required." He describes his techniques in general, and the evolution of *A Short Stirring*, carved in walnut for this demonstration, on the following pages.

ARTISTIC PHILOSOPHY

"I seek to avoid emulating the literal and try instead to *translate* nature into my own personal equivalents through the medium of wood. I still use the abstracted figure as a basis for my designs, but I always try to imbue my figures with some form of familiar human sentiment or emotion and stylize the design accordingly in order to achieve these aims.

"Although I enjoy carving logs that are by nature monolithic, I have recently started to develop a more "open" quality in my work.

SELECTING THE WOOD

"Factors that I consider in selecting wood for carving are color, tone, and prominence of grain and figure. In addition, I try to find a particular wood that seems to be suited to the design that I intend to carve. Generally, I don't use a wood that has a strong grain pattern for a sculpture that involves complicated shapes. On the other hand, I feel that simple sculptural forms lend themselves to woods with prominent grain and figure. Another consideration that I make in the planning stage is the alignment of the design to the wood-grain in order to allow maximum built-in strength for the proposed wood sculpture.

"Although I have carved many types of hardwood, I prefer either walnut or cherry because of the satisfying visual and carving characteristics of both of these woods.

Obtaining Wood. "Hardwood is expensive to buy, and quite often difficult to obtain in logs or flitches. I've been fortunate to acquire some choice woods from friends and acquaintances, and I also make frequent out-of-town excursions in search of suitable logs, which provides me with healthy exercise and needed breaks from the normal studio routine. But not *all* woods are suitable for carving. Some woodgrain is like a "cow-lick"—there's simply *nothing* you can do with it!

"Once I bring the logs back to my studio, I coat the ends with melted paraffin, label them with the date they were cut, and store them away in a special storage shed for seasoning.

Precautions. "Before I carve wood from trees that grew near fences, barns, or houses, I'm careful to check the wood first. There is always the possibility that I may hit a hidden nail within such woods and do extensive damage to my prized chisels. Therefore, if I'm in doubt about a certain wood, I don't start carving with my best tools until I'm sure that the wood is free of any such potential obstructions.

BEGINNING THE CARVING

"To me, the act of beginning a woodcarving without first having an idea is too much like just "messing around." Therefore, I usually begin a piece by first pre-planning it in some way—either through a series of preliminary drawings or by making small three-dimensional models in clay. Whether I'm satisfied with simply making the drawings or going to the extra trouble of making a clay model depends largely on how confident I happen to be of my concept.

"Generally, there's is a considerable lag between the time that I draw ideas for sculpture and then get around to develop them into three-dimensional forms. My sketchbooks are full of drawings that have never materialized into wood sculptures. Sometimes, even though the wood sculpture may be well underway, I stop and do additional clay studies or drawings from the live model in order to gain extra information regarding details or to solve problems that have occurred.

"In preparation for this demonstration carving, I first made a preliminary study in Plasticene that measured about 6½" (16.5 cm) high. As the clay model was used solely for purposes of study, it wasn't finished in any great detail. It must be remembered that a carved work has a certain incisiveness and clarity of form that is quite different from that of modeled clay sculpture.

Tools. "My favorite wood-carving tools are shown on the next page. They include two mallets (one heavy, the other medium weight), a variety of gouges and rasps, a surform tool, sandpaper, and a metal scraper. Other useful shop supplies include chalk for drawing outlines on the wood during the carving process, and a specially constructed "V"-shaped trough that I constructed for holding the log while it's being carved. I also use oil stones, which I carefully inset into blocks of wood to prevent them from slipping while I sharpen my carving tools. (Remember, it's important to keep edged tools razor sharp in order to carve properly. Frequent interruptions of your work are therefore necessary.)

The Roughing-out Stage. "In the first stage, I roughed out basic forms and shapes. Using a deeply curved 1" (25 mm) gouge, powered with the heavy mallet, I established the large basic forms by carving across the grain, horizontal to the length of the timber. When wood is cut in such a way as to compress the fibers and not separate them, clean shiny chips will be produced. When my design called for an "open volume," I first drilled a hole within that area with a brace and bit and then opened the shape by chipping away with a narrow gouge.

I used white chalk throughout the carving process to outline shapes prior to carving. I find that drawing on the wood prior to carving helps me determine the composition and "flow" of the sculptural forms. Between carving sessions, I stored the wood sculpture in a sealed plastic bag to minimize checking. *Checking* refers to small or minor cracks ("checks") or severe splitting of the wood, which often occurs when green wood is subjected to rapid drying. On the other hand, seasoned wood should not be subjected to radical atmospheric changes either,

or checking, splitting, and warping may occur. *All* severe changes of temperature and humidity impose deleterious effects on wood.

INTERMEDIATE STAGES

"As the carving progressed, I began to define the intermediate shapes and volumes with a smaller tool, the ¾" (20 mm) gouge. The carving was done in a freer manner, but in a diagonal as well as crossgrain direction during this stage. I caution my students to pay particular attention to developing the intermediate shapes and forms in their wood carving. Too often beginners tend to ignore this stage, carving only initial forms and then abruptly shifting to the development of details.

Repairs. "I saved several pieces of the sapwood that were removed from the sculpture during the early stages of carving for repairing cracks. To use them, I carefully shaped and fitted them into the cracks and glued them in place. I then shaped them to conform to the surface of the wood.

Smoothing Wood Surfaces. "After the general forms of the sculpture were established with the large gouges, I shifted to wood rasps to smooth the surface. I have a collection of various types of rasps that range from coarse-cutting to fine-toothed tools. I particularly like the surform rasp. It's an ideal tool for smoothing wood surfaces because it leaves a "clean" surface as it planes rather than abrades the wood. The combination rasp is also a very useful tool for smoothing wood, and riffler rasps are good for getting into difficult areas and smoothing inner shapes. To avoid tearing the wood fibers

with the rasps, I rasped the wood in the same direction I followed when carving with the chisels.

Sanding. "For sanding hardwood, I used garnet paper. I folded the paper over twice so that it becomes more substantial and less likely to crumble. It also remained pliable enough to conform to varied surface configurations of the wood sculpture. I always wear a protective mask during sanding operations to guard against dust inhalation.

Color Corrections. "Quite often in my work, the inner portions of the sculpture, which are carved of heartwood, may be radically different in tonality than the outer sapwood. If I find this objectionable, I darken the lighter portions with a suitable woodstain, repeating the operation until the tones of the heartwood and sapwood are matched.

FINISHING

"For the final surface treatment of my wood sculpture, I brushed a liberal application of Danish oil over the wood and then sanded it with fine grades of waterproof sandpaper. Sanding the wood while the oil still remains on the surface produces an excellent finish. I use finishing oils in a well-ventilated room, since many of these products contain petroleum distillates and produce toxic fumes.

Oiling may be repeated many times to produce a highly lustrous surface, but I personally prefer a satinlike finish that only a few applications will produce. When the task was done, I wiped the wood clean with a soft cloth or paper towel. For the final finish, I applied paste wax with no. 000 steel wool, rubbing the wax down lightly."

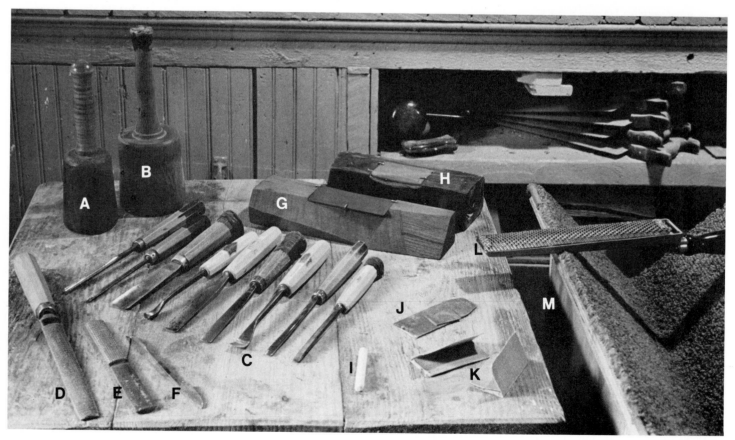

The tools that Walter Driesbach used in carving the figure in wood for this demonstration include: A. 1½-lb mallet, B. 2-lb mallet, C. straight and short-bend gouges, D. medium-coarse half-round rasp, E. combination rasp, F. riffler rasp, G. oilstone, H. hard Arkansas stone, I. chalk, J. metal scrapers, K. sandpaper, L. surform rasp, and M. carpeted trough (for holding the wood while carving).

THE FIGURE

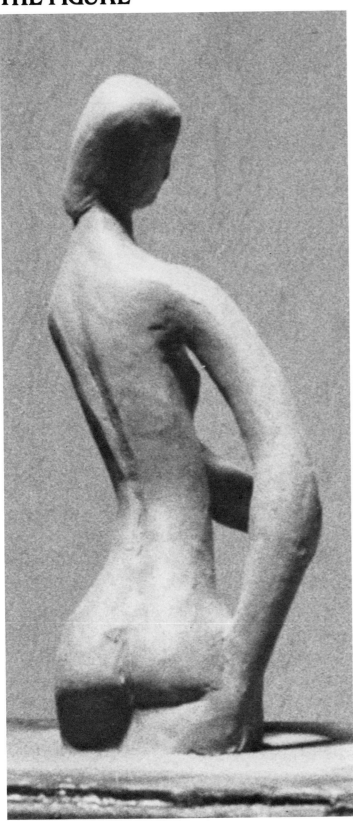

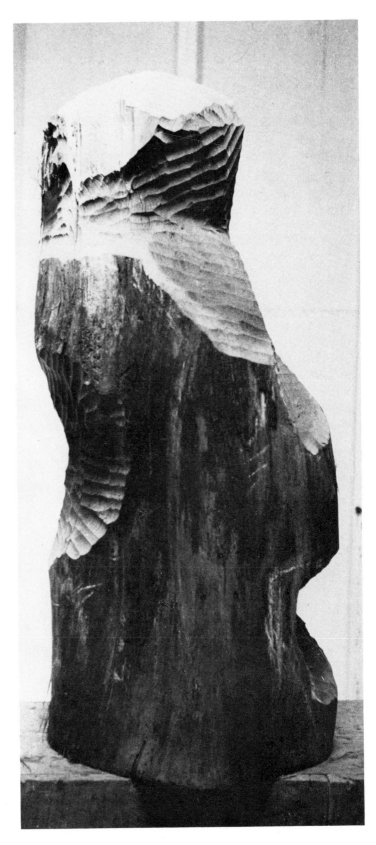

The Clay Model. Before beginning to carve in wood, Driesbach makes a preliminary study of the proposed sculpture in plasticene. The general composition and gesture is established in the clay model. No attempt is made to create a "finished" sculpture.

First Stage, Roughing-out. A seasoned log (walnut) is selected for carving the figure. At the very offset, a few large areas of the log are removed with a chain saw (not shown); then a 1" (25 mm) deep-curved gouge is used to begin the roughing-out stage. The gouge is powered by the 2-lb mallet. White chalk is used to outline basic forms prior to carving and the essential shapes are roughed out. The carving chisel is kept razor sharp, producing clean chips.

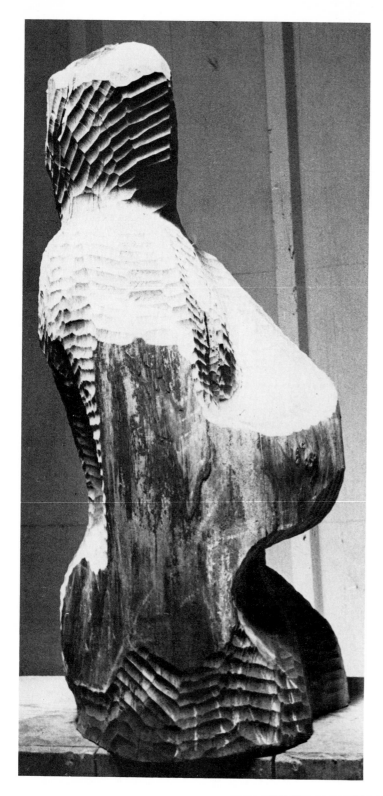 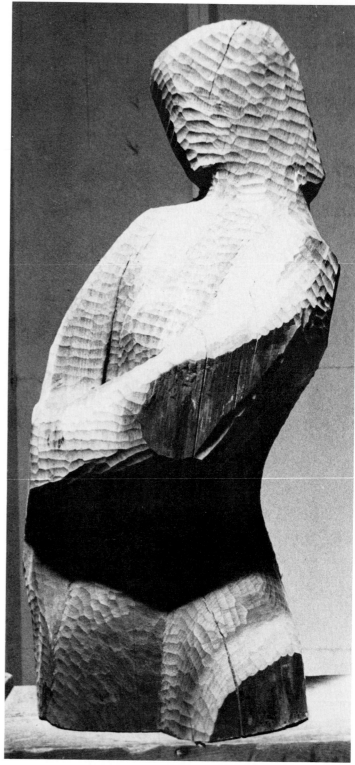

Second Stage. In this photograph, you can see the direction of the carving across the grain (around the trunk horizontally). In this stage, the general planes and basic forms are defined and gesture of the figure is established.

Second Stage (Continued). The work is frequently turned and the carving progresses evenly; no one section is finished before the others. Carving is done in a diagonal direction in relationship to the grain of the wood, as well as in a cross-grain direction. Careful attention is given to the establishment of volumetric relationships between the head, body, and limbs. The vertical quality of the log is modified considerably as the lyrical gesture of the figure is established.

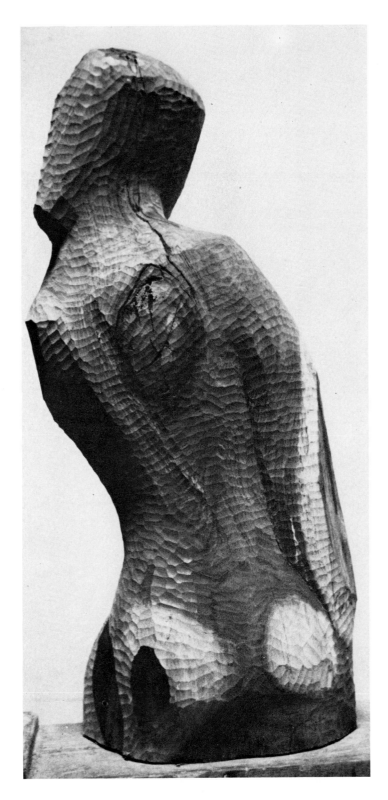

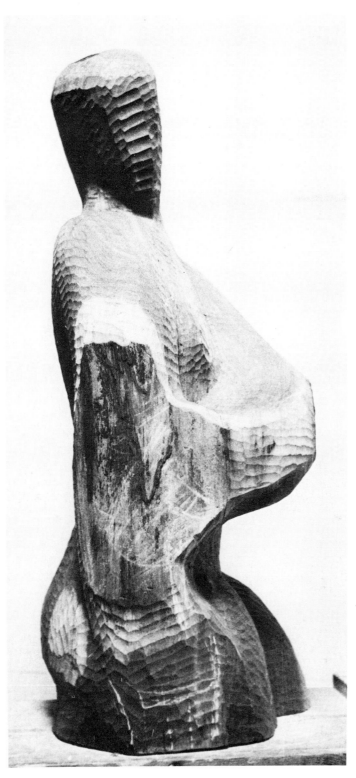

Third Stage. A ¾" (20 mm) gouge is used to establish the intermediate forms. The flow and continuity of surfaces and volumes are integrated through the interweaving tool marks. During the carving, several blemishes are discovered in the wood. These are marked for future repair. (Extra sapwood from the log is saved for this purpose.)

Third Stage (Continued). The shallow ¾" (20 mm) gouge is used to "round off" the ridges left by the large gouges. Driesbach alternately uses chalk and carving tools, drawing forms on the wood prior to carving.

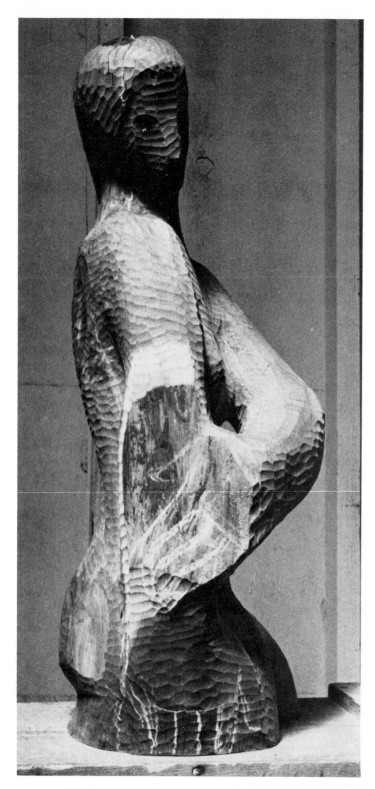

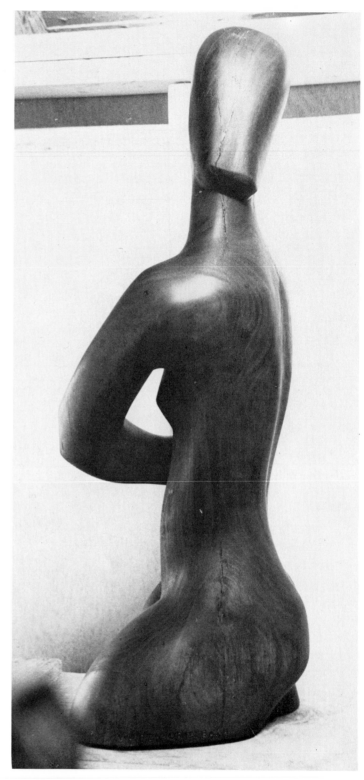

Fourth Stage. Driesbach continues to establish intermediate details, such as the planes of the face and shape of the hair. A brace and bit is used to open an area, which is further carved to create a negative shape in the sculpture.

Fifth Stage. Rasps are used to remove chisel marks, smoothing the surface. First, a medium-coarse rasp is used, followed by the surform tool and the riffler. (Metal scrapers are also used to smooth surfaces during this stage.) Sanding progresses from medium through fine grades of garnet paper. As the surface is smoothed, the pronounced grain pattern of the wood emerges. Details of the head are made more precise with the riffler file and sandpaper. Danish oil is brushed on the surface, and a fine grade of waterproof paper was used for the final sanding.

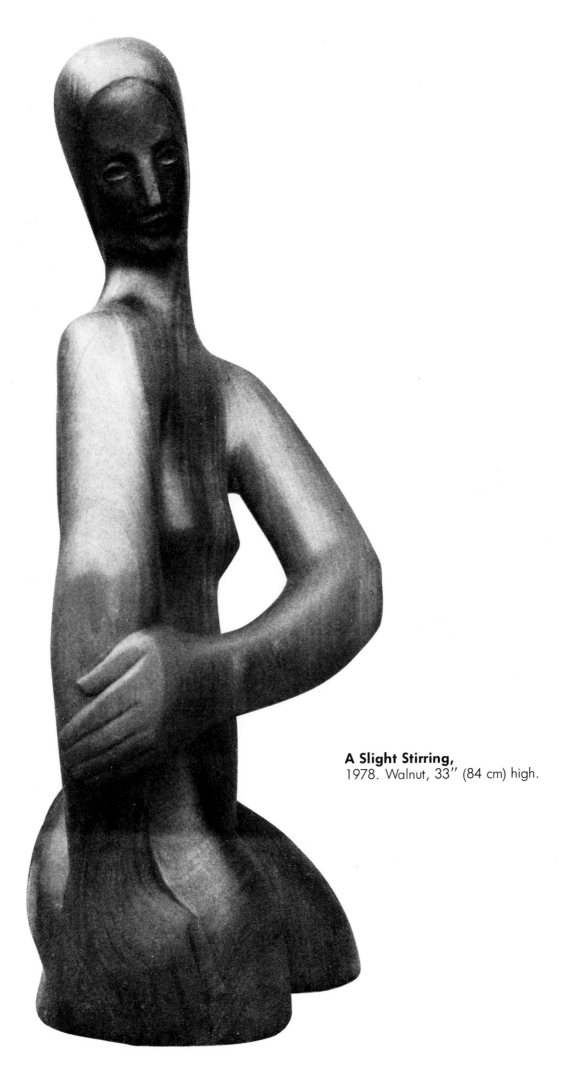

A Slight Stirring,
1978. Walnut, 33" (84 cm) high.

DAVID HOSTETLER

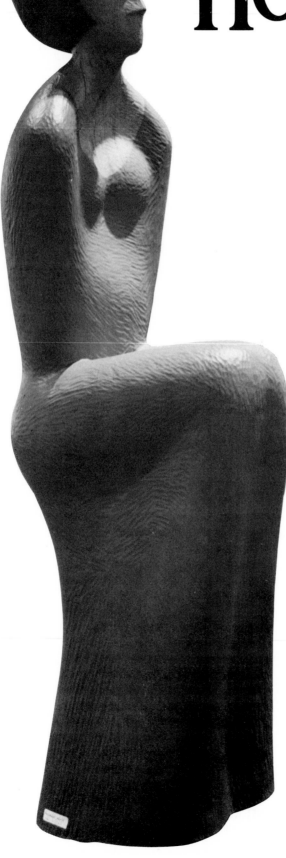

Seated Woman. Elm and acrylic paint, 50" (127 cm) high.
Photo: Stuart R. Bolin III.

David Hostetler is particularly well known for his "American Woman Series," a theme he has successfully developed in his polychromatic wood sculptures. His style of figure carving is based on the use of simplified abstract forms. His carved ladies are not intended as portraits of specific people, but as symbolic references to social archetypes. Their images have evolved as a result of the artist's personal observations and experiences, particularly his Amish ancestry and interest in early American folk art. Other influences that seem to be manifested in his work are derived from such sources as the work of Nadelman, Maillol, Lachaise, and Moore.

Hostetler's studio is situated in Athens, Ohio, on a 75-acre farm bristling with mature trees. There he cuts elm or sassafras wood as he needs it, and surprises his sculpture colleagues by breaking the "cardinal rule" of woodcarving in audaciously carving "green" timber. In this demonstration, he shares the technical "wherewithall," disclosing the successful studio techniques he has developed during his twenty years of wood carving.

CARVING GREEN WOOD

In wood carving, you can either (1) dry and season the wood according to the traditional methods, or (2) keep the wood *wet* under plastic sheeting during the entire working process, even between carving sessions. Asked about the latter process, his controversial method of carving green wood, Hostetler says: "I found after some 20 years of carving that it's easier and more fun to carve green, wet wood. To keep it wet, I add water and keep the log wrapped in plastic and wet rags during the storage and carving. This humid, fungus-ridden environment also encourages *spalting*. (That's the pretty linear pattern that appears during wood decay.) Also, when you're air-drying a log, you're drying a lot of volume that will be carved away later. When you let a green piece dry under polyurethane (that is, under five coats of polyurethane varnish applied to the surface), you're usually drying no more than 50% of the log. The polyurethane coating lets the water out of the wood slowly, and usually without any strain or checking. (The cooler and more humid its environment is the first year, the better!) The only checking I've encountered in my pieces is if someone places the carving in a very hot, dry atmosphere during its first year of drying."

Asked if he had ever used polyethylene glycol (PEG) to "bulk" his wood prior to carving, he replies, "I found PEG expensive and time-consuming compared to my own process. It has a tendency to 'bleach' the wood and repel the aniline dyes and finishes that I like to use later."

PRELIMINARY WORK

Hostetler often cuts paper silhouettes of his proposed sculpture and then hangs them on the studio walls as references, or he makes rough sketches on paper prior to carving. He enjoys carving directly and instinctively, however, and doesn't bother with elaborate sketches or drawings.

FIRST STAGE

The demonstration sculpture *Sassafras Lady* was carved directly from a freshly cut log of sassafras. The electric chain saw, his only power tool, was used just at the beginning to block out the basic geometric forms of the work and to remove the large excesses of wood. Then, after sawing away the unwanted portions of wood, he attached the work to a *power arm*, a hydraulic device that holds the wood securely to the workbench but also allows it to be swiveled and positioned anywhere within a 360° arc.

Roughing Out. In roughing out the general form of the head and torso, Hostetler began by using the 1½" (38 mm) gouge with a medium-weight mallet. He alternately used this with a 1¼" (32 mm) gouge and carved crossgrain as well as diagonally, removing large chips. In this manner he quickly established the features of the face and torso in general terms—concave shapes without details for the eyes, a salient geometric form to indicate the nose, and so forth.

INTERMEDIATE AND FINAL STAGES

After the basic forms were roughed out, Hostetler switched to a narrower, ⅞" (22 mm) quick gouge and developed the surface texture and finer details. The "scalloped character" of the surface texture emerged as the tool marks blended to impart a rich and light-capturing quality over the entire surface of the sculpture. To refine the area of the face, Hostetler used the shallow ⅞" (22 mm) gouge and smoothed down the chisel marks in that area, emphasizing the distinctive concentric patterns of the woodgrain.

FINISHING

As soon as the work with the carving tools was completed and the "wet-wraps" were removed, the sculpture was allowed to air dry for a short time (until fine hairline drying checks started to appear). Then it was lightly sanded with no. 320 grit paper, and the first coat of polyurethane varnish was applied to the surface. As soon as the varnish dried, a second, then a third coat was applied. The application of three "quick coats" of polyurethane was essential to seal the wood and prevent checking. One or two coats are not sufficient.

In varnishing wood, some clouding may appear in very moist areas, but this will disappear as the wood loses its moisture content. Also, as the sap water leaches slowly through the coats of varnish, it may leave fine residue in the form of little black "zits" in some localized areas. These are easily sanded off later with a fine grade of abrasive paper.

Staining. Hostetler's trademark is the polychromed figure. "I apply the aniline dye over several coats of polyurethane," he said. "It doesn't dry as rapidly as it would if applied directly to the wood, but in this way it doesn't "bleed" or tend to run with the grain. I can delineate an edge, that is, a dress or the hair, for example, or draw a precise line with the aniline dye. The dye will remain "tacky" for four or five days, but when it doesn't come off to the touch, then I apply the two remaining coats of

polyurethane. (The time that it takes the aniline to dry varies according to how much it is diluted with water or alcohol.) The dye stain is transparent, bringing out the grain of wood. For *Sassafras Lady*, I used a brown aniline dye to color the hair, and a gold stain over a section of the torso to delineate the shape of the dress."

Final Touches. After the application of aniline dye stain to some local areas, two additional coats of varnish were applied to the sculpture, making a total of five protective coats. Hostetler used no. 458 *Polyurethane Wood Varnish* (no. 90 Satin Clear), available from Jewel Paints, Division of Kurfees Coatings, Inc., Chicago and Louisville, Kentucky 40202; and *Tru-Tone Concentrated Aniline Liquid Colors*, available from the James B. Day Company, Day Lane, Carpentersville, Illinois 60110. (The stains are toxic, so protect your skin with plastic gloves.) The polyurethane varnish allows the water to leach out very slowly over a protracted period of time. Between the application of the last two coats of varnish, the surface was rubbed down with nos. 320 and 400 grit abrasive paper.

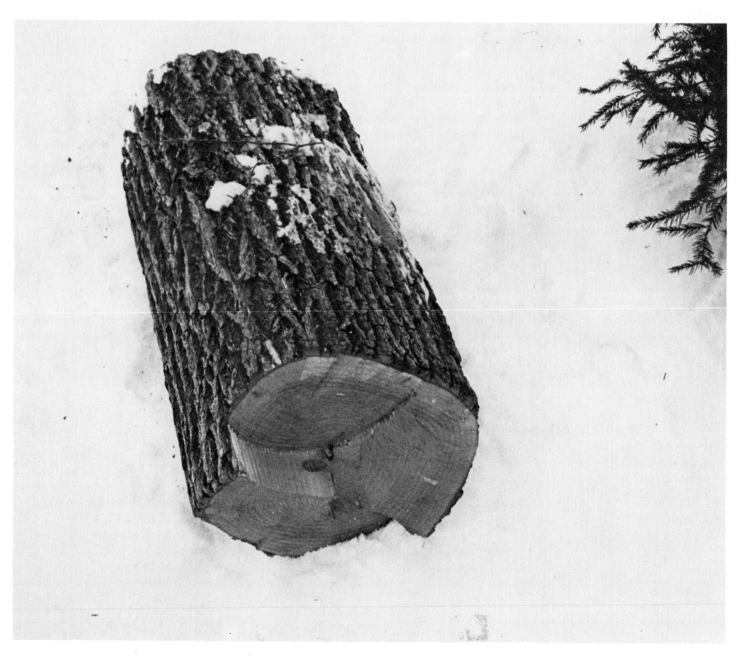

The Wood. A log of sassafras wood is cut in preparation for carving. Wood cut during the winter (when the sap is down) expedites seasoning.

THE HEAD AND TORSO

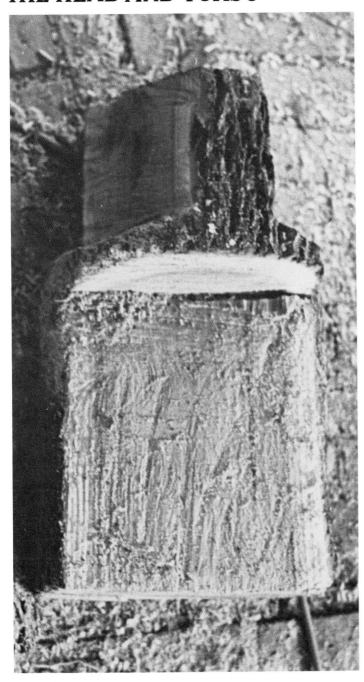

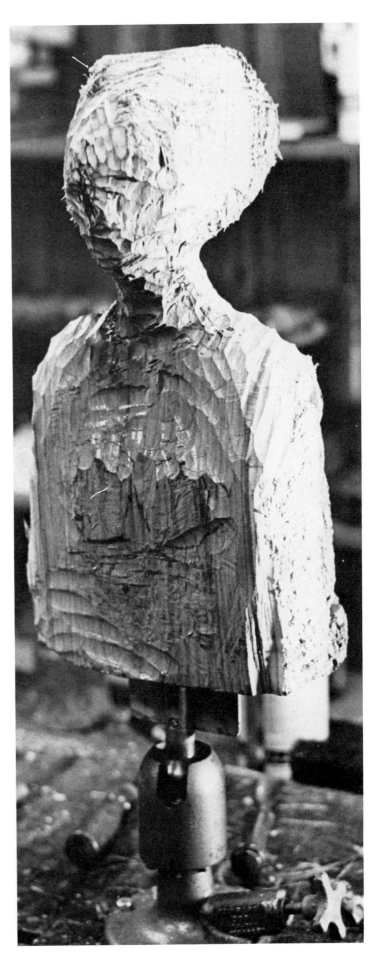

▲**The Completed "Blocked-out" Stage.** Hostetler carves unseasoned (green) wood, but exercises special precautions to prevent checking. The electric chain saw, the only power tool he uses, was found to be a quick way of removing excess wood. Hostetler uses it to block out the basic geometric forms of the head and torso.

▶**Roughing-out.** The wood is attached to a power arm and roughed out with a 1½" (38 mm) quick (deeply curved) gouge. The gouge is powered by a medium-weight mallet and is directed across the grain of the wood and also diagonally. The geometric shapes are rounded off; the gesture and general forms are established.

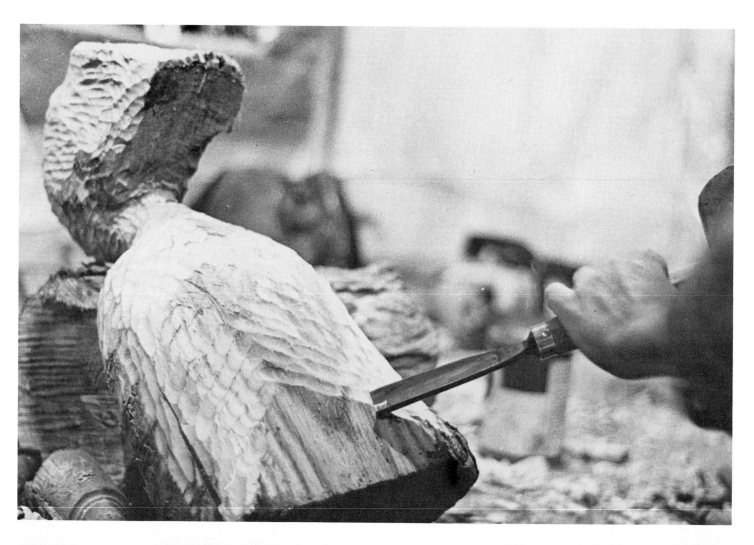

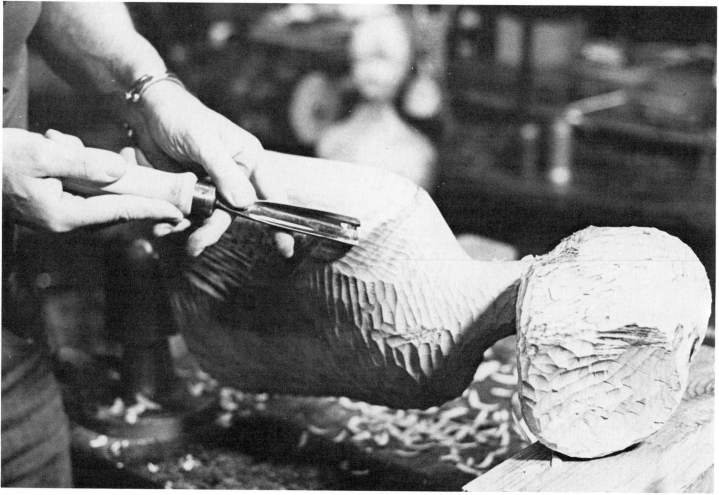

◄**Refining.** A 1½″ (32 mm) quick gouge is used to further refine the shapes and surfaces of the sculpture.

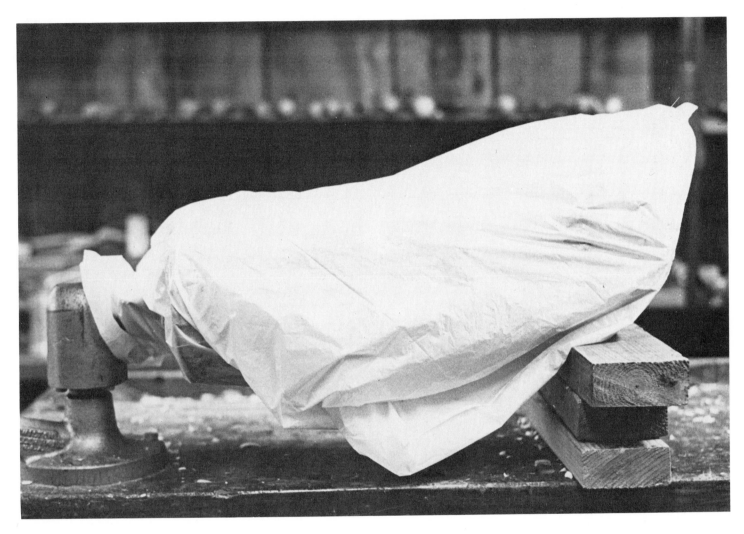

◄**Surface Texture.** A ⅞″ (22 mm) quick gouge, powered only by hand pressure, is used for developing the final surface texture. Razor-sharp tools carve green wood easily, producing richly scalloped surfaces. (Later, a shallow gouge is used to smooth down the surface of the face, emphasizing the woodgrain in that local area.)

▲**Keeping the Wood Wet.** Between carving sessions, the wood is kept moist by applying wet cloths covered with polyethylene plastic sheets. Spalting (controlled surface discoloration) is also encouraged in this manner.

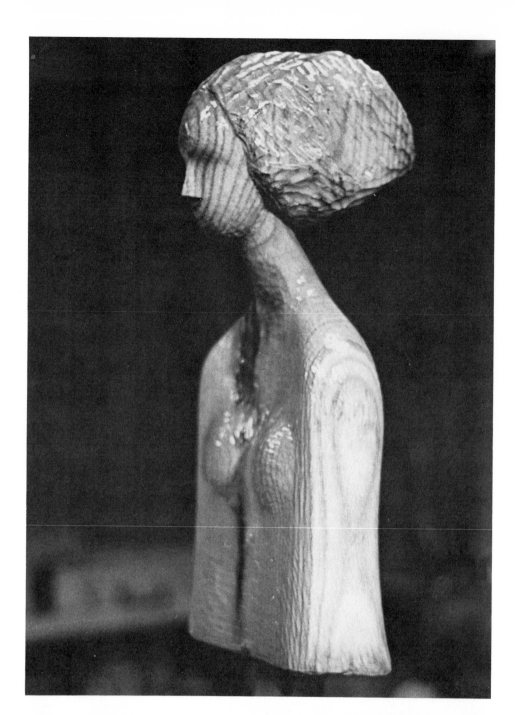

Sealing the Surface. Hostetler applies three coats of a wet-cured polyurethane varnish to the surface of the completed wood sculpture (which is still green). This application seals the surface, allowing the water to leach out slowly over a period of time, and prepares the wood for aniline dye stains.

Staining. Hostetler applies a brown aniline dye to color the hair. Previous coats of varnish keep the stain from "migrating" and produced a "clean" edge. Ochre stain is applied to delineate the dress. After the stain is dry, three more coats of polyurethane varnish are applied to the surface, rubbing down between coatings with Nos. 220 and 330 abrasive paper. The final coat is rubbed down with No. 400 grit paper.

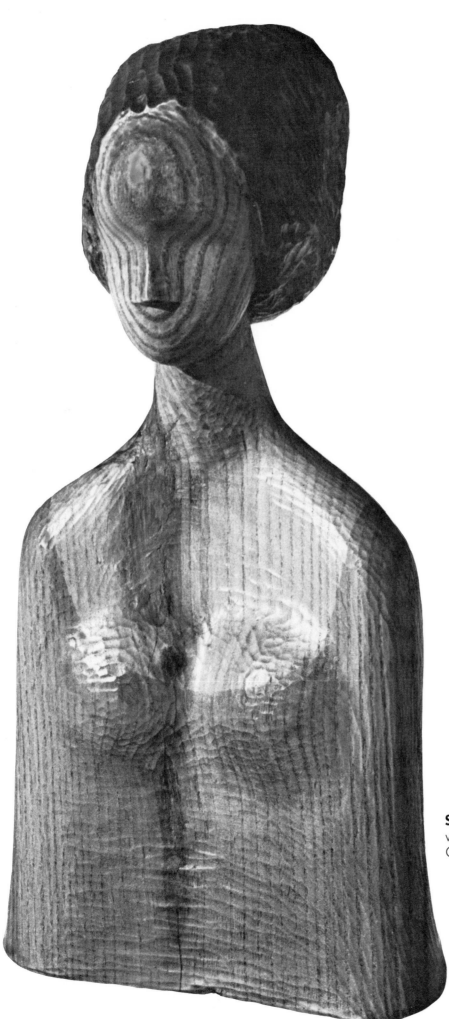

Sassafras Lady, 1978. Sassafras wood, 23″ (58.4 cm) high. Private Collection. Photos: Doni Grix.

PETER BOIGER

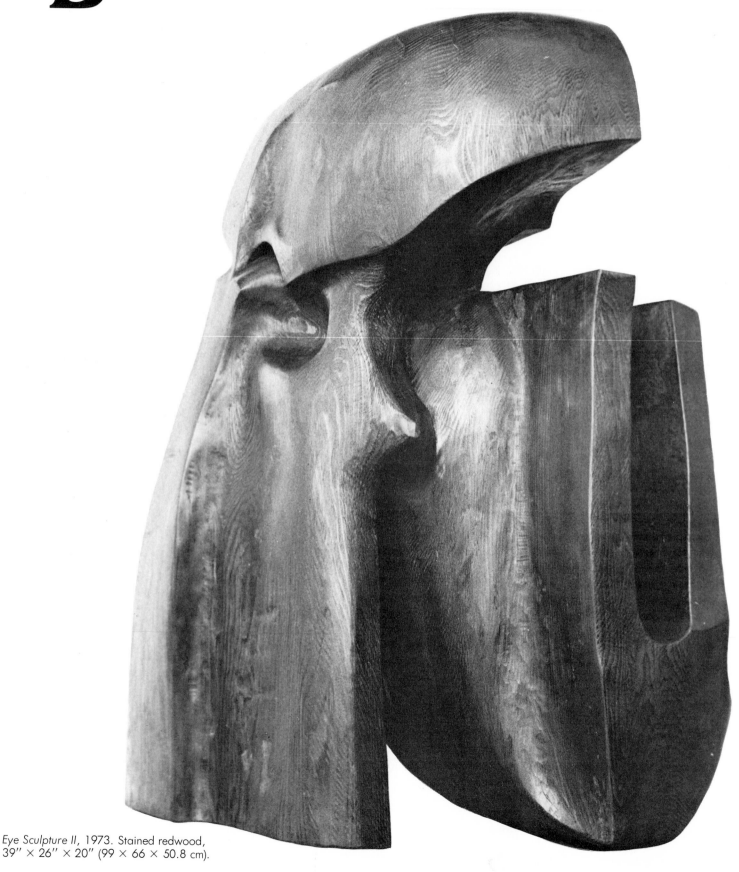

Eye Sculpture II, 1973. Stained redwood,
39" × 26" × 20" (99 × 66 × 50.8 cm).

In this demonstration, California artist Peter Boiger carves an abstract sculpture from a large flitch of black walnut.

Boiger's concepts for sculpture are generally derived from his observation of natural forms. He analyzes and combines organic forms with figurative elements, deriving an "anthropomorphic hybrid" (particularly in his vertical pieces).

His present work tends to develop design themes in one of two directions: (1) vertical anthropomorphic abstractions with a vertebraic character, and (2) massive sculptural volumes that are composed of interacting volumetric forms within the monolithic shape. *Standing Figure*, the sculpture demonstrated here, is an example of the first category, while *Eye Sculpture II* (opposite page) is typical of the second category.

Boiger's work also shows a penchant for expressionism (particularly evident in the dynamic composition of his vertical figures) and is reminiscent of cycladic figures and tribal art forms. His tall vertical figures also bring to mind the totem carvings from the Pacific Northwest native carvers as well as contemporary works from such artists as Brancusi, Giacometti, and Moore.

SELECTING THE WOOD

Boiger gets most of his wood himself, usually within a 200-mile radius of his San Francisco Bay area studio, often taking his pick-up truck out to the country to get "logs from trees that people want cleared away." He keeps his studio well supplied with redwood, walnut, and pecan wood that he has found on such safaris, and stores the wood outside his studio for long periods to thoroughly season before carving by air drying.

"I prefer to use only half of a log for carving," Boiger explains, "as I've found that, regardless of how careful one may be with seasoning, bulking, or finishing methods, the log always seems to have a predisposition to check. However, by first cutting the log in half lengthwise and then seasoning it for a lengthy time, many of the interior pressures are relieved and the checking is minimized.

"As my concept for *Standing Figure* (demonstrated in this chapter) called for a slender and vertical design," he says, "I was able to avoid using most of the heartwood from the black walnut that I had set aside for this sculpture.

"I always prefer to use well-seasoned wood for my sculptures, and sometimes even go to the extra trouble of setting a roughed-out sculpture aside in my studio for six months to a year for additional seasoning before completing the carving," Boiger says. "If I have the time, I find this to be an ideal method of seasoning. In the case of *Standing Figure*, the wood first underwent air drying outside, then was partially carved, and then continued to dry inside before being completed." The wood for *Standing Figure* had been seasoned for six years.

SEASONING THE WOOD

Boiger has a unique method of seasoning his wood. He first saws the log in half lengthwise with a chain saw (or on shorter logs, drills out the pith with a drill and extended auger), paints the ends of the wood with roofing tar, and then stands the two sections upright outside his studio to dry.

To protect the wood from rain and the elements, he makes a small "roof" with plywood and roofing paper and nails it to the top of the two sections. This keeps the pieces together in the upright position and prevents them from falling over. A 2" (5 cm) space between the two timbers allows for air circulation. The wood is set on 2 × 4's and concrete blocks to allow the air to circulate underneath and to protect the wood from mildew. Peter Boiger describes the evolution of *Standing Figure* in the following text.

STARTING THE SCULPTURE

"I make many sketches, most of which are small line drawings, in preparation for my wood sculptures. Occasionally, however, I may decide to make a full-size line drawing that's used as a reference for subsequent carving. In the case of *Standing Figure*, I worked from sketches.

Roughing Out. "The first stage in actual carving was roughing the figure out. I removed the large portions of excess wood with a chain saw, occasionally also employing an axe or sculptor's adze for this purpose. Another tool I also found useful for roughing out basic shapes was the bow saw. I equipped it with a 1¼" (22 mm) blade for straight cuts and a ¼" (6 mm) blade for curved cuts. (See lower photograph on next page.)

CARVING: FIRST AND INTERMEDIATE STAGES

"When I had completed roughing out the basic geometric forms with the saws, I switched to large curved gouges and a 3-lb beechwood mallet. I used a 3" (75 mm) deeply curved gouge and a 2" (50 mm) fishtail gouge. (I get my edged tools from a German manufacturer, F. W. Rosenbach, who produces very high-quality carving tools.) (See second photograph on next page.)

"In carving the intermediate forms, I used a narrower gouge, a ¾" (20 mm) gouge with a flatter sweep, which was powered by a 1¼- lb mallet. I used the flatter gouge to remove the ridges left by the larger gouges and sought to round off forms and develop intermediate details. I find that I get the most accurate control from my carving tools by using only my hands: holding and directing the gouges with my left hand and powering it with pushes from my right. I use this technique when approaching the final surface.

Smoothing the Surface. "During the next stage, I used a variety of abrading tools and abrasive papers to smooth the wood surface. These included round and flat surform rasps and sandpapers of various grits. I like the marks that the surform tool leaves on the surface of the wood, and in some

places allowed it to remain as a final texture. In *Standing Figure*, I sought to integrate a variety of surface textures, including the marks of the gouges and smoothing tools.

"For sanding large areas, I used a power sander, starting with no. 100 grit paper and then finishing up with no. 200 grit. Because it was difficult to sand the smaller and more complex areas with the power sander, I sanded these areas by hand, using a makeshift tool: garnet paper wrapped around small pieces of shaped wood.

FINISHING

"I found that the black walnut used for *Standing Figure* yielded a particularly attractive color and figure and required very little in the way of finish. I applied three coats of Watco Danish wood oil, following the directions on the can. The application darkened and dramatized the figure and color of the wood as well as offering a durable surface protection.

"In general, after I finish a wood sculpture, I don't allow it to leave my studio immediately. Instead, I set it aside and wait for any cracks to develop. If they do, I fill them with small wedge-shaped slivers of wood of the same material as the sculpture. These are then glued in place and finished to match the surface."

▶ Carving tools used for preliminary work include 2″ and 3″ (50 and 75 mm) gouges and a heavy 3-lb mallet. The work is held down to the workbench with a large clamp.

Other tools Boiger uses are heavy and lightweight mallets, quick-slide clamps, a bow saw and back saw, big gouges (2 to 3″, 5 to 7 cm), smaller gouges (1″, 25 mm), surform rasps (flat and round), an air sander, and abrasive disks.

THE ABSTRACT FIGURE

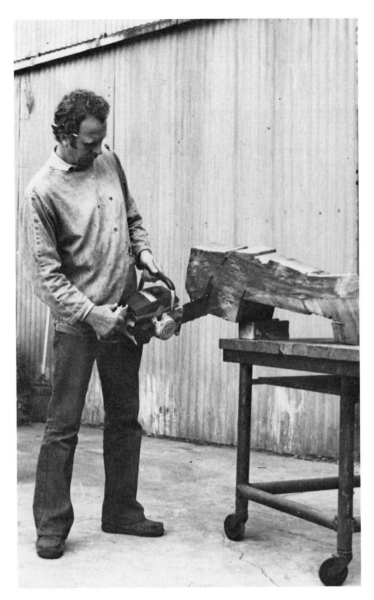

Seasoning Lumber. A log of California black walnut measuring 5½' (1.7 m) in length is cut in half lengthwise with a chain saw and set up on end to season. A makeshift roof shields the lumber from the elements and air is allowed to freely circulate between the two sections. The wood is seasoned for six years.

Roughing-out Basic Shapes. Peter Boiger roughs out the basic geometric shapes of *Standing Figure* with a chain saw.

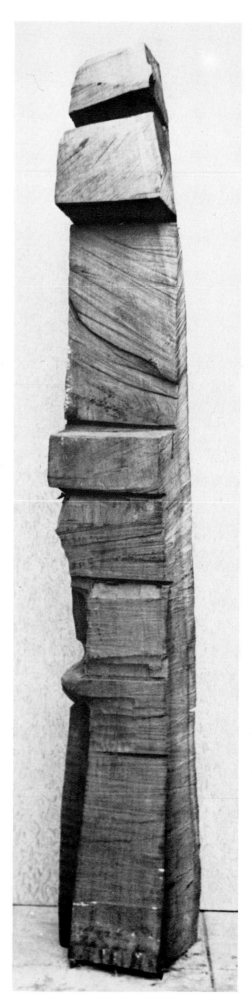

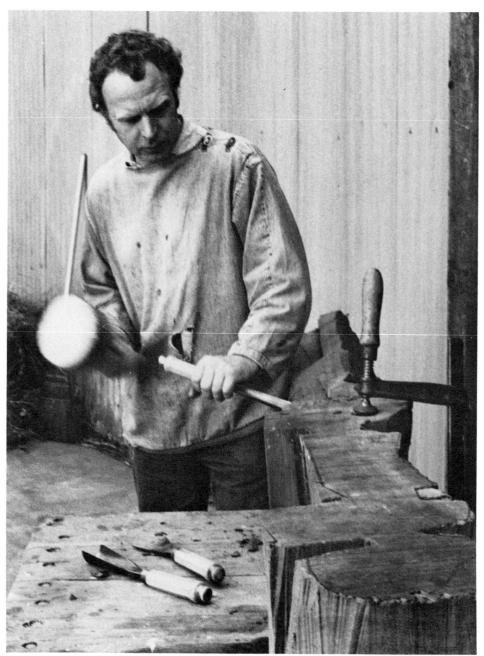

◄**The Roughed-out Form.** One section of the black walnut is roughed in simple geometric terms, establishing the basic proportions and volumetric relationships. In addition to the chain saw, Boiger uses a sculptor's adze to remove excess wood.

Roughing-out Intermediate Shapes, Stage One. After roughing out basic shapes with the chain saw, Boiger shifts to the use of large gouges. A 3″ (75 mm) fishtail gouge, powered with a 3-lb beechwood mallet, is first used to define the curvilinear volumes of the piece. The wood is securely held to the workbench with a quick-slide steel clamp.

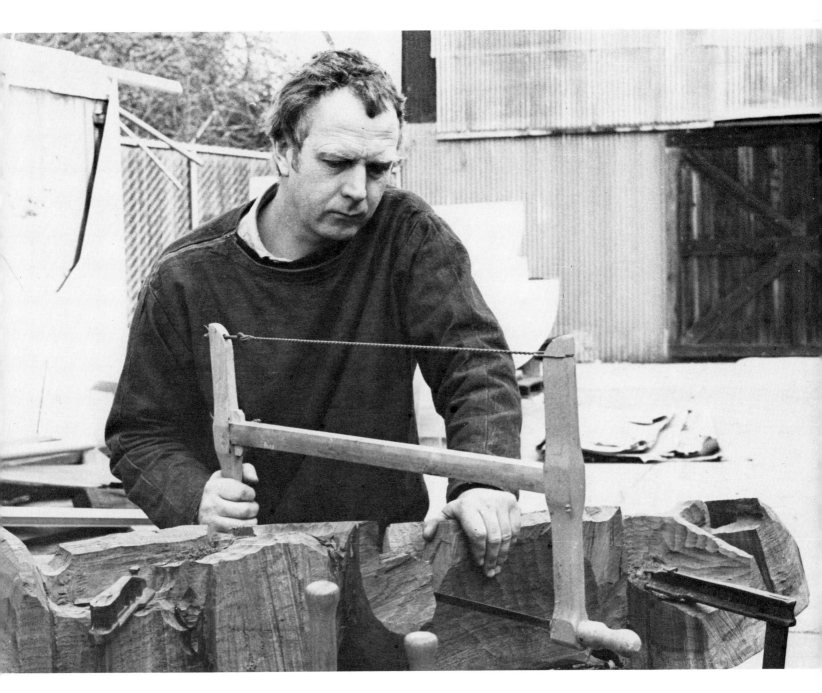

Roughing-out Intermediate Shapes, Stage Two. Further roughing-out of intermediate shapes is accomplished with the bow saw. A ¼″ (6 mm) blade is used for making curved cuts, and a 1¼″ (32 mm) blade for straight cuts.

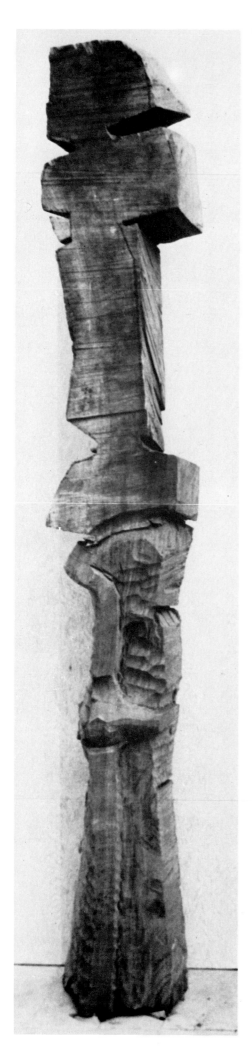

◄The Work in an Evolutionary Stage. The upper half of the sculpture is still in the roughed-out geometric state, while the lower half has been carved into rounded volumetric forms with the large gouges.

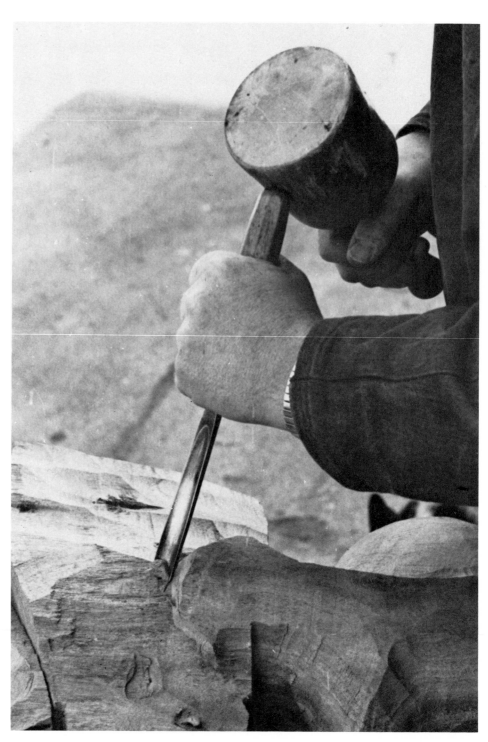

Developing Intermediate Volumes. Boiger works the gouge crossgrain, in a diagonal direction across the wood.

Smoothing the Surface. Forms are further refined with surform rasps, using the tools to remove chisel marks and smooth the surfaces. This is followed by the use of abrasive papers, using both power and hand sanding for final smoothing.

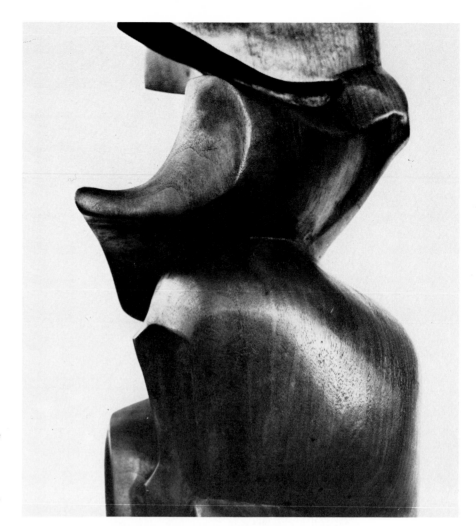

Smoothing and Finishing (Detail). Both power and hand sanding is used to smooth the final surface of *Standing Figure*. An air sander is used to smooth larger areas, while more intricate areas are smoothed with garnet paper, either folded over and used by hand, or wrapped around slender pieces of wood and used for smoothing out more intricate areas.

Form and Structure (Detail). Here, the form and structure of the sculpture are more evident, as well as the pattern and grain of the wood. The vertebraic form of the sculptural units is reminiscent of organic forms from nature.

Standing Figure (Two Views), 1978. California black walnut, 87" (218 cm) high with 14" (36 cm) base of copper sheet. To preserve the finish and enhance the grain and pattern of the wood, several coats of Watco Danish oil are applied over the surface.

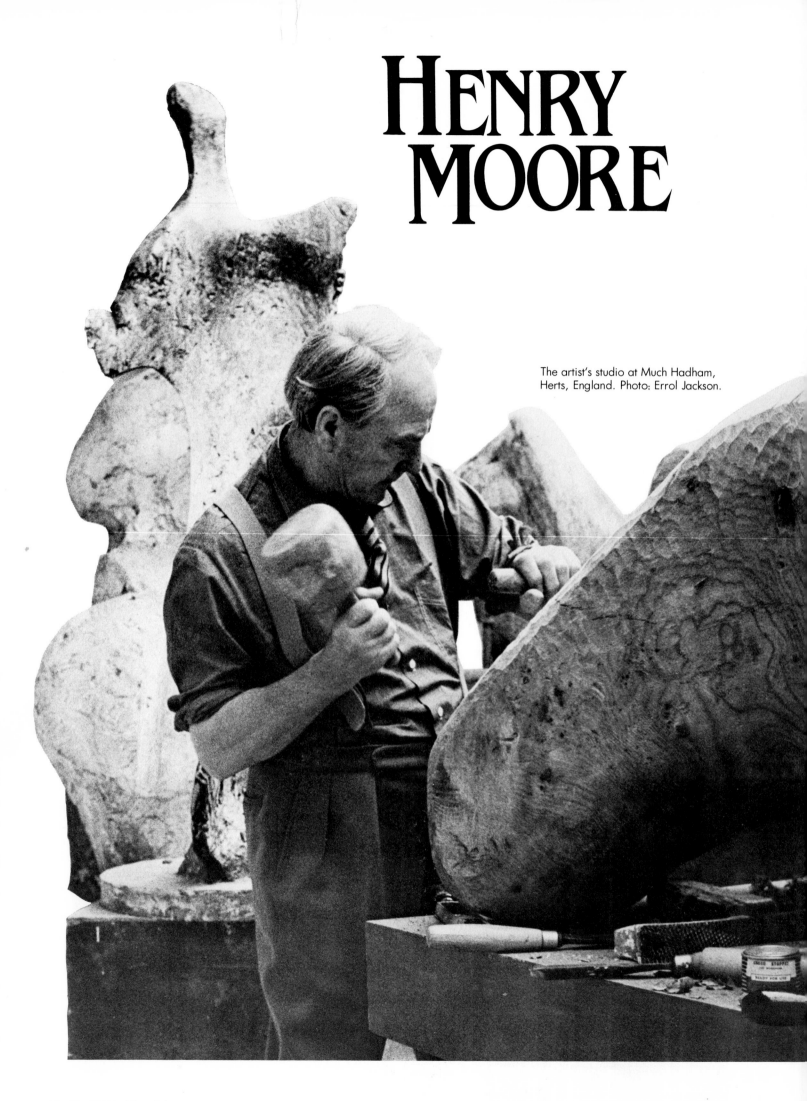

HENRY MOORE

The artist's studio at Much Hadham, Herts, England. Photo: Errol Jackson.

> "One distorts form in order to create space."
>
> Henry Moore

Henry Moore once described the human figure as having three fundamental poses: standing, seated, and reclining. Of the three, he thought the reclining pose offered the sculptor the greatest freedom compositionally and spatially, being both free and stable at the same time, Although the human figure has always been a principal basis for Henry Moore's compositions, it has always been modified and abstracted by the forms of nature. He has written that observation and analysis of nature is the inspirational aspect of the artist's life, that "it enlarges his form-knowledge and keeps him fresh and from working only by formula."

Moore's work is never perfunctory or mechanical, nor does it seek to mime the characteristics of nature, but reflects the organic *qualities* of growth that are inherent in nature. Therefore, following the tenets of nature, the volumetric forms of his sculpture "grow" into each other in subtle transition. It is not surprising, then, that for many years he has been particularly preoccupied by the study of bones and trees because of their interesting and subtle transitional qualities as well as the inherent design engineering that has produced both strength and beauty in these forms.

MOORE'S RECLINING FIGURES
Moore's passion for the study and analysis of organic form in nature is also reflected in the compositions of his reclining figures.

The idea that a reclining figure could serve as a double metaphor (sculpture in the image of man; the image of man as mountain) dates back to reclining figures that he created in 1929 and 1930 and was articulated in some of the artist's early writings when he spoke of the "mysterious fascination of caves in hillsides and cliffs." Since then, the motif of the reclining figure has become a recurrent and obsessive theme for Henry Moore. He has constantly reworked it and has produced many outstanding sculptural versions during the past twenty-five years, in wood, stone, and bronze.

FORM AND SPACE
John Russell once wrote that Moore's finest work is always ambiguous, enigmatic, and full of implications that he leaves for us to resolve. And Moore himself once said, "The sculpture that moves me the most is that which has a life of its own and is independent of the object it represents." Therefore, although his original inspiration for the theme of the reclining figure was pre-Columbian art, specifically the carved stone figure of *Chacmool*, a Toltec-Mayan sculpture (900–1000 AD) that was discovered in the temple of Chichen Itza in the Yucatan and is now in the collection of the National Museum of Anthropology in Mexico City, the sculpture had other implications for him. What he admired most in this pre-Columbian figure was its basic simplicity and power of form, that is, its integrity and "volumetric strength" within its three-dimensional reality. These factors soon became intrinsic characteristics of Moore's subsequent work.

On the subject of the interrelationship of space and form, Henry Moore once wrote, "If space is a willed or wished-for element in the sculpture, then some distortion of the form, to ally itself to the space, is necessary." Therefore, using pre-Columbian sculpture as a basis, Moore proceeded to modify it to his own conceptions. One way he did this was by drilling holes in these massive forms. He carved his first "open figures" in the late thirties.

In the book *Henry Moore on Sculpture*, the artist is quoted as saying that at one time he created holes in his sculptures for "their own sake," trying to become conscious of spaces in his sculptures. But later he sought to make the forms and the spaces inseparable, neither being more important than the other.

The holes served another purpose, too. Moore conceived of space as being imbued with a corrosive energy that was constantly at work eroding mass and producing forms that were either partially or completely interpenetrated. He recalls the immense satisfaction that he derived when boring into the wood "and seeing that first speck of daylight coming in from the other side." The cavernlike hollows and semi-open spaces created in the sculpture did more than supply it with an elegant design, however. They also relieved the sculpture of its "heaviness" and the feeling of dead weight usually inherent in monolithic forms.

RECLINING FIGURE (1959–1964)
Moore's elm carving of *Reclining Figure* (see demonstration that follows) is a magnificent example of a sculpture that successfully blends both heroic metaphor and dynamic composition, dramatized through the use of interacting positive and negative volumes. The sculpture was started in 1959 and was finished slowly over a period of six years. It is one of the many sculptures on this subject. Other versions he has carved, also of elm, are:

Reclining Figure, 1935–1936. 37½" (96 cm) long. Collection Albright-Knox Art Gallery, Buffalo, New York.
Reclining Figure, 1936. 42" (107 cm) long. Wakefield City Art Gallery.
Reclining Figure, 1939. 81" (206 cm) long. Detroit Institute of Art.
Reclining Figure, 1945–1946. 75" (191 cm) long. Originally Collection Cranbrook Academy of Art.

A discussion of his technique follows.

SKETCHES FOR SCULPTURE
Henry Moore relies heavily on drawing as a means of exploring sculptural concepts. He thinks of drawing as a way of sorting out ideas and "finding your way about things and of experiencing ideas more quickly than sculpture allows." To keep his drawings from draining excessive creative energy from his final work, Moore says that he leaves a wide latitude in their interpretation.

He often starts his ideas for a sculpture by scribbling doodles in a notebook. At a certain stage in his mind, some sketches will crystallize into sculptural forms. Once the drawing has metamorphosed into a desirable sculptural concept, he gets the solid shape of the sculpture "inside his head" and expands its scale mentally in preparation for actual work.

SEASONING THE WOOD

The next step is to prepare the wood. A clue as to the nature of Moore's procedure in seasoning wood may be gleaned from his memos describing his method of carving *Internal and External Forms*, a sculpture he carved of elm between 1953 and 1954, which is now in the Albright Art Gallery in Buffalo, New York (see demonstration at the end of this chapter). For this carving, he used a giant log of elm that measured 5′ (1.5 m) in diameter and 8′ (2.4 m) in length. The carving was initiated only a week after the tree was cut because, calculating that wood seasons on the average about 1″ (25 mm) per year, he reasoned that to season a log of that size would have taken 30 years of air drying.

Although he began to carve the green wood immediately, he employed special precautions: By carving the wood slowly over a period of two years and by also insuring that the design of the final sculpture had no thickness exceeding 5″ (13 cm), the tendency of the wood to check was minimized and seasoning "was less precarious."

In carving the *Reclining Figure* shown in this demonstration, he essentially followed the same procedure, but allowed even a longer period of time for the wood to season during the carving period. This sculpture was finished over a period of six years and was also carved from an elm log measuring 8′ (2.4 m) in length. The final sculpture measures 7′6″ (2.2 m) in length.

CARVING

Henry Moore first began roughing out the 1959 elm *Reclining Figure* by first using large, deeply curved gouges and a heavy mallet, carving crossgrain and diagonally on the wood. He then progressed into the intermediate stages by switching to smaller curved gouges and followed the sculptural "flow" of the design, producing a rich network of interweaving chisel marks as a surface texture. During the intermediate stages, he also began to "open up" the negative volumes in the design and started smoothing some of the surfaces with rasps and abrasive tools. Some checking did occur during the carving, but these cracks were filled and then smoothed to conform to the surface.

HARMONY OF CONTRARIETIES

As *Reclining Figure* developed, strong dynamic contrasts began to emerge. Moore, who is a master conciliator of the principles of opposition, pitted concave against convex forms, open against closed, smooth surfaces against rough, sharp edges against curved, and woodgrain against tool marks.

Although forms as well as surface textures worked against each other, they also worked with each other. As always, Moore's woodcarvings are sympathetic shapes to the integrity of the wood, preserving the quality of growth and movement as the sculpture begins to assume its own organic vitality.

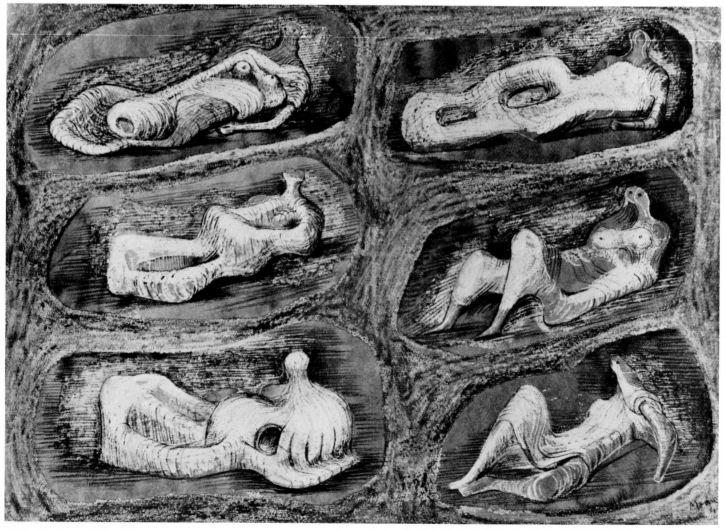

Preliminary Sketches, 1941. Chalk, pen, and watercolor, 15″ × 22″ (38 × 56 cm). Collection University of Colorado, Denver.

DEMONSTRATION FOUR
THE MONUMENTAL FIGURE

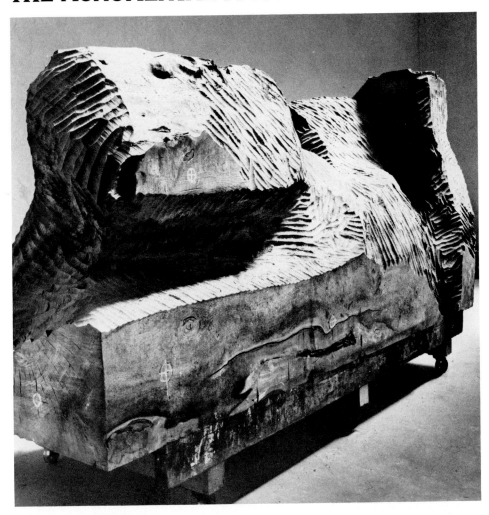

Beginning to Carve. A large log of elm measuring 8' × 5' (2.4 × 1.5 m) in diameter is cut into a flitch in preparation for carving. The wood is carved green almost immediately after the tree is cut. First tools used are a large curved gouge and a heavy mallet.

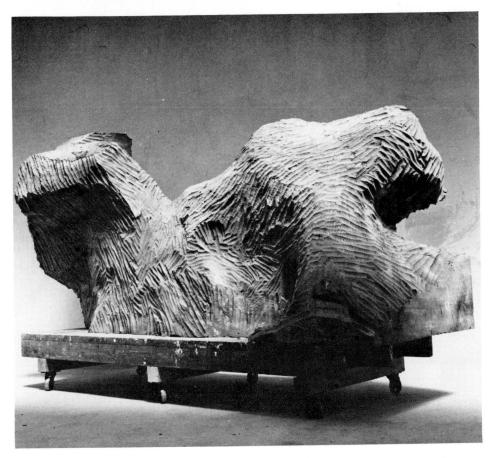

Back View. As the work progresses, Moore switches to a smaller gouge and follows the "flow" of the sculptural form.

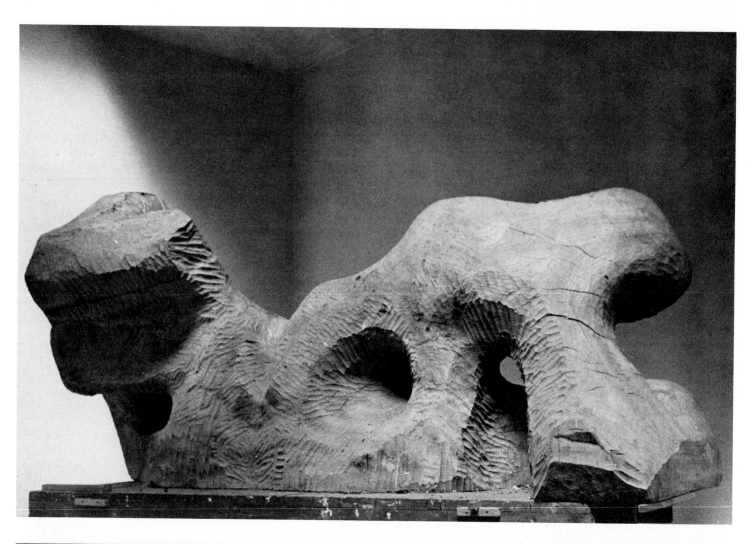

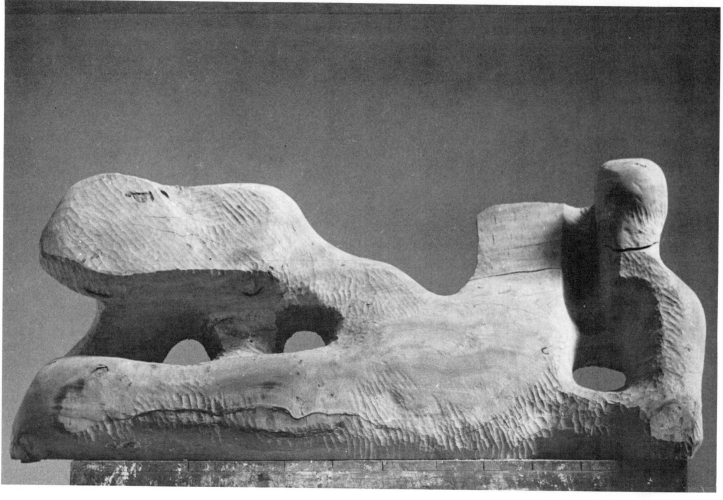

◄Opening up the Figure. Here, Moore begins to "open up" negative volumes by tunneling through the wood in several areas.

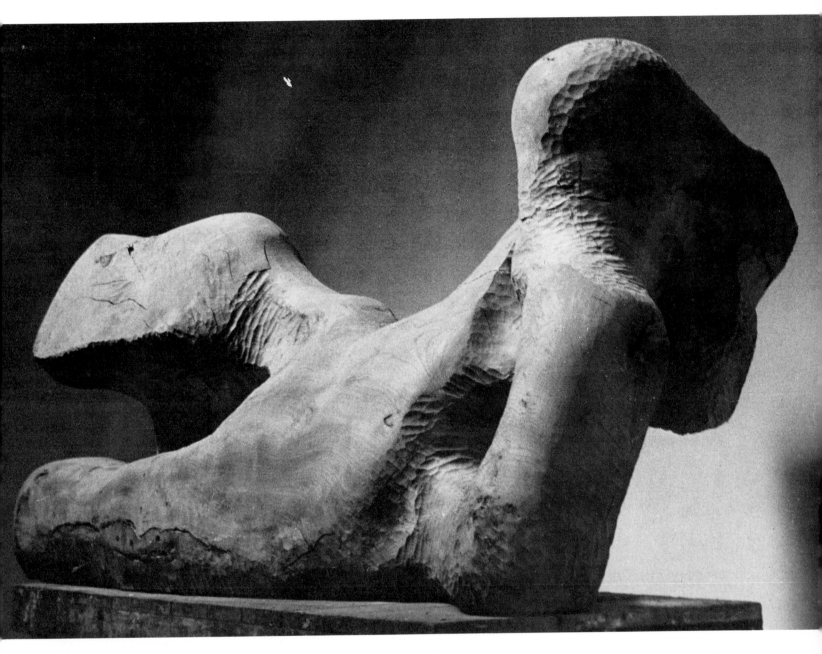

◄Modeling the Form. The dynamic composition of the work begins to emerge as Moore puts the element of opposition to work: convex versus concave forms, solid versus open shapes, rough versus smooth surfaces, and so forth. Rasps and abrasive papers are used to smooth some areas, while the chisel marks are allowed to remain in others. Checking develops, but is later repaired.

▲Further Modeling. Surface forms continue to be developed and the grain and figure of the wood is brought out by sanding with progessively finer abrasive papers. Fluidity of line and a feeling of "progressive transition" is established in the sculpture.

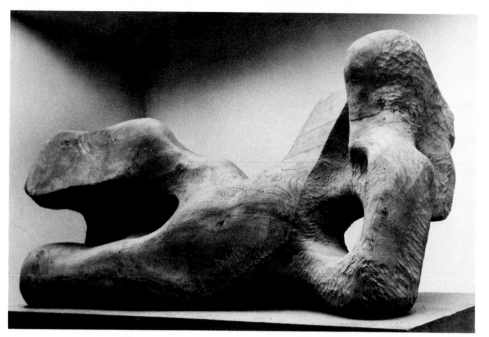

◄Smoothing and Final Shaping.
Subtleties of form-continuity are defined and the "leading edge" is introduced as a geometric design element to work in contrapuntal harmony with curvilinear volumes. As smoothing and finer shaping continue, the line continuity of the sculpture is further developed.

▼Reclining Figure, 1959–1964. Elm, 7½' (2.3 m) long. Courtesy The Henry Moore Foundation. Additional smoothing of the figure develops a greater lyrical flow between volumetric elements. Note how the grain of the wood "flows" with the sculptural volumes, integrating form and surface treatment.

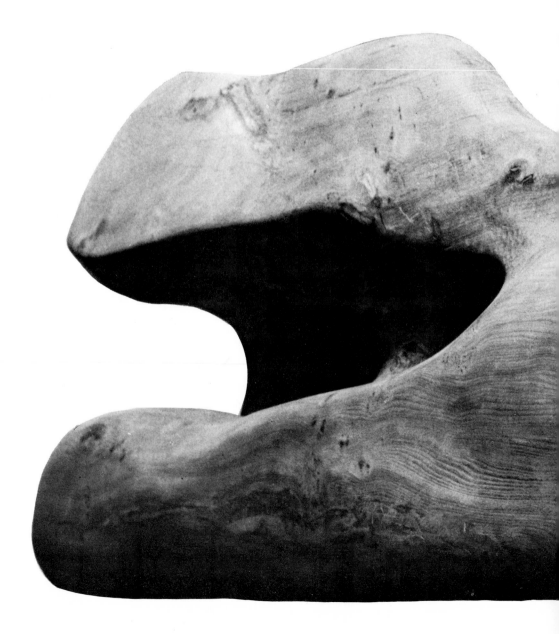

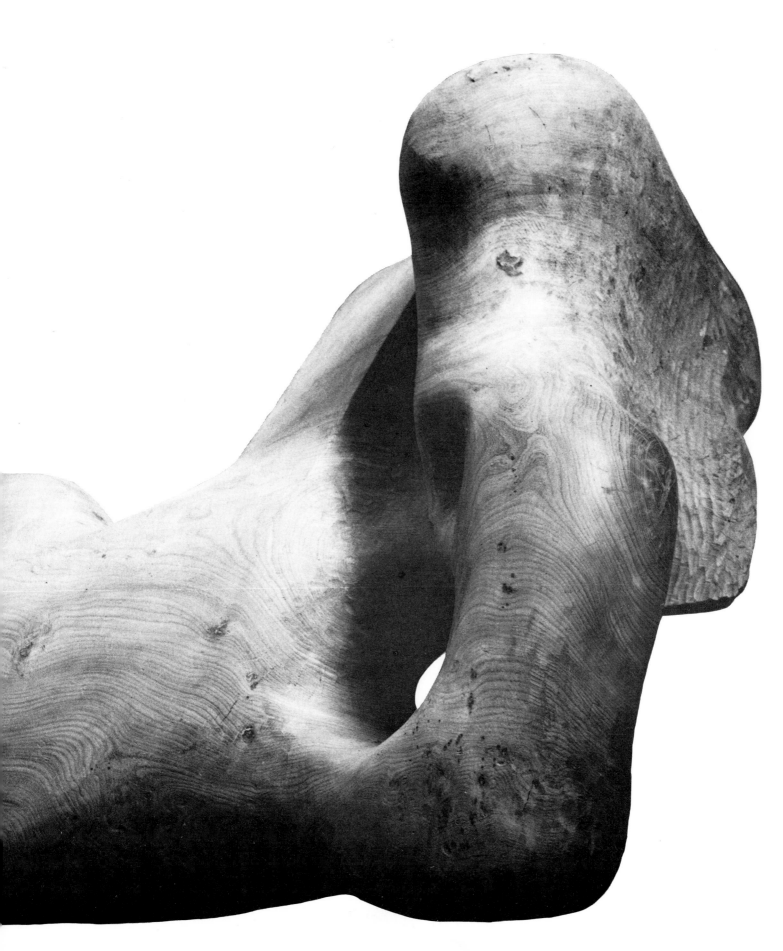

▼**Another Sculpture in Progress.** The forms were roughed out with gouges and the sculptor's adze.

▶**Detail.** The roughed-out forms.

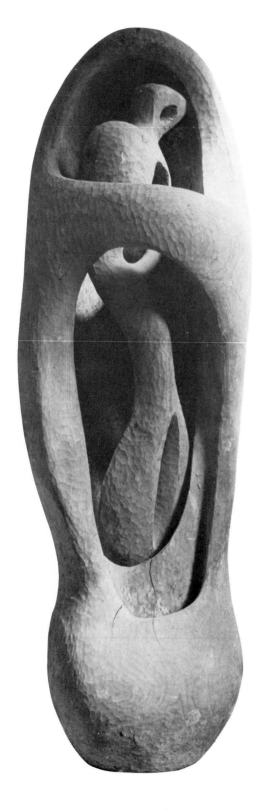

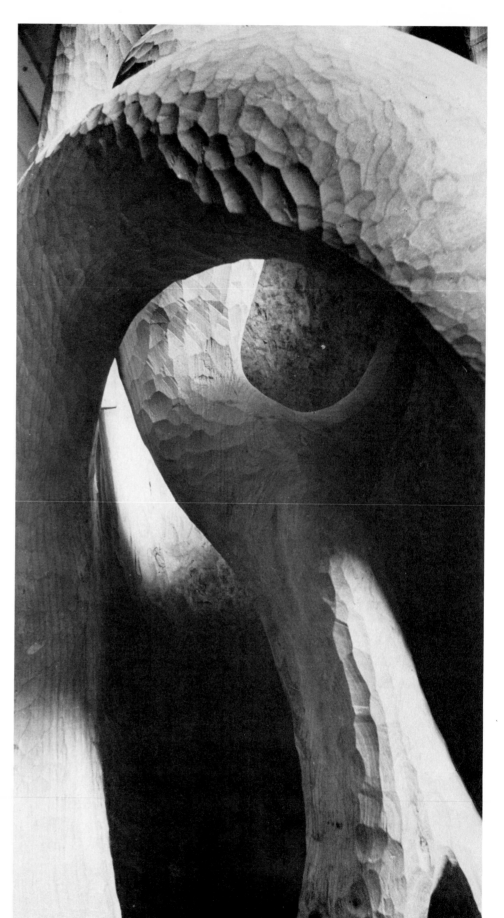

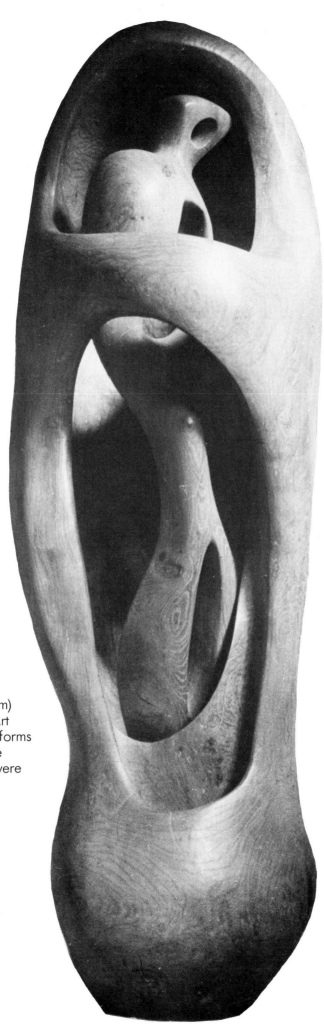

Internal and External Forms,
1958–1954. Elm, 8′7¼″ (2.6 m)
high. Collection Albright-Knox Art
Gallery, Buffalo. The sculptural forms
were smoothed to emphasize the
woodgrain and figure. Cracks were
repaired.

NICHOLAS ROUKES

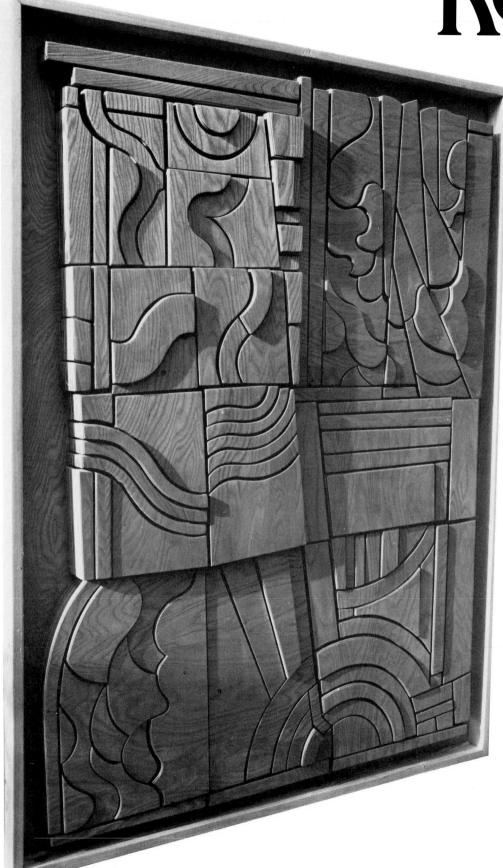

Montreaux Cluster, 1979.
Ash, 39" × 50" (99 × 127 cm).

Relief: Derived from the Italian: *relievo*, from *rilievare*: to raise. *Basso rilievo*, or low relief (bas-relief) is a form of sculpture wherein the scale of projection is very slight, with no evidence of undercutting, contrasted to high relief, in which forms jut out radically from the ground plane.

In the art of sculptural relief, the ground plane functions much as the picture plane does in painting, allowing some forms to emerge into three-dimensional space. Unlike painting, however, sculptural forms are not illusionistic. They are *real* physical projections from the ground plane.

Relief sculpture is a hybrid artform that lies somewhere between the territory of drawing and sculpture. On the one hand, it may be perceived of as "drawing attempting to emerge into the realm of the three dimensional," while conversely, it can also be considered "three-dimensional form collapsing towards the two-dimensional plane." The distance between the most prominent points of the raised forms and the ground plane determines whether the carving is of the high or low relief order—a characteristic that is strictly up to the artist.

The essential stages of relief carving involve four basic steps: (1) Outlining the design with a V tool. (2) Carving away excess background material to allow forms to jut out from the ground plane (there can be several "steps" in the salient planes of the carving, or just one). (3) Shaping and smoothing the projected forms according to the artist's aesthetic dictates (wood can be embellished with chisel marks or sanded smooth). (4) Finishing the final wood surface with an application of either wax or a penetrating oil finish. The author describes the making of *Phoenix* as follows:

"For this demonstration I carved a low-relief sculpture in basswood, creating a work that I called *Phoenix*, a circular wood relief that measures 32" (81 cm) in diameter.

SELECTING THE WOOD

"I chose basswood for this relief. It's an ideal wood for carving, especially for the beginner, since it's easy to carve and holds detail extremely well. It has a light, creamy color and a straight and close grain that's normally featureless. The wood is obtained from the lime tree and has been a favorite of craftsmen for centuries. The exemplary work of Grinling Gibbons, the seventeenth-century English woodcarver, for instance, was carved exclusively in basswood.

STARTING OUT: PREPARING THE DESIGN

"It often seems that the toughest part of any art project is the initial concept visualization or idea stage. In preparing for *Phoenix*, I made dozens of sketches with pencil and paper before I finally evolved a design I was particularly happy with and one that I thought would lend itself to the relief format. Next, I made a careful line tracing of the design on clear acetate and then enlarged the design to 32" (81 cm) in diameter with the aid of an overhead projector.

PREPARING THE WOOD FOR RELIEF CARVING

"Finding a single piece of wood big enough for large relief carvings is difficult. Therefore, I usually laminate several planks of wood together to make up the required surface area. For *Phoenix*, I laminated six 2"×6" (5 × 15 cm) planks

of basswood to create the necessary surface area. Care was taken to match the grains of wood as closely as possible and to insure that they ran in similar directions.

"First, the wood was planed, then it was glued and clamped. Yellow carpenter's glue was used, along with long pipe clamps, to hold the pieces together while the glue set. Next, the panel was taken to a local cabinet shop where it was once again surfaced by running it through a large shop planer. Finally, I scribed a 32" (81 cm) circle on its surface and cut out the circular blank on a band saw.

Transferring the Design to the Wood. "To transfer the full-size drawing to the wood's surface, I placed carbon paper face down on the wood, then carefully taped the drawing into position. The details of the design were then carefully traced onto the wood. In preparation for carving, the wood plank was secured to the workbench with the aid of C clamps.

CARVING: PRELIMINARY STAGES

"Before carving, I carefully contemplated the design and tried to imagine the relief projections in my mind's eye. Previsualization is necessary in any subtractive sculptural process, because once the material is gone, it's gone.

"Next, I sharpened my tools. They included V tools, firmer chisels, and shallow gouges, all of which were honed to a razor-sharp edge.

Outlining with a V Tool. "The first step in the actual carving procedure was to carefully outline the design on the wood's surface with a V or parting tool. I used a ¼" (6 mm) V tool and made a groove about ¼" (6 mm) away from the edge of the design, using a lightweight mallet.

"I followed the grain of the wood and made sure the V tool was kept sharp in order to produce clean cuts whenever I had to cut crossgrain. I went over the channel several times in order to deepen the groove to about ¼" (6 mm). Next, I switched to a ⅝" (16 mm) gouge of medium sweep and widened the groove by making cuts toward the original groove at right angles.

SETTING IN THE DESIGN

"The next procedure called for the use of a firmer chisel to make the walls of the emerging form vertical. Here I used a ¾" (19 mm) firmer chisel, powered by a heavier mallet, and cut directly on the traced lines in a precise manner. The chisel was held at right angles to the wood. I also used various curved gouges to cut the curvilinear portions of the design, also holding these tools at right angles to the work.

REMOVING THE BACKGROUND

"Excess wood was roughed out from the background with two tools: a ¾" (19 mm) shallow gouge and a 1" (25 mm) firmer chisel. The gouge was powered by a heavy lignum vitae mallet while the tool was held almost perpendicular to the wood.

"A series of scalloped cuts were made into the wood,

about ¼" (6 mm) deep and about ½" (12 mm) apart. Care was taken to drive the gouge with consistently even pressure into the wood, producing scalloped rows resembling shingles on a rooftop. The wood chips were then removed with the firmer chisel and the background cleaned and leveled with the same tool. This technique was repeated several times in order to eventually lower the background to the desired depth.

"By scribing a line along the edge of the panel with a carpenter's marking gauge, a guideline was produced that aided in maintaining an even depth for the background. A ¾" (19 mm) skew chisel was useful in cleaning out corners of background material and a finer 5/16" (8 mm) gouge was used to clean up the finer details.

As backgrounding removed certain portions of the traced design, it was necessary to use the original drawing to retrace portions of the drawing as work progressed.

MODELING THE RELIEF FORMS

After the background was carved away, the design began to emerge boldly in relief and a clear distinction appeared between the salient forms and the ground plane. The outside edges of the relief forms were then rounded off, using a firmer chisel or gouges of medium sweep. The V tool was also used to delineate additional form within the larger shapes. For some areas that were hard to get to, I used a short bend gouge, a handy tool for those difficult areas that require shaping.

SMOOTHING AND FINISHING

As the carving progressed, I debated whether to use chisel marks as surface enrichment or go for a clean, smooth surface. Eventually I decided that the finish for *Phoenix* should have a "clean" look, so I chose to sand the surface and remove all traces of the tool marks. This turned out to be a long and tedious process and I found myself putting in long hours while progressing through the many grits of garnet paper, starting with no. 80 and then working through nos. 120, 220, 320, and 400. I finally wet-sanded with no. 600 wet/dry paper and Watco oil. The sandpaper was cut to small pieces, about 3" × 3" (8 × 8 cm) and then folded over twice to make small sanding pads. As a final finish, I applied a darker Watco oil, which enriched the wood's surface, rubbing in about six coats of the oil with a soft cloth."

THE BAS-RELIEF

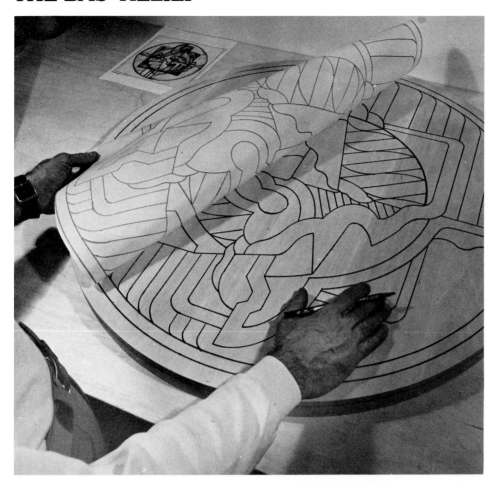

Transferring the Design. In preparation for carving *Phoenix*, I make a full-size drawing, which is transferred to the surface of a laminated basswood panel.

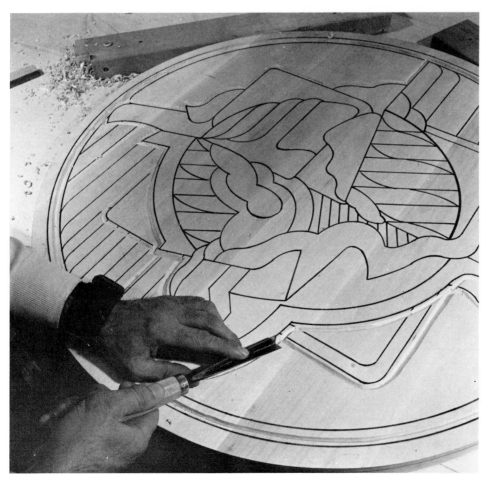

Outlining the Design. A *V* (or parting) tool is used to outline the design. Care is taken to cut approximately 1/8″ to 1/4″ (3 to 6 mm) away from the edges of the design. The groove is deepened by going over the channel several times.

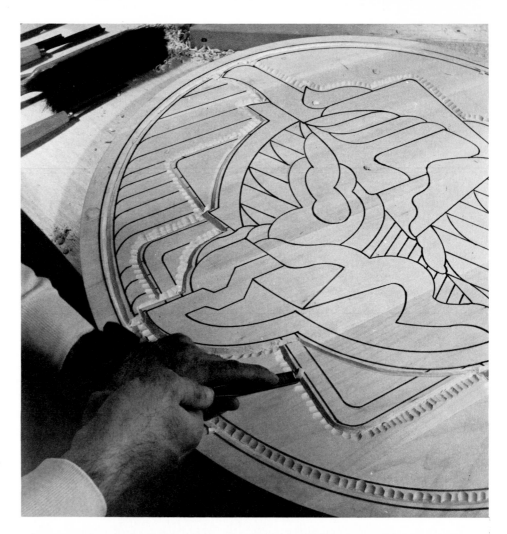

Widening the Groove. A ⅝″ (16 mm) gouge of medium sweep is used to enlarge the groove, cutting at right angles to the V channel. Tools must be kept razor sharp to insure clean cutting action.

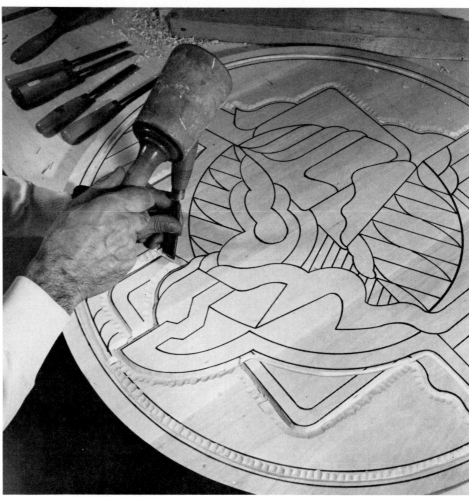

Setting in the Design. The design is "set in" by following the design with flat, firmer chisels and various gouges. Chisels are carefully placed directly on the lines of the drawing and held at right angles to the work. A medium-weight mallet is used to drive the chisels.

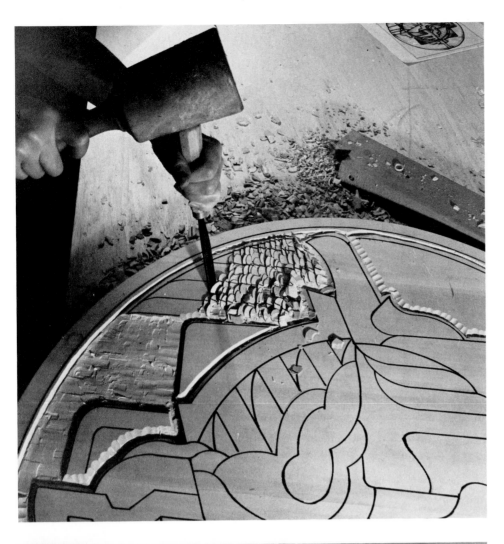

Removing the Background. Excess wood is removed by making rows of scalloped cuts. A ¾″ (19 mm) gouge of medium sweep is used, powered by a heavier mallet. Each blow is struck with equal pressure to insure even depth of cutting. A wide, firmer chisel is used to remover the chips and clean up the surface of the wood (left foreground).

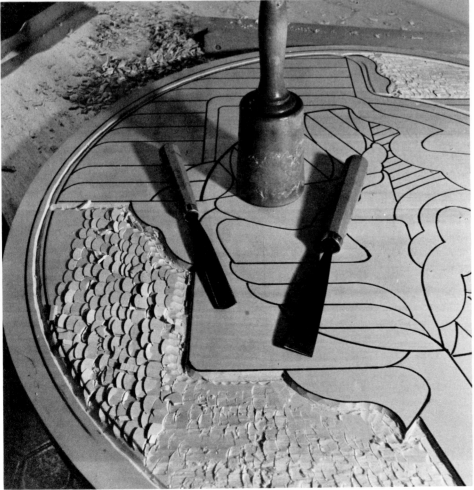

Tools. The tools for removing the background are shown here in detail: The ¾″ (19 mm) gouge (left) is used for making the series of scalloped cuts. The flat, firmer chisel (right) is used to remove the wood chips and clean up the surface. The operation is repeated several times in order to establish the required depth of the background plane.

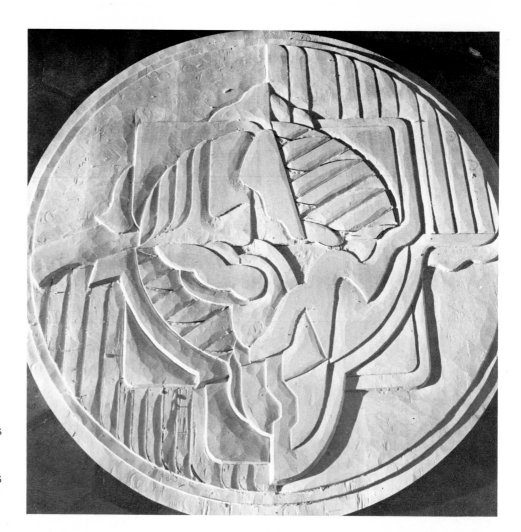

Modeling. As sculptural forms begin to emerge into three-dimensional space, a variety of gouges and chisels are used to model the most prominent forms. Strong side lighting brings out the sculptural characteristics of the bas relief and is used throughout the carving process.

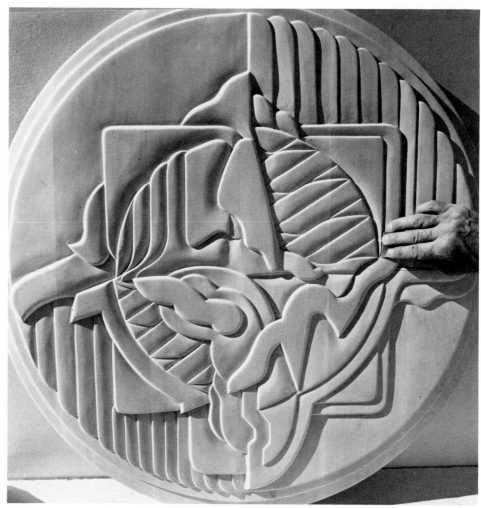

Smoothing the Surface. The relief is sanded with garnet paper, progressing from no. 80 grit through nos. 120, 220, 320, and 400 paper. Small sanding pads were made by cutting the sandpaper into 3" (75 mm) squares and folding them over twice.

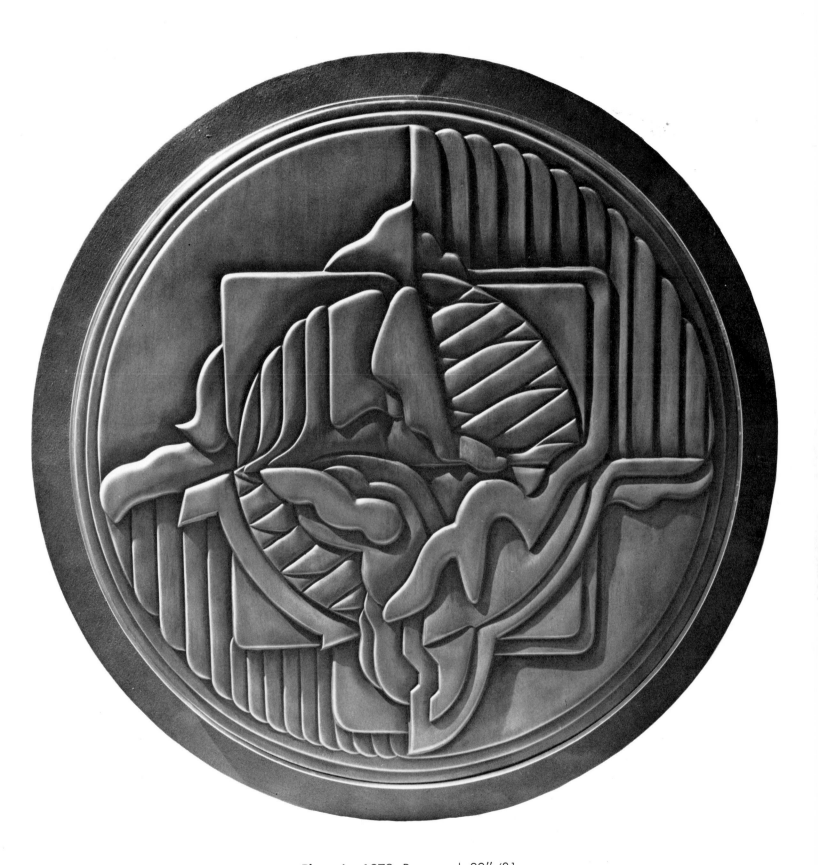

Phoenix, 1979. Basswood, 32" (81 cm) in diameter. The final surface of the bas relief is given several coats of dark Watco oil, rubbed in with a soft cloth to impart a rich golden surface to preserve the wood.

DIRECT CARVING

◄Walter C. Driesbach, Jr., *Seated Woman*, 1971. Walnut, 31" (78.7 cm) high. Private Collection.

►Hortense Kassoy, *Adam* (detail), 1975. Hard rock maple, 5' (1.5 m) high. Photo: Bernard Kassoy.

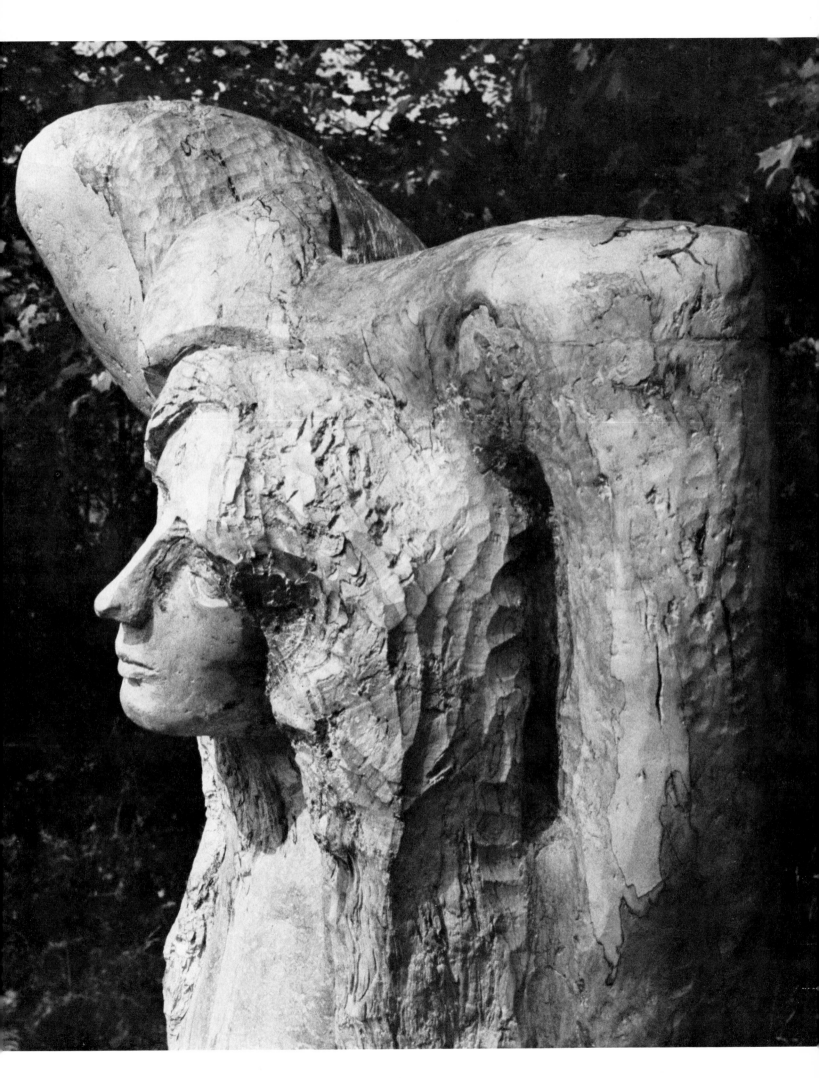

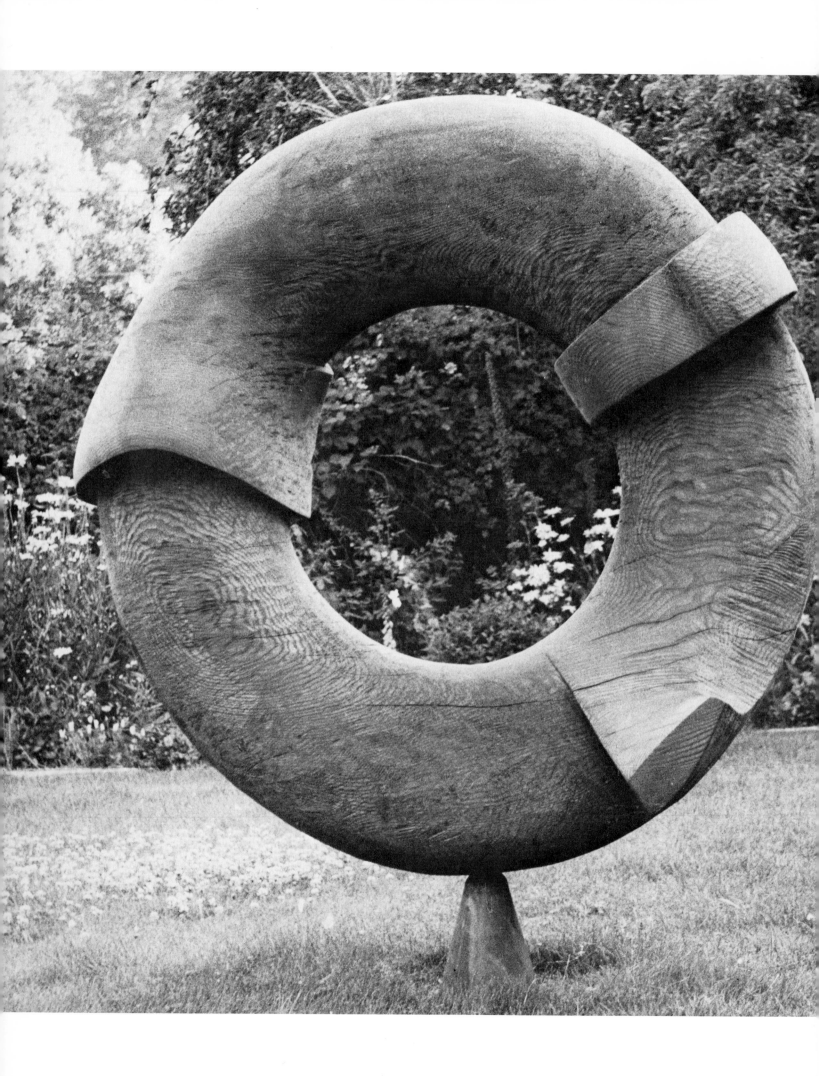

◀ J.B. Blunk, *Continuum*, 1975. Redwood, 4′ (1.2 m) diameter.

▼ Chaim Gross, *Sisters*, 1956. Santo Domingo mahogany, 28″ (71 cm) high. Private Collection. Photo: Soichi Sunami.

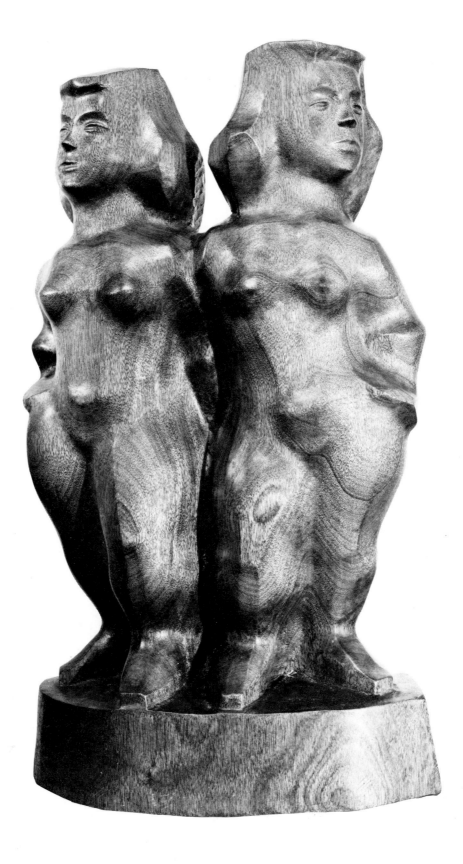

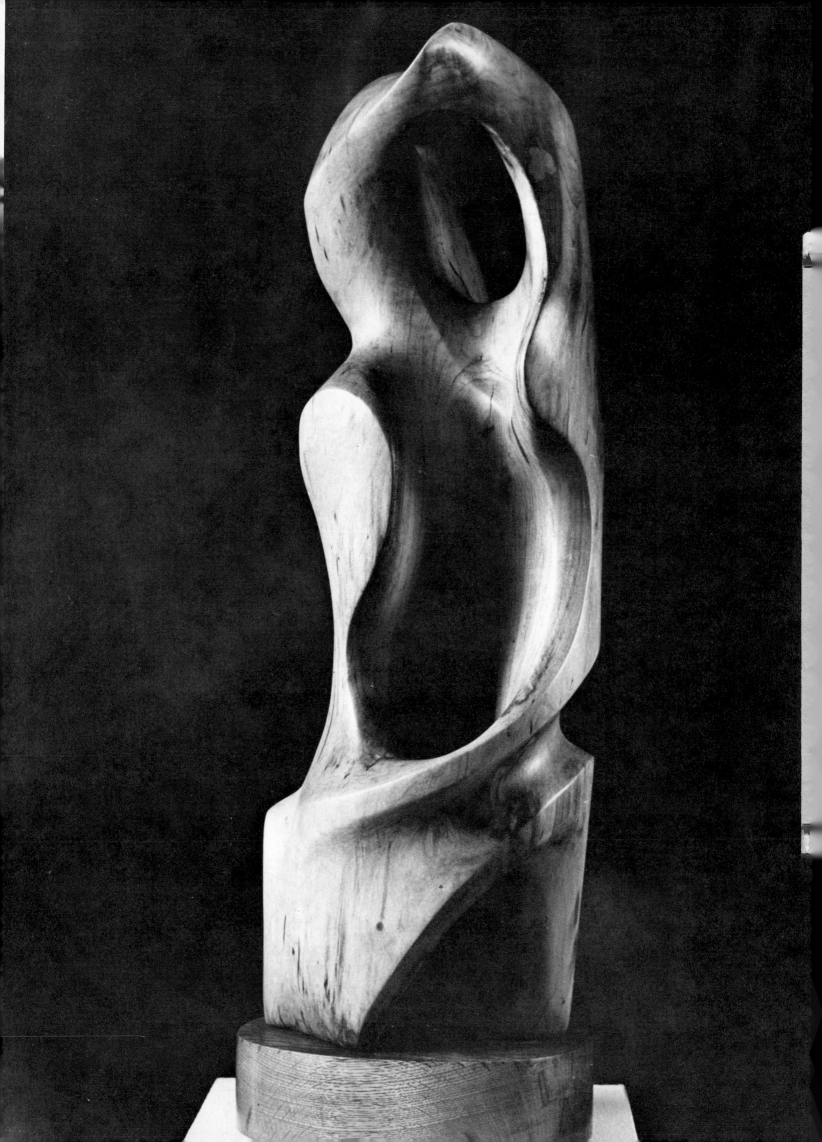

◀Ralph R. Baney, *Cathedral*, 1975. Cherry, 29″ (73.7 cm) high. Private Collection.

▼Richard Hoptner, *Repression/Escape*. Teak, 62″ × 15″ × 20″ (157.5 × 38 × 51 cm).

▼Michael Lekakis, *Rythmisis*, 1951–1961. Elm on mahogany, 63½″ (161 cm) high with base. Collection of the artist.

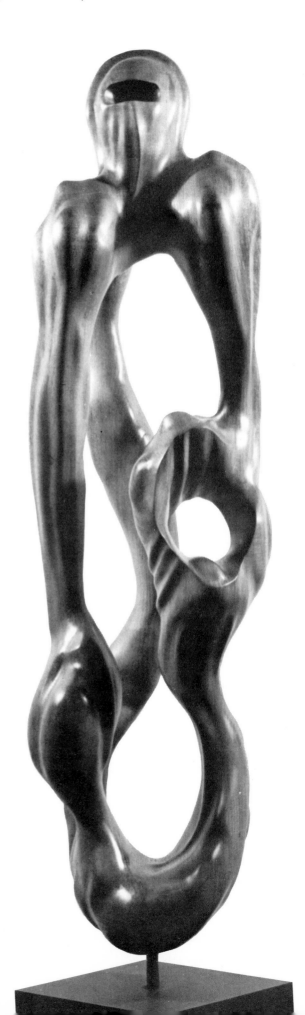

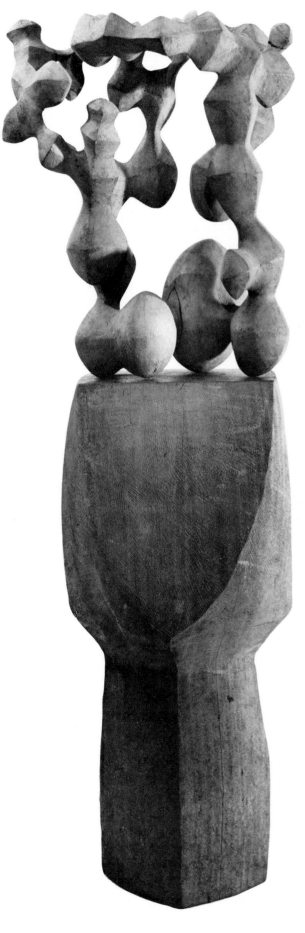

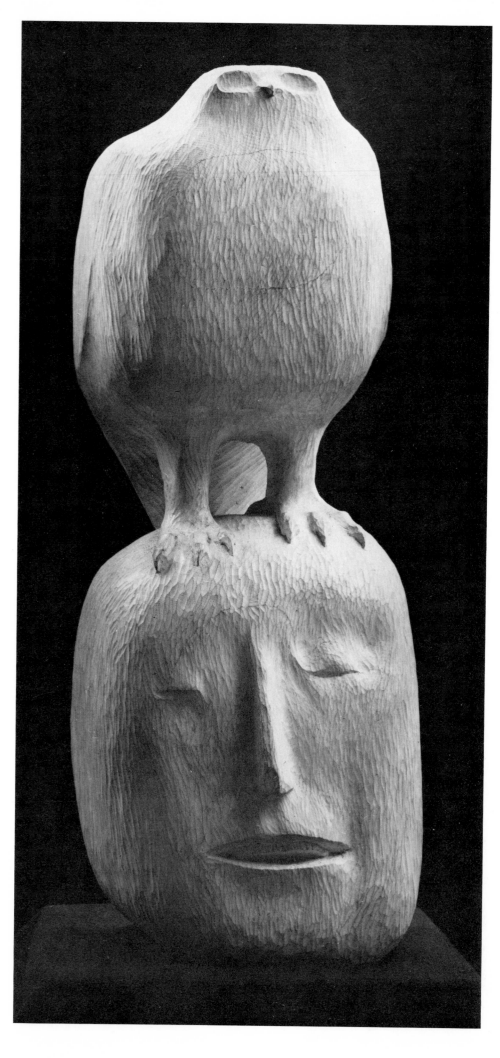

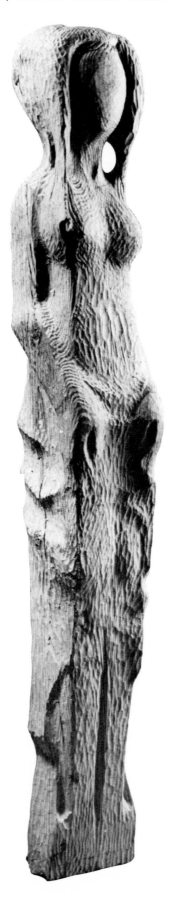

◄Leonard Baskin, *Oppressed Man*, 1960.
Painted pine, 31″ (78.7 cm) high. Collection
Whitney Museum of American Art, New York.
Photo: D.E. Nelson.

▶James Hueter, *Rising Figure* (detail).
Mahogany and oil paint. Courtesy of the
artist.

▼Lorrie Goulet, *The Offering*, 1965. Pine,
56″ × 7½″ (142 × 19 cm). Courtesy
Kennedy Galleries. Photo: Bob Hanson.

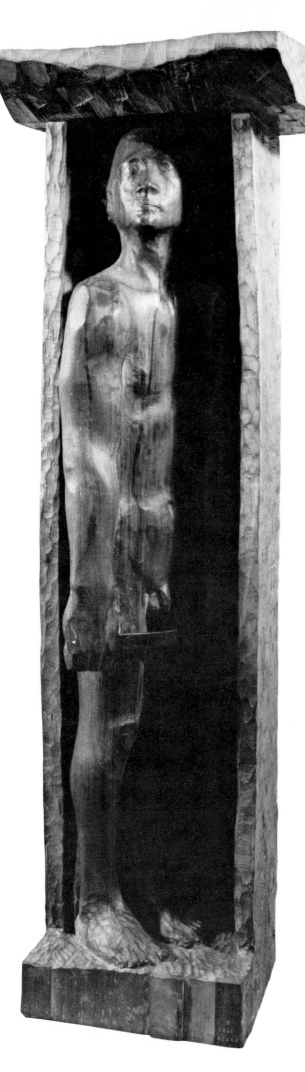

◄Sidney Simon, *Oedipus as a Young Man*. Black walnut, 34″ (86 cm) high. Private Collection. Photo: Thomas Feist.

▼Concetta Scaravaglione, *Floating Woman*, 1947–48. Pear, 19″ × 33″ × 13″ (48 × 83 × 79 cm). Courtesy Kraushaar Galleries, New York. Photo: Geoffrey Clements.

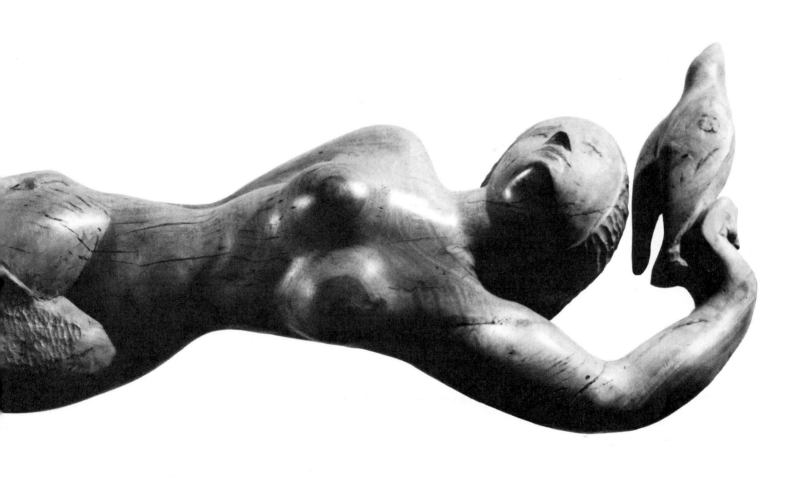

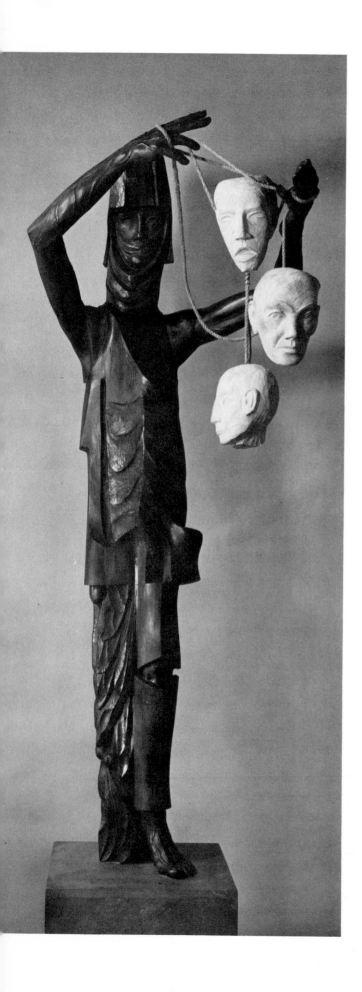

◄Wolfgang Behl, *Godgame*, 1973. Ebony, 8' (2.4 m) high. Courtesy of the artist. Photo: E. Irving Blomstrann.

▼David Hostetler, *Young Woman*. Elm with aniline dye stain, 19" (4 cm) high.

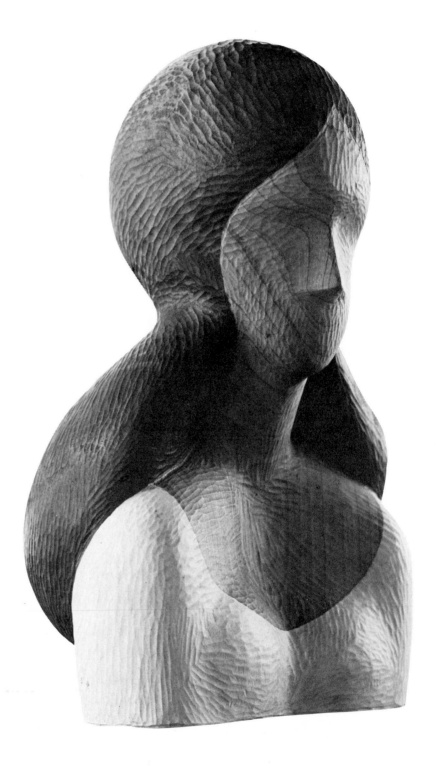

►Louise Kruger, *Man Wearing Vest*, 1975. White pine, 10'6" (3.15 m) high. Courtesy of the artist.

►Hans Hokanson, *Hat No. 3*, 1970. Elm and catawba, 36″ × 21″ × 15½″ (91 × 53 × 39 cm). Courtesy Grace Borgenicht Gallery, New York. Photo: Arthur Gorson.

▼Frank Smullin, *Bystanders*, 1975. White oak, carved entirely with a chain saw, 42″ × 22″ × 35″ (107 × 56 × 90 cm).

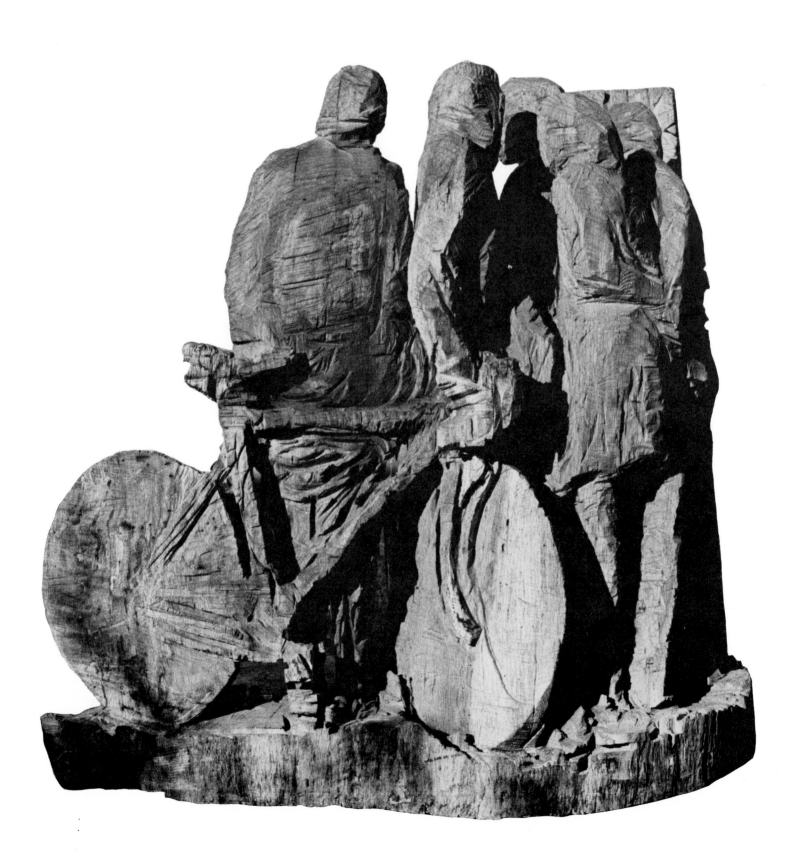

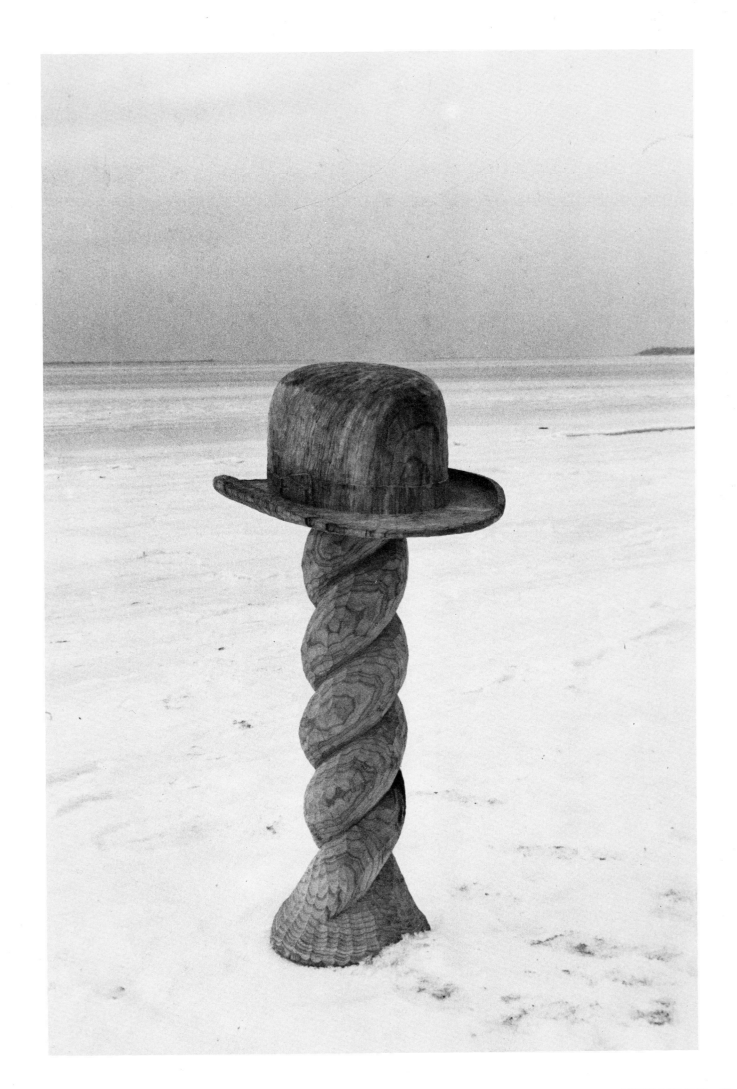

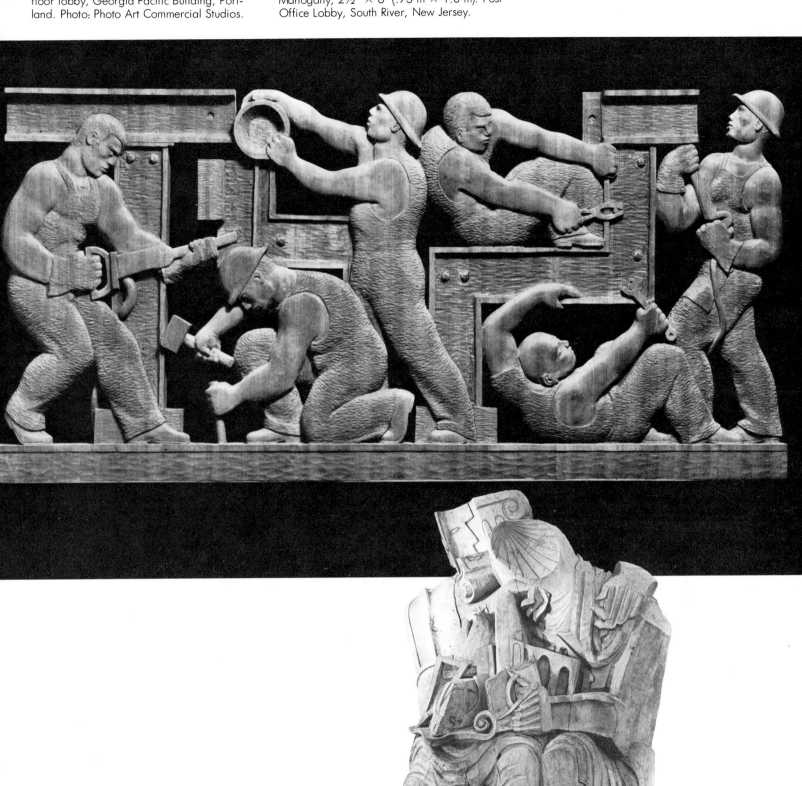

◀Leroy Setziol, *Bas Relief* (detail). Executive floor lobby, Georgia Pacific Building, Portland. Photo: Photo Art Commercial Studios.

▼Maurice Glickman, *Construction*, 1940. Mahogany, 2½' × 6' (.75 m × 1.8 m). Post Office Lobby, South River, New Jersey.

Ossip Zadkine, *Homo Sapiens*, 1934. Wood, cubist sculpture. Collection Musées Nationaux, Paris.

WOLFGANG BEHL

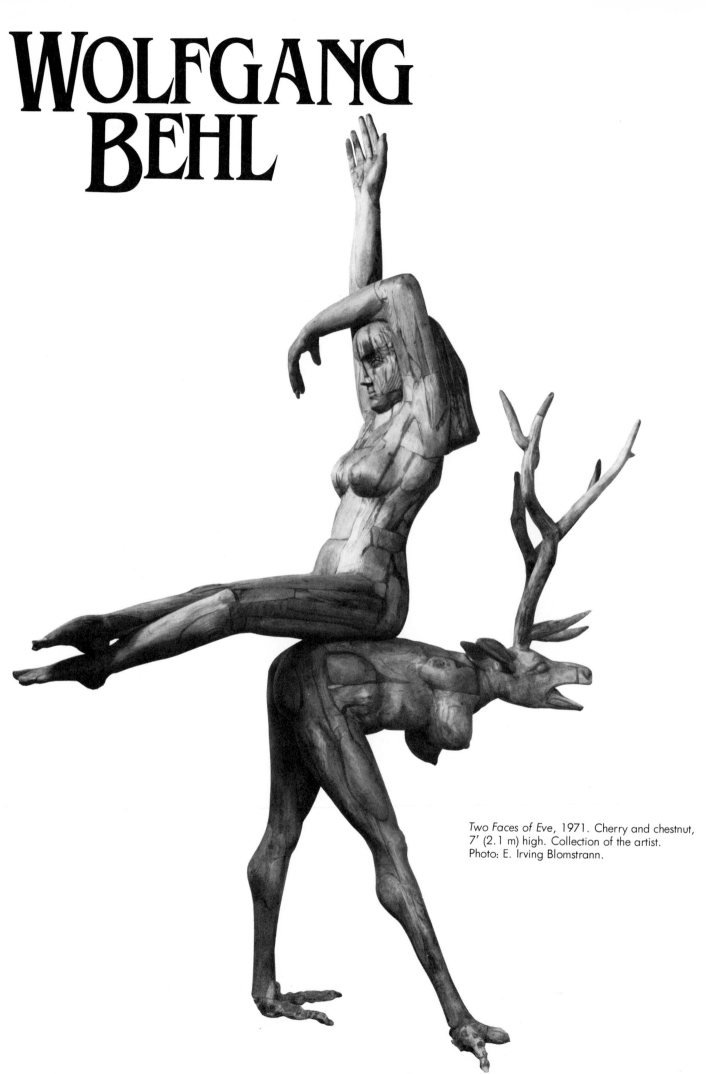

Two Faces of Eve, 1971. Cherry and chestnut,
7' (2.1 m) high. Collection of the artist.
Photo: E. Irving Blomstrann.

> "Heard melodies are sweet, but those unheard
> Are sweeter; therefore ye sweet pipes, play on;
> Not to the sensual ear, but, more endear'd,
> Pipe to the spirit ditties of no tone."
>
> John Keats,
> Ode to a Grecian Urn

The work of Wolfgang Behl is delightfully perplexing. Like author John Fowles (*The Magus*), he invariably foils my attempts to "logically" interpret the symbolism of his work.

Of Germanic ancestry, Wolfgang Behl couples the extraordinary skill of the Gothic woodcarver with a devilish wit and fantasy that adeptly fuses dream and reality. As in ancient myths, Behl's sculptural scenarios rely heavily on hybridization, the strange cross-linking of animal and human forms. Behl seems to place animals and humans on equal parity and creates curious three-dimensional tableaus involving odd characters enacting strange rites and rituals. Through the presentation of these equivocally perceived images, the rug is always neatly "tucked out from under me" in terms of an easy resolution.

Dali has written of the artist's license to "systematize confusion through a paranoic and active thought process in order to assist in the complete discrediting of reality." Behl is an artist of this ilk. Like the Surrealists, he possesses a fascination for creating disparate links and often creates "illogical-logical mixtures" as portrayed in the world of René Magritte and Max Ernst. Thus, the images he creates find meaning principally through subjective annals.

Compositionally, Behl's sculptures are not compressed or monolithic; his forms jut out dynamically into space. Negative volumes are important ingredients to his work. Most of his pieces are usually made of many different species of woods, carefully joined together to produce overall sculptural forms that seem precariously perched, another calculated device that the artist uses to heighten the dynamic and emotional character of this work.

Frog Hollow is a particularly fine example of Behl's peculiar brand of fantasy and technical skill. It is a tableau that evokes strange erotic overtones that seem to allude to a bizarre ritual or cryptic fertility rites. At a sculpture convention in Toronto in 1978, the artist explained his ideas and techniques to me in detail. They are presented in the following text.

INFLUENCES

"I don't know where the idea for *Frog Hollow* came from, since intuition always dictates my ideas. But nature influences me a lot. I love being out in nature, close to the unspoiled environment and being able to feel the closeness between the animals of nature and the human animal. My hybridized forms owe part of their being to my feelings regarding the harmony within the ecological family. I don't just put "man" on the pedestal.

"The other motivation is part of my subconscious and my need to relate a make-believe tale in the vein of the Brothers Grimm or Hans Christian Anderson. My work is a throwback to the Gothic, bordering on the Baroque, and I enjoy the work of sculptors from that epoch. I also like the work of Wilhelm Lehmbruck and Ernst Barlach, although I don't want that "heaviness" of Barlach's work in my own. However, contentwise, I feel pretty close to the Surrealists, people like Magritte and other artists concerned with presenting the cryptic metaphor or "vexing situation."

"Faces and facial expressions are important to me too, but unlike the Gothic artists, I like to express emotion through the use of body gesture or body language, particularly that of the extremities, the hands and feet. The hand to me is as personal a thing as the face.

"Compositionally, I'm drawn toward double figures, triple figures, or various types of sculptural designs that require the tableau format. I'm not interested in making just monoliths.

PRELIMINARY DRAWINGS

"I usually start by sketching my ideas on paper, though sometimes, but not too often, I make a small wood carving or wax model of an idea in preparation for the larger work. When I'm drawing, my ideas flow quickly and my intuition is allowed maximum flexibility. So, like a jack rabbit, I cover lots of ground during the drawing stages. But sculpture is slow and tedious. So, once I start my sculpture, I become a turtle and move slower.

"When I drew the sketches for *Frog Hollow*, I intuitively felt the "correctness" of design and content. Later, when I began to analyze what I had done, I realized that these were exactly the right decisions and, now that I'm conscious of them, I would make them again.

ASSEMBLING THE SCULPTURE

"When I start a sculpture, I try to find logs and timbers that have the general configurations of the forms that I want. Then I use the additive-subtractive process, carving one component after another, adding timbers for required elements.

"If I don't like a particular form on the sculpture, I simply whack it off, add a new timber, and begin anew. In using the additive-subtractive method, wood does not restrict me. Instead of employing the purist's notion of finding an image within the confines of a log, I get the idea first, then find the wood to suit the image.

"My work is expansive and space-oriented and also quite prone towards precarious balances. I like precarious balances; I believe that compositions that appear unstable are not only visually dynamic but also affect the spectator with greater emotional impact.

SELECTING THE WOOD

"*Frog Hollow* was made from a mixture of woods, both the hardwood and softwood varieties. I used black cherry for the lower legs for strength and weight, and lighter willows for the rest of the sculpture, except for the hands, which were made of maple. For the hollow central section, I used apple.

"I don't buy any lumber. I cut my own timber and use it both green and seasoned.

Seasoning Wood. "For *Frog Hollow*, I used seasoned wood

because of the shrinkage factor of the different woods. There was a lot of gluing and joining in this piece and I didn't want to have problems with the woods shrinking out of the joints later.

"However, when I do use green wood, I season the wood as I work. When I first start a sculpture, I remove a lot of wood; big chunks come off. So whatever drying that has taken place within the top surface layers is removed. Then the remaining wood starts to dry after each day of work. Therefore, the wood never has a chance to really check out until I get to the point where I don't want to take the work any further. Then, of course, the wood begins to check. But the wood isn't as thick then, so the cracks are minimal. I let whatever checking that's going to take place go on for a long time until it seems to stop. Then I wait an additional six months before filling the cracks with wedges of wood and a little carpenter's glue. The wedges are then sanded down to make a perfect seam.

ROUGHING OUT

"In the preparatory stages, I cut out the rough shapes with an 18″ (37 cm) band saw and sometimes with an electric chain saw and then roughed out the form with a disc grinder. I tried to saw the wood as close as I could to the ultimate forms that I wanted to avoid excessive grinding later. Since my studio is in the same building of my living quarters, I try to avoid creating excessive dust.

"I used the power tools only to prepare the surfaces, allowing sufficient wood to remain for the next stage in which I used only hand tools, working the entire surface with hand chisels to achieve the ultimate form and texture of each component section of the sculpture.

"For the rough grinding and preliminary shaping, I used a Milwaukee grinder with a 6″ (15 cm) disc of coarse abrasive paper. I also used a lightweight Sears grinder, which is excellent for this purpose.

USING GOUGES

"Most beginners think that in order to work fast they have to use monstrous 3″ (7.5 cm) gouges. But you don't necessarily work faster with such big tools; the ratio of energy required to drive these tools through the wood diminishes your progress in the long run. Therefore, I personally find such tools relatively useless and, in working with hardwood, I never use them. Instead, I use the smaller 1″ to 1¼″ (25 to 30 mm) gouges, and whack away with more strokes to get the job done.

"My gouges are fairly shallow, and I edge them into the wood, going in with one edge and shingling off clean chips. I start with the no. 4 shallow gouge (obtained from Sculpture House, 38 East 30th Street, New York, N.Y. 10016) and progress to the no. 3 shallow gouge as the work continues.

"I keep the gouges absolutely razor sharp and pause frequently during the work to hone them. At first, I cut mostly crossgrain, but later finish by cutting with the grain of the wood. I finish most surfaces with the no. 3 gouge. I don't use riffler files for the details; I prefer to carve everything with chisels.

Gluing the Sections Together. "Actually, I don't glue. Instead, I fill the gaps with mastic that acts as a glue, using polyester resin thickened with wood flour, which is dimensionally stable. It hardens and doesn't leave any gaps so I don't have to force parts to join together tightly like a cabinetmaker. On the contrary, I want the seams to show, and consider them part of the sculpture's aesthetic character. I also use bolts, screws, nails, and other types of fasteners to further secure the component sections of the sculpture.

FINISH

"I brush a commercial walnut-colored stain over the entire sculpture to help "pull together" the color contrasts between the various woods. I apply the stain in a thin even coat first and then apply thicker coats to special areas, but never so thick as to obscure the grain. I allow the stain to dry for twenty-four hours, and then wax the sculpture.

"I make my own wax from carnauba and beeswax. It's a simple operation: I pour a little turpentine into a jar and then throw in some wax chips that I cut off with a knife. I use mostly beeswax, and only about 5% carnauba. Then I allow the mixture to set overnight. The next morning I have a fine paste that, when stirred up slightly, is ready for use. I applied several coats of this wax to *Frox Hollow*, rubbing it down briskly between coats.

"I feel that wood should be allowed to "breathe," and for that reason don't like using penetrating oils. The difference between using wax and a penetrating oil is comparable to the difference between wearing a cotton shirt and a plastic raincoat. Wood should be allowed to expand and contract naturally once it has reached its equilibrium moisture content. Wax slows the reaction, but doesn't stop it. Furthermore, I like what wax does for the wood's surface. Wax-treated sculptures require only a minimum of upkeep, just like any other finely crafted wood object."

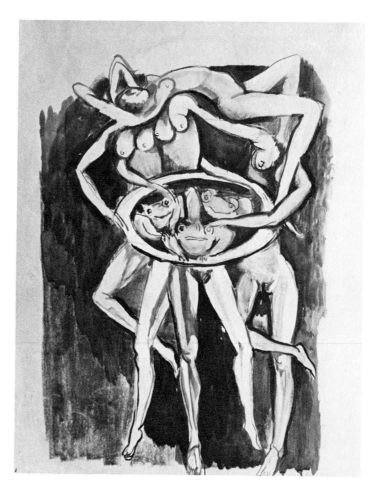

First Stages. Wolfgang Behl uses brush and wash to visualize some of the possible combinations for *Frog Hollow*. He works spontaneously and intuitively, relying largely on subjective feelings for inspiration.

THE FIGURE GROUP

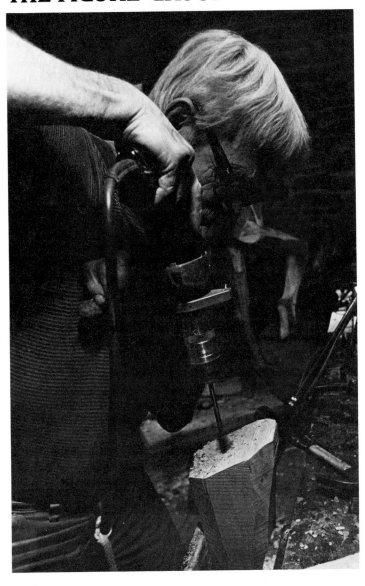

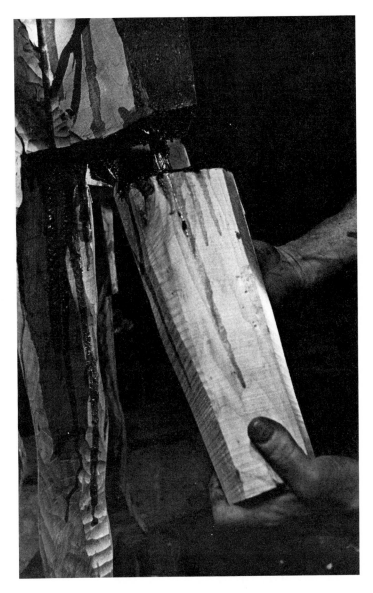

Drilling Holes for the Anchor Bolt. Black cherry was selected for the legs and lower section of the sculpture for maximum strength and support. The timber is first rough-cut on a band saw. Here Behl is shown drilling a hole for attaching the anchor bolt.

Joining the Leg Section to the Anchor Bolt. To attach the two sections of the sculpture, the hole for the anchor bolt is first filled with catalyzed polyester paste. Then the anchor bolt is placed in the hole and the two sections are brought together. A bar clamp is used to hold the wood together until the polyester has set.

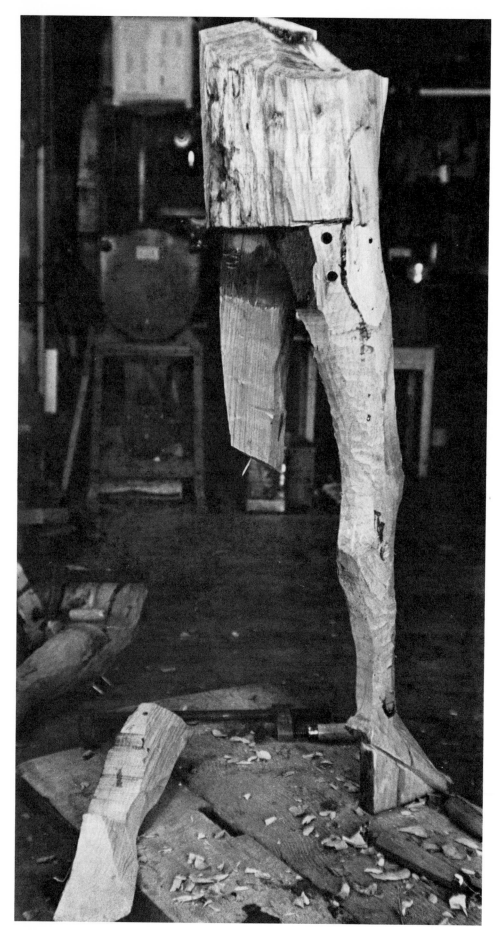

◄**Building up the Sculpture.** Using the additive process, the sculpture grows architecturally, from the ground up. Hardwood legs of cherry or maple support a section of lighter, soft wood like basswood or willow. A grinder is used to roughly shape the form after the polyester has set. Later Behl further defines the form and surface texture with hand chisels.

▲**Holding the Wood Together.** Hand clamps are used to hold additional sections of wood together. Wood flour is added to the polyester "glue" as a thickener.

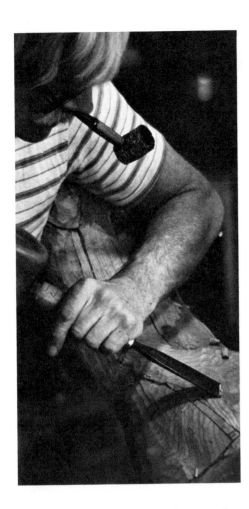

▲Developing the Form. After rough-shaping with a grinder, Behl proceeds to develop the surface form with a shallow no. 4 gouge, powered by a medium-weight lignum vitae mallet. He first carves in a crossgrain direction, the switches to a no. 3 shallow gouge and carves with the grain of the wood as the final surface form and texture is attained.

▶The Growing Sculpture. Additional sections of wood are rough cut on the band saw or with a chain saw and added to the structure. In addition to the polyester, Behl also employs countersunk bolts and screws to further secure the component parts.

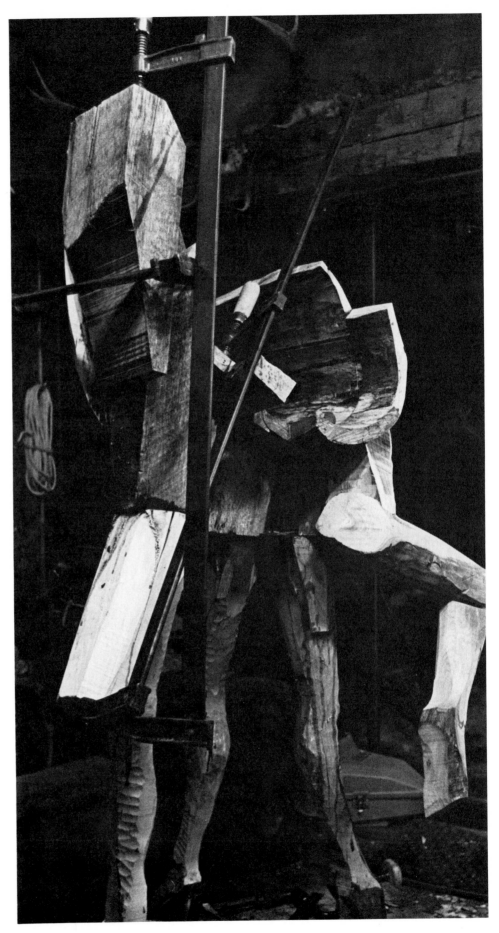

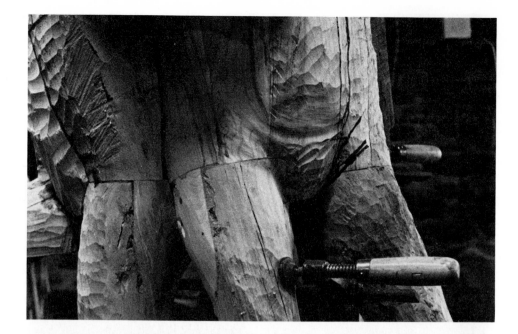

Detail of the Basic Support Unit.
Behl integrates the seams made by the
polyester glue as part of the sculpture's
character. As the work progresses, he
draws directly on the wood with dark
poster paint to help visualize further
carving.

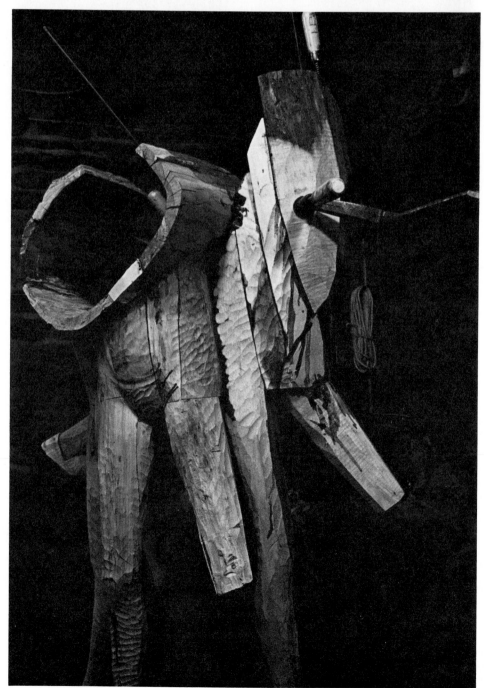

Roughing-out the Twisted Body.
The sculpture grows in an irregular
and unorthodox fashion. As some of
the lower forms near completion, new
rough-cut component are added. The
hollow section of wood directly above
the pelvis is assembled from the trunk
of a hollowed-out apple tree. Note
how Behl has begun to define the form
of the figure at the left with the hand
chisels.

▶▶**Joining Additional Wood.** The hol-
low section is closed up as additional
wood is joined to the sculpture. Notice
the joining technique of the lower leg
of the figure at the left; a counterset
lag screw helps to secure the compo-
nents.

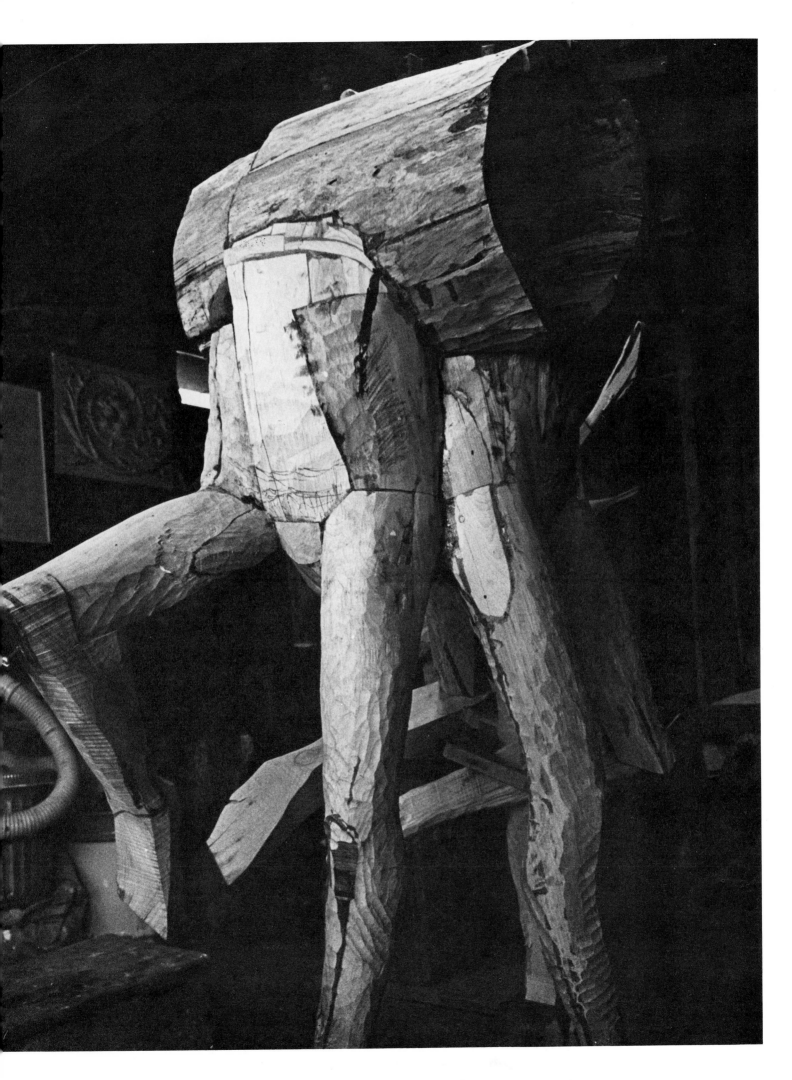

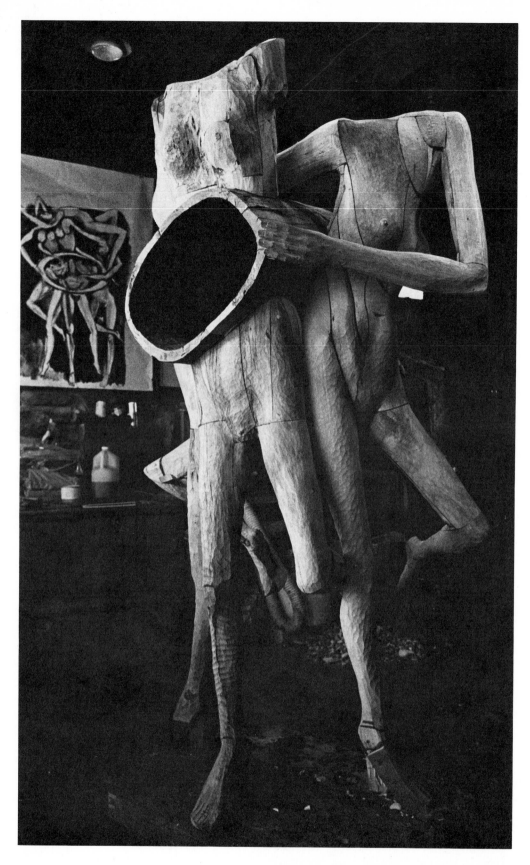

Adding Lighter Woods and More Details. Additional components added to the top are made of lighter woods (willow and basswood). Wolfgang Behl further defines the final sculptural form and surface texture and also begins to carve some of the finer details using a no. 3 gouge with a lighter weight mallet. You can see the surface carving and laminated seams in the detail.

▶**Attaching Another Figure.** An additional figure is created of lighter basswood and willow and attached to the top of structure. Although appearing unstable, Behl carefully calculates the balance and center of gravity to achieve stability.

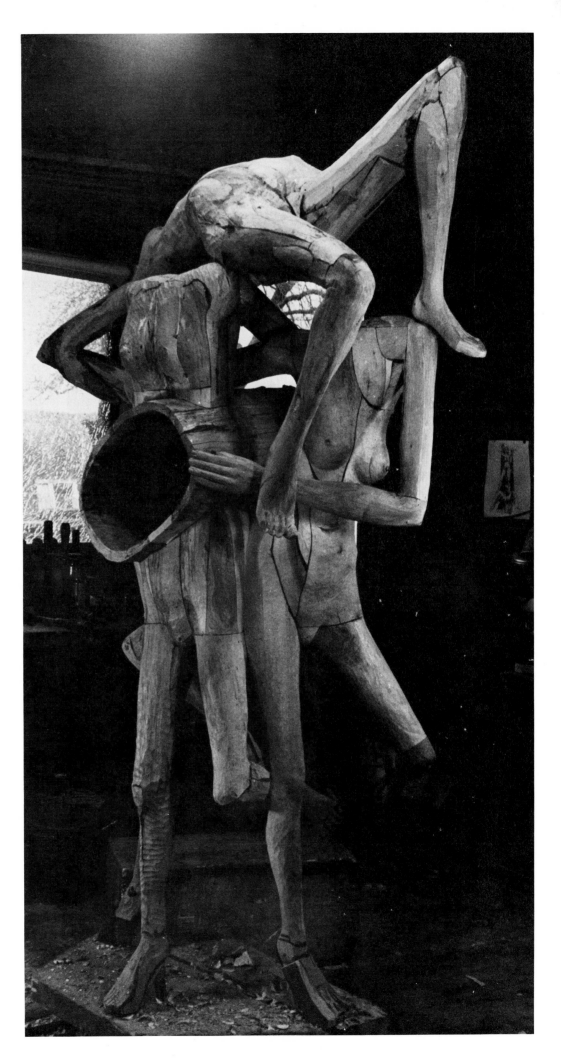

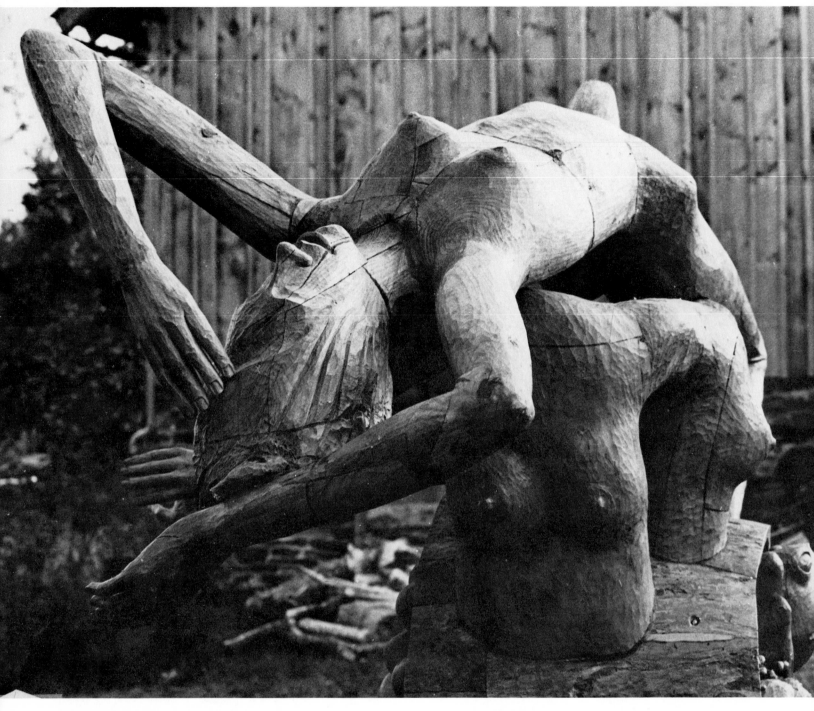

▲**Final Definitions.** Behl continues to define the form of the top figure, delineating the surface form and developing details. Notice the delicate carving of the hands, done with a no. 4 gouge.

▶**Frogs and Eggs.** Frogs and egg shapes are carved and attached to the frontal portion of the hollow central section of the sculpture.

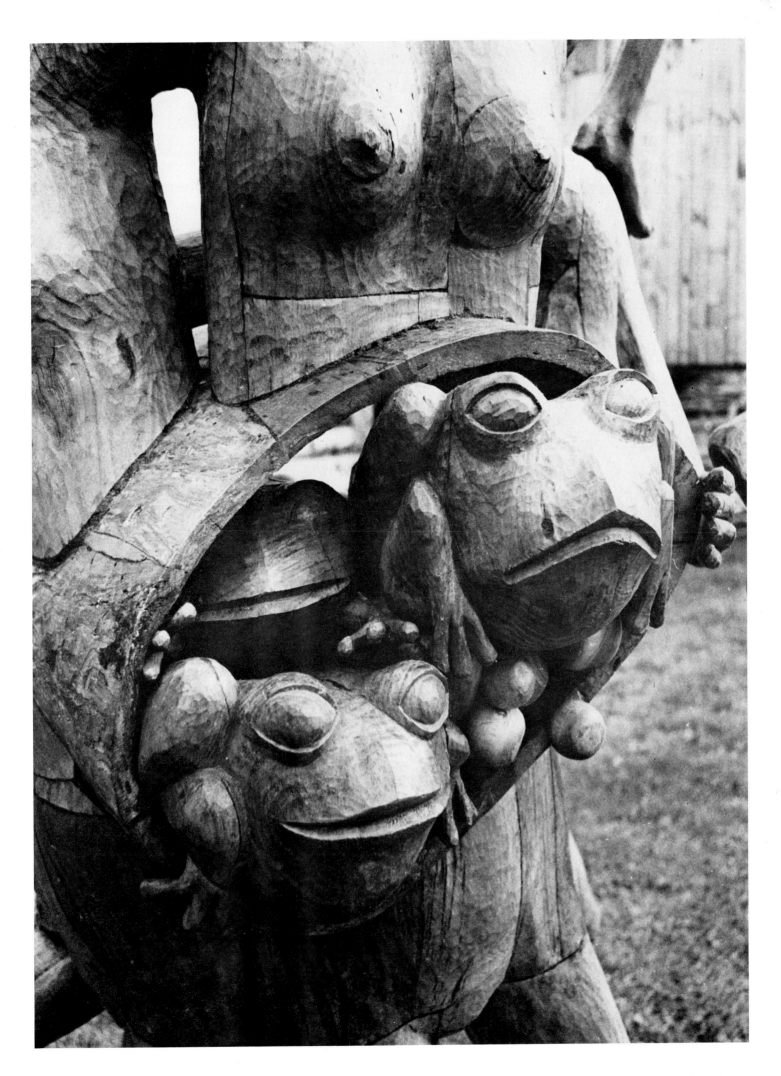

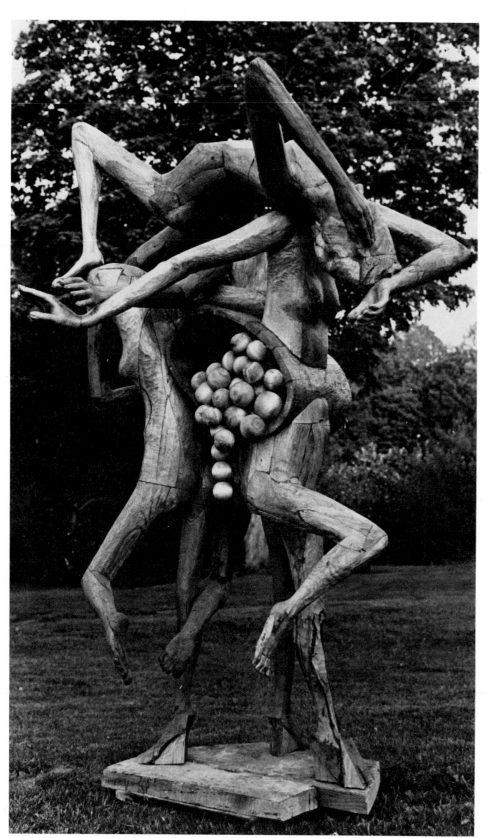

◄**Back View.** Egg forms are carved and joined to the structure. Lag bolts secure the sculpture to the wooden base.

►**Frog Hollow,** 1978. Cherry, maple, willow, and basswood, 9' (270 cm) high. The finished sculpture has grown to 9' (2.7 m) in height. Dynamic linear thrusts emanate from the central section. The work maintains the spontaneity of the original sketch and effectively utilizes diagonal thrusts and negative volumes.

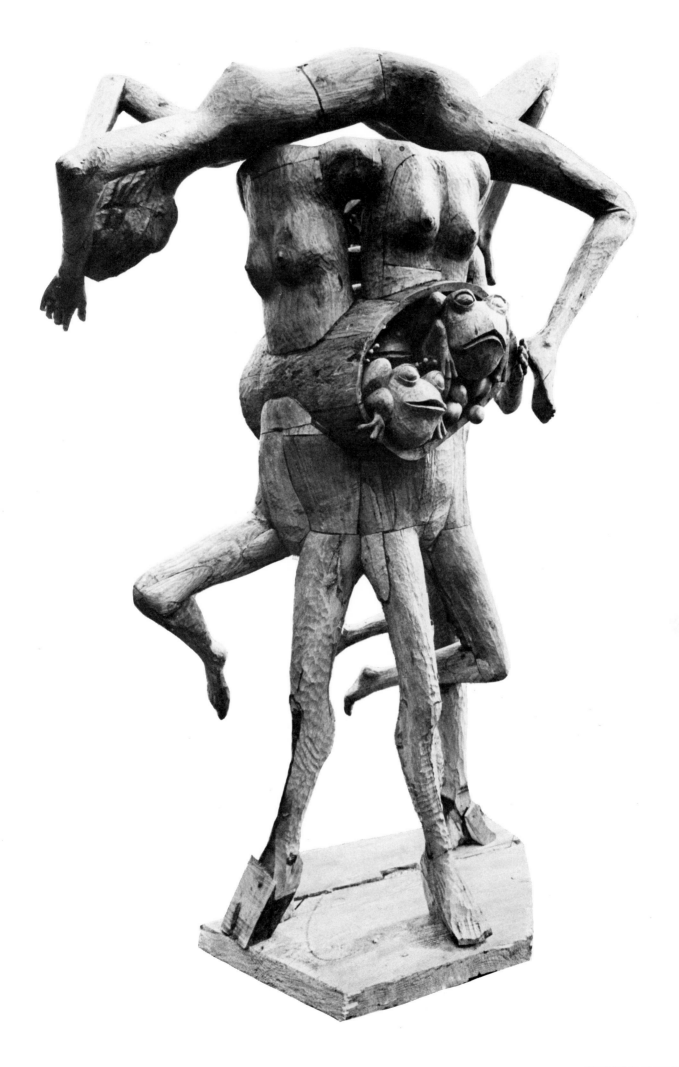

PETER ROBBIE

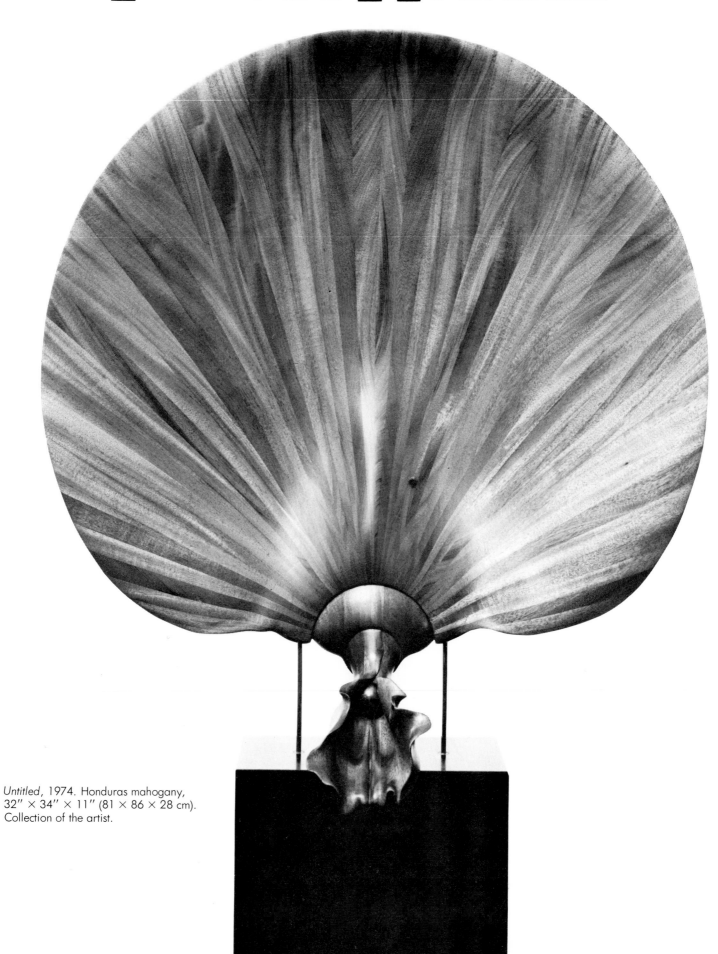

Untitled, 1974. Honduras mahogany,
32″ × 34″ × 11″ (81 × 86 × 28 cm).
Collection of the artist.

> "I am particularly interested in the space between ordinary objects and the perception of those objects, the discrepancy between actual facts and perceived facts. . . . Intuitively, the medium of wood feels right for the expression of my ideas."
>
> Peter Robbie

L ike many contemporary sculptors, Peter Robbie is aided to a great extent in the production of his work by recent achievements in wood technology and new fabrication processes.

Seed, the work shown in this chapter, is a fine example of how an artist exploits the technology of past and present generations to full advantage. In creating *Seed*, Robbie used traditional hand tools: chisels, gouges, files, scrapers, and so forth, along with pneumatic and electric power tools and equipment. The method of laminating and carving that he employed also offered a unique flexibility in allowing him to develop the final shape and form of the sculpture. This technique has now become a standard practice in the studios of many wood sculptors.

CONCEPT

In terms of its "reality," *Seed* is a paradox in sculptural form. Its idea was based on a simple, yet effective premise: that of transforming an ordinary object by changing its scale and substance. The selected object, a small sea shell, was altered radically in its known dimensions in the artist's construct. It was designed and constructed on a large architectural scale and beautifully "rematerialized" in wood, an act that transformed its "object-reality" to the realm of the bizarre and mysterious.

BEGINNING THE SCULPTURE

Robbie usually starts by making a series of preliminary drawings to examine the various possibilities of a particular idea. Next, larger drawings are made to determine the scale and major contours of the work and also to work out the technical details regarding the lamination process.

STACK LAMINATION

The term *stacking* refers to the technique whereby the sculptor glues planks of wood together in a "stairlike" fashion for subsequent carving and shaping. The principal advantage of stack laminating is that there is far less wood to cut away later, and that the artist is not limited by the physical size of the wood, as is the case in carving a log.

After the planks are glued together and the desired volume of the wood is achieved, the "stair steps" are removed with either a heavy gouge and mallet or with power sanders, grinders, or a chain saw. An advantage of the stack-laminating method is that the artist can always add additional planks of wood at any stage of carving should he desire to extend the size and shape of the sculpture.

Aliphatic resin glue (yellow glue) is usually favored for wood laminating because it's tough, permanent, and easy to use.

Laminating Seed. In preparation for the lamination of *Seed*, Robbie selected 4" × 8" (10 × 20 cm) planks of Honduras mahogany. To build up the volumetric form required for the sculpture, he planed them smooth, then glued and clamped them together.

The lamination was slow and tedious, and wood volume was built up slowly, usually two layers at a time; all of the surfaces were carefully hand planed before the subsequent layers were added. Extra thicknesses of wood were also laminated to the volume to allow for any extra adjustments of the form as the carving progressed.

TOOLS

For rough shaping the preliminary forms, Robbie used heavy gouges, a chain saw, the electric planer, and a heavy portable sander. The initial shaping was done with no. 36 grit sanding discs.

For shaping the intermediate and finer details of *Seed*, Robbie used a die grinder equipped with various carbide cutting burrs, a small electrically powered orbital sander and a variety of gouges, rasps, files, and wood scrapers. The lightweight electric sander was used extensively for shaping and smoothing the surface as the work approached its final surface. A great deal of work in the final stages was done entirely by hand, utilizing gouges (both flat and curved), surform rasps, riffler files, and abrasive papers of various grits. (See photographs of Robbie's power and hand tools on the following page.)

SANDING AND FINISHING

Sanding progressed from no. 36 grit paper to no. 80 grit (used in the heavy-duty grinder) to a no. 120 and no. 220 grit aluminum oxide paper, used with the orbital sander. Garnet paper was used for hand sanding, progressing from no. 150 to no. 220 grit for the final smoothing. As a final surface finish for *Seed*, Robbie applied several coats of butcher's wax, rubbed with steel wool and buffed between coats.

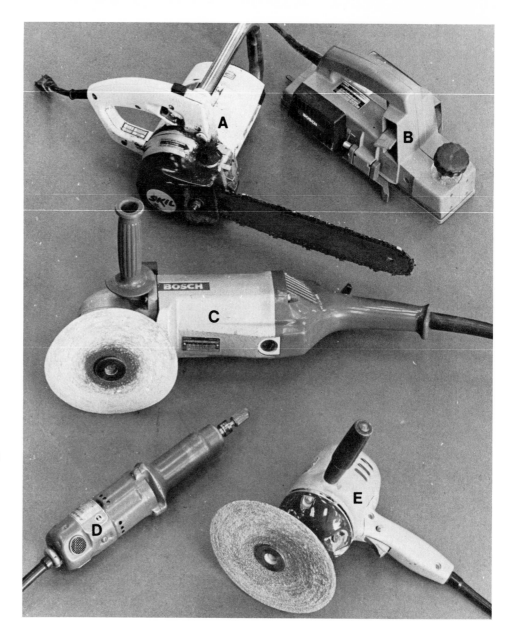

Power tools used are: (A) Electric chain saw, used for roughing out the preliminary form. (B) Electric planer, for reducing and shaping broader areas. (C) Portable disc grinder, used with coarser abrasive discs for shaping broad contours. (D) Die grinder with carbide burr, for shaping more delicate and hard-to-get-to areas. (E) Lightweight orbital disc sander, for more precise final shaping.

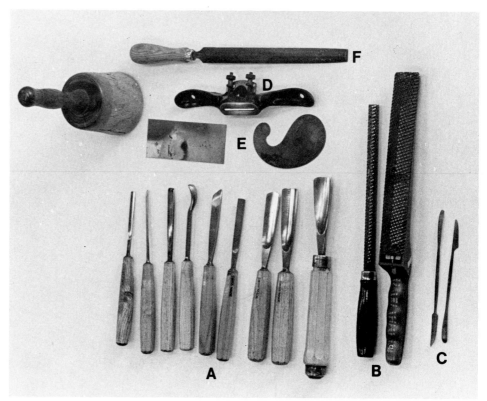

The hand tools used for intermediate and final shaping of Seed include: (A) wood gouges, (B) surform files, (C) riffler files, (D) spokeshave, (E) metal scrapers (flat and curved), and (F) wood file.

LAMINATION AND CARVING

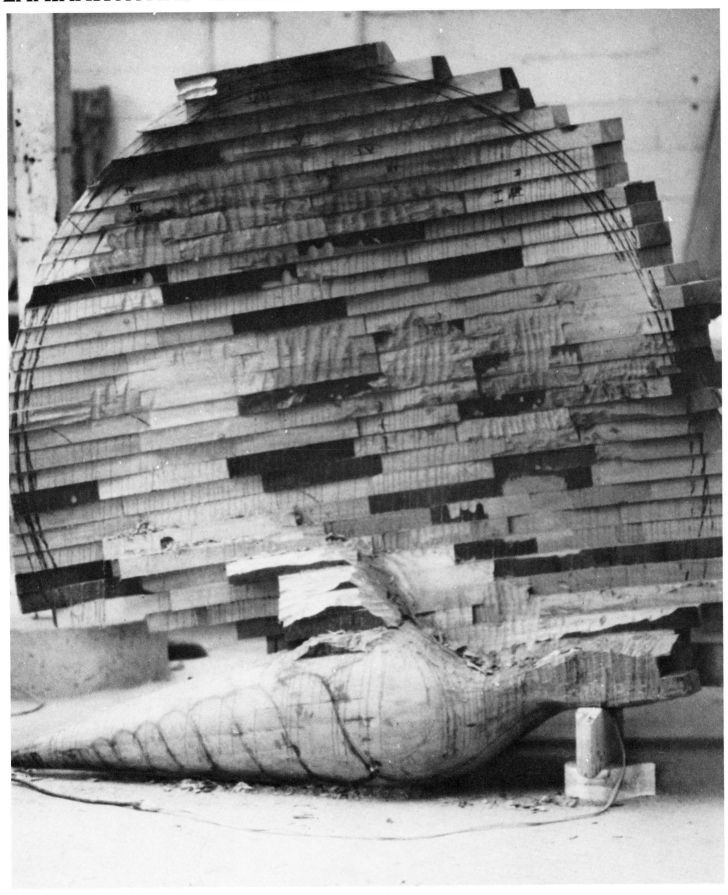

Building up the Form. Planks of Honduras mahogany are first planed smooth and then "stack-laminated." Here the lower section of the sculptural form has already been roughed out while at the top, additional planks of wood are laminated in order to continue building up the form.

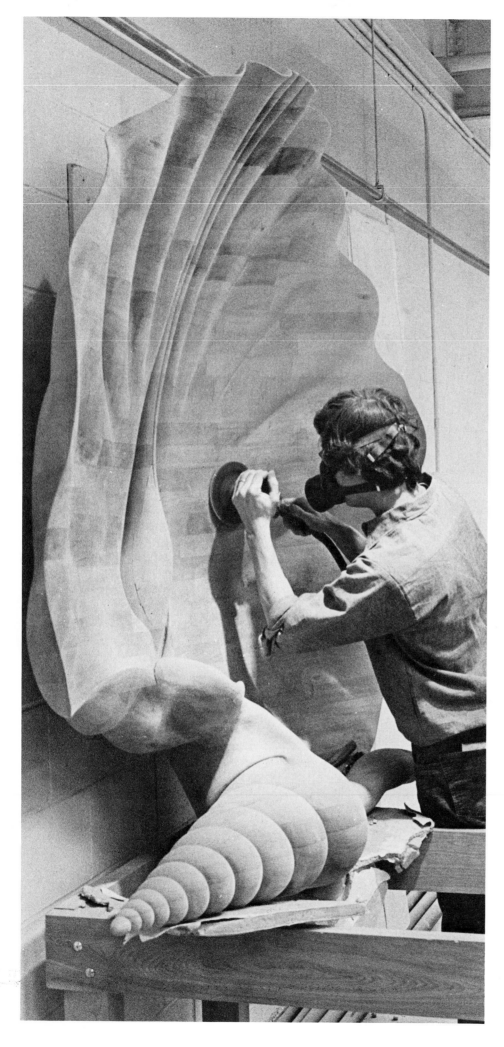

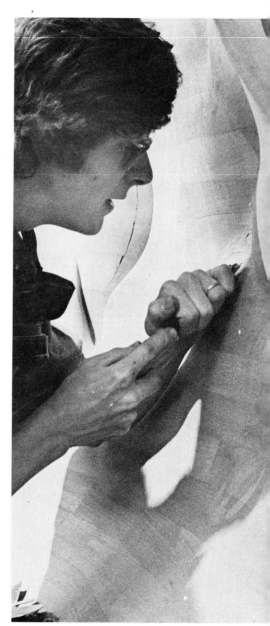

◄Shaping the Surface. Here Robbie uses the lightweight orbital sander equipped with no. 120 and then no. 220 grit aluminum oxide paper for intermediate and final shaping of the curvilinear surfaces.

▲Using the Hand Tools. Robbie switches to the use of hand tools for final details. Rifflers and gouges are used to shape the more intricate forms. He uses only hand pressure to power these tools, including the final hand sanding with nos. 120 and 220-grit garnet paper.

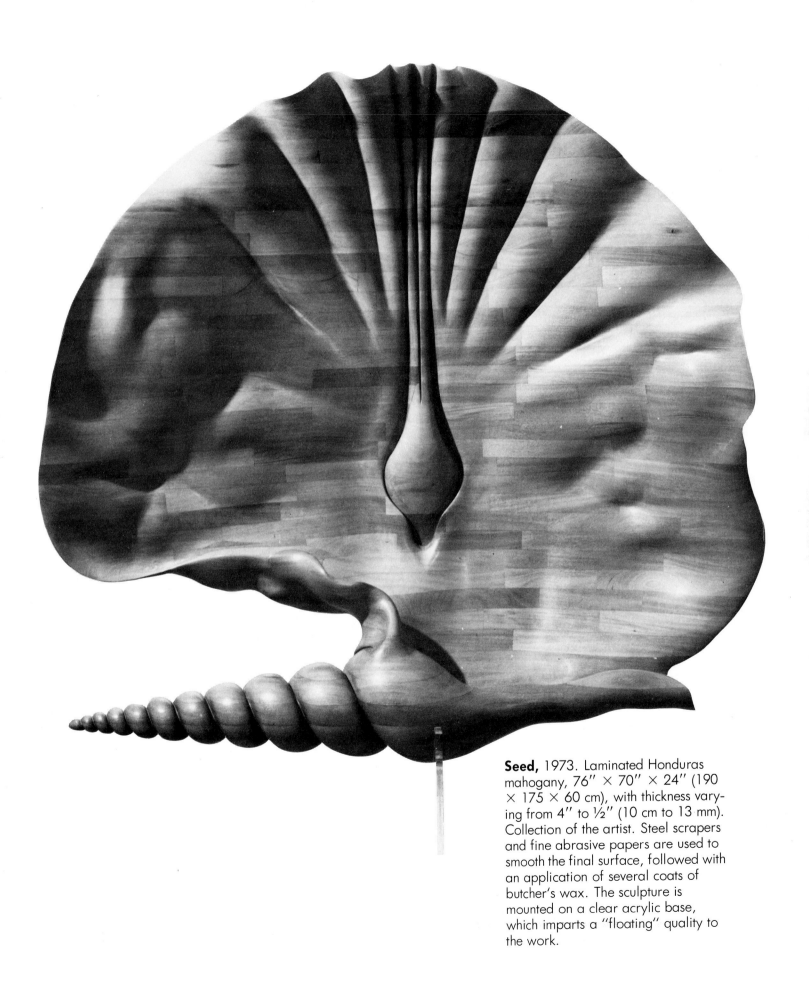

Seed, 1973. Laminated Honduras mahogany, 76″ × 70″ × 24″ (190 × 175 × 60 cm), with thickness varying from 4″ to ½″ (10 cm to 13 mm). Collection of the artist. Steel scrapers and fine abrasive papers are used to smooth the final surface, followed with an application of several coats of butcher's wax. The sculpture is mounted on a clear acrylic base, which imparts a "floating" quality to the work.

FUMIO YOSHIMURA

Typewriter, 1972. Wood, approximately
lifesize. Courtesy Nancy Hoffman Gallery,
New York.

The ancient definition of "bicycle" above is particularly amusing when we compare it to the ten-speed models of today. Grandpa certainly deserved due credit and praise for simply mounting the old "bone crushers," let alone attempting to guide those archaic missiles. But bicycles made of wood in the 1970's?

To the inveterate gallery-goer, that image is synonymous with the creations of Fumio Yoshimura, a Japanese-born sculptor who lives in New York. Yoshimura not only loves old bicycles and constructs wooden versions of them, but he also sculpts other commonplace objects as well. These include sewing machines, typewriters, motorcycles, and even skeletal structures of odd-looking fish. All of these subjects, many of which are just nostalgic memories of the past, are marvelously transformed by the artist into his favorite medium, wood—an act that changes the subjects both physically and, in terms of their perception, emotionally. Their raison d'être lies somewhere within the spectator's realm of subjective perception.

YOSHIMURA'S BICYCLES

Although Yoshimura has researched historical prototypes and bicycle design extensively, he doesn't try to construct "faithful replicas" of historical prototypes. Instead, he calls his work "interpretations," and works toward a concept he calls "approximate believability." Nuts on the ends of axles or pips on chains are no longer functioning elements, but little bits of "punctuation marks that are there to catch the light." To exhibit the bicycles, Yoshimura enjoys suspending them in space (a throwback to his kitemaking days), a method that lends an additional anachronism to his works.

Yoshimura's works seem fragile and delicate, yet they're quite strong. The artist is also fascinated by analogous forms in nature that combine delicate configurations and fragility with great strength, such as a blade of grass, bone structures, or plant designs.

The technique of bentwood lamination is especially well suited for the production of the strong skeletal or curvilinear shapes that Yoshimura prefers. The text that follows describes the technique of bentwood lamination itself, as well as Yoshimura's personal approach to it.

SELECTING THE WOOD

In choosing wood to be cut into strips for bentwood lamination, it is a good idea to select a wood with a fairly straight grain, which will help to avoid cracking when the wood is bent later. You may use either prepared veneer wood, such as aircraft plywood (Sitka spruce) that has already been cut into strips, or prepare the strips yourself by cutting them from a larger plank of wood. Yoshimura uses either lightweight yellow cedar or linden wood.

MAKING THE JIG

In preparation for making a bentwood laminate, a jig or guide fence must first be made that will accommodate the wooden strips. The jig guides the wood and determines the thickness of the cut, which will vary with the nature of the project, the type of wood used, and the amount of bend desired. For projects demanding only mild curvatures, there is less bending and the strips may be cut thicker, but for more intricate configurations, the strips must be cut thinner, sometimes paper thin.

To make the twisting curves of bentwood laminates, jigs can be made from an iron bar that has been formed to the desired shape and reinforced with steel supports to maintain its shape. However, Yoshimura has a fairly uncomplicated way of making jigs. He takes lumber, such as a piece of $2'' \times 6''$ (5×15 cm) fir, sketches out the desired curves on it with a pencil, cuts out the shape on the band saw, and then uses the two sections, along with bar clamps, for administering pressure to hold the laminate in place while the glue sets.

CUTTING THE WOODEN STRIPS

Now the wood is ready to be cut into thin strips. A band saw is generally used for this step, though a table saw can also be used. However, there is more wastage of the wood with the latter, due to the thickness of the saw blade.

Although Yoshimura generally uses a band saw, at a wood sculpture symposium in 1977 at Vancouver, British Columbia, he had access to a special saw used by box manufacturers in making thin slats for wooden crates. He fed $2'' \times 6''$ and $2'' \times 8''$ (5×15 and 5×20 cm) cedar planks through the saw to produce the thin strips required for his laminates. (A neat machine to have on hand.)

To provide a perfect interface between the wooden strips for gluing, the next step is to sand off the saw marks or, if the strips are thick enough, send them through a surface planer.

GLUING THE LAMINATE

Before gluing and clamping the wooden strips, a "dry run" should be made to reveal any problems. To do this, place the entire assemblage of wooden strips into the jig and apply pressure to see how it will bend. (Before clamping, Yoshimura first gave the wooden jig a coat of wax on the inside surface to prevent the glue from sticking to it.)

When you're ready to glue the laminate, first, wipe away any dust from the surface of the wooden strips. Then apply the glue with a wooden shim or spatula. Use an aliphatic resin glue such as Elmer's carpenter glue or a plastic resin glue if waterproofing is required. Then apply the bar clamps. You can use the clamps as Yoshimura did, or improvise anything as a clamp that will administer pressure.

SHAPING THE LAMINATE

Now the laminated wood is ready to be shaped, using either power or hand tools. Although Yoshimura generally avoids power tools to a great extent, he did use three power tools for for construction of his Vancouver bicycles: the band saw, the drillpress, and the lathe. The band saw was useful in cutting out many of the intricate component parts. The drill press was used for drilling holes that were subsequently filled with maple doweling, which acted as fastening devices. [A 1″ (2.5 mm) Nicholson cutting burr was mounted on the drill press and used to rout the underside of the bicycle seat.] Finally, the lathe was used to turn the intricate parts, the straight tubular sections, and the hubs for the wheels.

As for hand tools, Yoshimura did most of the basic shaping with carving knives, particularly with a Swedish utility knife that had a 5″ (13 cm) cutting blade. He also periodically used a round and half-round wood file to shape some of the surfaces.

After the wood was roughly shaped with the knives and file, he switched to sandpaper for finer shaping, progressing from a no. 80 grit to a no. 150 grit garnet paper. To facilitate sanding curved sections, Yoshimura cut irregularly shaped wooden sanding blocks on the band saw and glued sandpaper on the surfaces.

WHEELS AND SPOKES

Although the artist normally builds the wheels for his bicycles by using the bentwood lamination technique, Yoshimura sometimes also uses ready-made laminated hoops instead. (These are imported from Germany and were originally designed for stretching curved canvases.)

The spokes of his bicycle were made from ⅛″, 3/16″, and ¼″ (32, 48, and 64 mm) maple doweling that was obtained from hobby shops. In clamping the maple spokes to the hub of the wheel during the gluing operation, Yoshimura used wooden clothespins. However, he used no metal pins, bolts, or screws whatsoever for assembling the component parts of the bicycle. All joining was done with wooden pins or glue.

FINISH

In order to preserve the natural look of the wood, Yoshimura used only a clear plastic spray from an aerosol can. This served to protect the wood's surface and keep it clean.

BENTWOOD LAMINATION

Clamping the Jig for Bentwood Lamination. The desired curve is sketched on a 2″ × 4″ (5 × 10 cm) plank. The wood is then cut on the band saw. Pressure is applied to thin strips of wood that are glued and clamped within the jig.

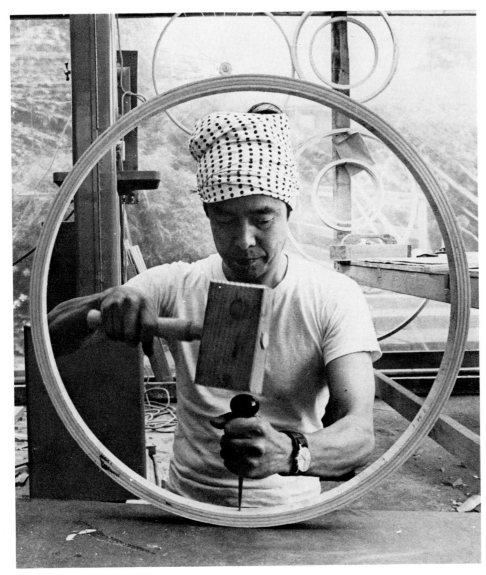

Setting Holes. Yoshimura uses a drive punch to set holes in preparation to drilling spoke holes.

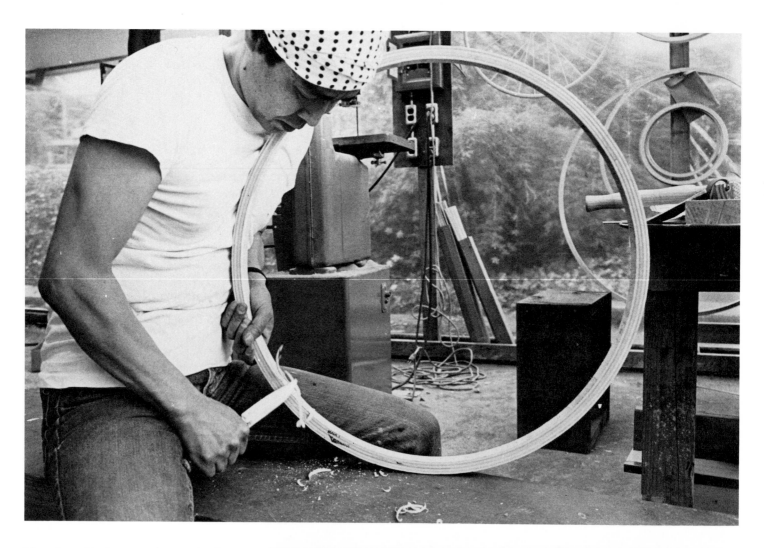

▲Shaping. Yoshimura shapes the laminated wood into a curvilinear form with a carving knife.

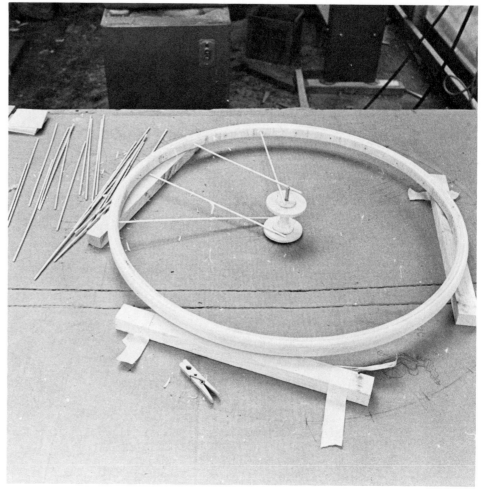

▶Assembling the Wheel. Maple doweling is used for the spokes, and clothespins clamp the doweling to the hub during the gluing operation. The hub is turned on the lathe.

▶▶Assembling. Additional components are made using the bentwood-lamination technique, along with parts that were turned on the lathe or cut out of planks on the band saw. Only maple pins are used as fasteners; no metal devices are used in the construction of Yoshimura's bicycles.

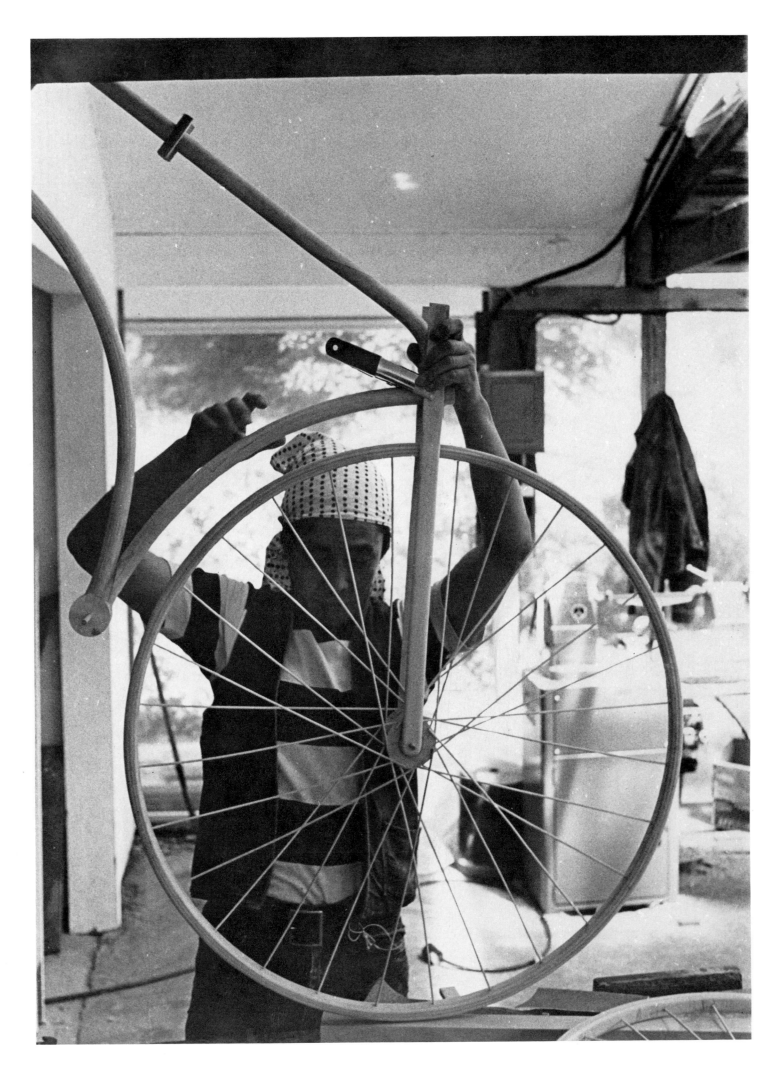

▲**Detail of Work in Progress.** The lamination is evident in the above detail. Many smaller intricate parts are turned on the lathe.

▶**Bicycle with Parking Meter,** 1978. Linden wood, 68″ × 53½″ × 16½″ (173 × 136 × 41 cm). Courtesy Nancy Hoffman Gallery, New York. Photo: Bevan Davies.

RAYMOND SELLS

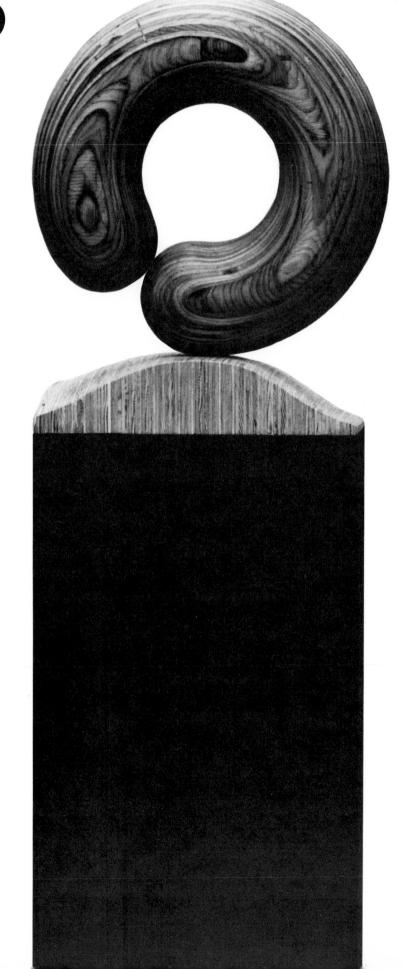

Untitled, 1975–1976. Laminated plywood,
6′ × 2′ × 1′ (1.8 × 0.6 × 0.3 m).

When plywood was first manufactured, it was called the "miracle wood sandwich." Today, it's part of a million dollar industry and is perhaps the most widely used of manmade materials.

Plywood is a flat panel that is built up of thin veneer sheets (plies) that are bonded together with adhesive under heat and pressure. The panels are assembled with an odd number of plies, the grain of each running perpendicular to its adjacent layer. The outside plies are called *faces*, while the inner ones are called *cores* or *centers*. The plies that are immediately below the face and back are called *crossbands*.

CATEGORIES OF PLYWOOD

Plywood is manufactured in both hardwood and softwood categories. The softwood variety is made principally for the construction industry and is made of Douglas fir, but other species are also used, including Western hemlock, larch, white fur, and pine. The hardwood plywood panels are used where appearance is of prime importance. These panels are often available with beautifully finished surfaces.

In its commercially available form, plywood can be purchased in 4′ × 8′ (1.2 × 2.4 m) sheets ranging in thicknesses of ¼″, ⅜″, ½″, and ¾″ (6, 10, 12 and 20 mm), which are the most commonly available, although other thicknesses are also manufactured for specialized purposes.

Plywoods are also made in two basic grades: (1) Exterior grade (with 100% moisture-resistant glueline), and (2) Interior grade (with a highly resistant moisture glueline).

MANUFACTURING PLYWOOD

At the plywood factory, debarked logs are placed on giant lathes that remove thin continuous sheets of wood, ranging in thickness from 1/100″ to ⅜″ (0.2 to 10 mm). The veneer sheets are then cut to desired lengths and sent through a dryer for 5 to 20 minutes, which reduces their moisture to about 5% MC (moisture content). [The oven temperature is usually about 350° to 500°F (160° to 225°C)]. Next, the veneer sheets are patched if necessary, then they travel through a glue spreader and on to the presses, where the plies are assembled and bonded together under heat and pressure to become the finished plywood panels.

ADVANTAGES OF PLYWOOD

Plywood is manufactured to rigid specifications, with prescribed mechanical properties and surface characteristics. Thus, knots, checks, and other imperfections that are inherent in natural wood products are removed.

Plywood is strong, rigid, and lightweight and does not chip or split readily. It is properly seasoned and not "green" wood. But because it is a wood product, plywood is still subject to cupping, twisting, and bowing. However, these tendencies are considerably reduced because of the dissimilar grain alignment between plies and the means of bonding the material together.

Although plywood is principally used as a flat material, the thinner stock can be easily bent to form curved surfaces that can be used as components for sculptural constructions or as wooden molds for casting concrete. The larger 4′ × 8′ (1.2 × 2.4 m) panels are especially useful in constructing larger architectural-size sculptures.

Plywood is easily worked with either hand or power tools and holds nails, screws, nuts, and bolts or other fastening devices quite well. It is also easily glued, painted, or stained and takes wood finishes well.

STACK-LAMINATING PLYWOOD

A basic means of producing volumetric shapes with flat material, such as ¾″ (20 mm) plywood, is to stack and glue the cutout sections, building "steps" that produce the desired volumes and configurations of the sculpture. After the glue sets, the plywood forms are subsequently sanded with progressively finer abrasive paper to develop the final sculptural form.

Curiously enough, stack-laminated plywood forms have a "woodier" quality than stack laminates made of natural wood planks. This illusion is due to the strong contrast of the emerging concentric rings that are created by the great number or laminate plies and gluelines.

RAYMOND SELLS

Raymond Sells, a San Francisco Bay area artist, creates sculptures exclusively from laminated plywood. Inspired by natural forms, the simple yet elegant shapes he designs are eminently well-suited to the plywood lamination technique. He usually uses ¾″ (20 mm) all-birch finished plywood, though he often employs Douglas fir, hemlock, or pine.

SELECTING THE PLYWOOD

As Raymond Sells explains, "The American Plywood Association has said that within the plywood plies, it is possible to find over 50 species of soft wood. Consequently, the variation, quality, and color of the grains can be numerous. Even hardwoods and imported woods are occasionally used, though Douglas fir is the wood most commonly used on the west coast. Some plywood inner plies—such as Douglas fir-faced plywood and the imported, all-birch, 13 or 15 thin-layered sheets, approximately ¾″ (18 mm)-thick from northern Europe—are more regular and standard in grain quality than others.

"In making a sculpture, I usually use ¾″ (18 mm)-thick plywood, which has five or seven interlocking or crisscrossed layers in thickness, and I buy it for the quality and color of the endgrain, and not necessarily for the species of wood used in the inner plies. In buying plywood for sculpting, wherever possible I handpick each 4′ × 8′ (1.2 × 2.4 m) sheet, paying close attention to all sides for the color, quality, and continuity of the various endgrains. I try to avoid sheets of plywood with many open spaces (voids), but where they do exist on the sculpture's surface, I fill them with a piece of wood that

matches the existing color and pattern of the layered grain. Except for very tiny fills, I avoid using wood paste fillers because they usually upset the continuity and woodiness of the grains.) Another important factor I look for in selecting plywood is the glue line. It is best that this line, which is usually dark, be clear and distinct.

"Regardless of whether or not I can handpick the sheets of plywood, each sheet or group of sheets has its own endgrain character. Sometimes the color, grain quality, and overall woodiness of the layers is essential to the feeling of a particular sculpture or part of a work, and an awareness of the end grain is necessary. At other times, it may not be that important. I must say, though, that there is always a continuity in a sculpture, including in the material, and it is up to the sculptor to learn to allow this continuity to come out. When you purposely attempt to form the continuity of a sculpture yourself or allow it to develop from the sculptor's own suggestions, there are always surprises, changes and illuminations that make working on sculptures very interesting, indeed."

CUTTING OUT AND LAMINATING THE PLYWOOD
Although Raymond Sells relies principally on the abrading process for shaping the final form of his sculptures, he avoids excess work and dust by carefully cutting out the required shapes to close tolerances on a band saw prior to assembling them. At that point, he normally then either clamps or nails them together to create volumetric forms, then glues them together.

For bonding the cut-out shapes together, Sells favors Titebond, a strong white glue that allows an extended working time prior to setting up. In addition to gluing, the artist often employs wooden dowels within the laminated structure for additional support. However, Sells often chooses to pre-nail the components together and shape them without glue.

That way, if something doesn't work out to his satisfaction, he can simply break the dry laminate apart, redo the troublesome section, and reassemble the structure.

SHAPING THE LAMINATED PLYWOOD
First, to roughly shape the basic forms, Sells uses a grinder-sander with a no. 50 disc for rough sanding (which seems to work best on plywood). Then he switches to disc sanders for most of the intermediate work, progressing to a no. 80 then a no. 110 disc for this work. The final sanding is done entirely by hand, starting with a no. 280 garnet paper and progressing through nos. 400 and 600 abrasive paper to achieve an extremely smooth final surface.

Sells also uses a variety of cabinet files for detail work on some of his more complicated pieces. Surform rasps are not generally used, however, since they tend to chip the plywood.

FINISH FOR PLYWOOD SCULPTURE
As a final finish for his plywood sculptures, Sells applies liberal applications of unboiled linseed oil over the surfaces. He begins by applying as much oil as the wood will take the first day (five to six coats). During the next few weeks, he adds additional coats of linseed oil, building up a total number of approximately 20 coats during the ensuing period. He then allows the linseed oil to dry thoroughly, resulting in a hard, varnishlike surface.

SPECIAL PROBLEMS IN WORKING WITH PLYWOOD
The biggest problem in carving plywood sculpture is trying to keep the edges of the plywood from chipping. When the wood does chip, however, repairs are easily made by gluing small slivers of the same wood to the damaged area. Wood putties are not used for making repairs because areas that are "doctored" in this way tend to be unsightly.

PLYWOOD LAMINATION

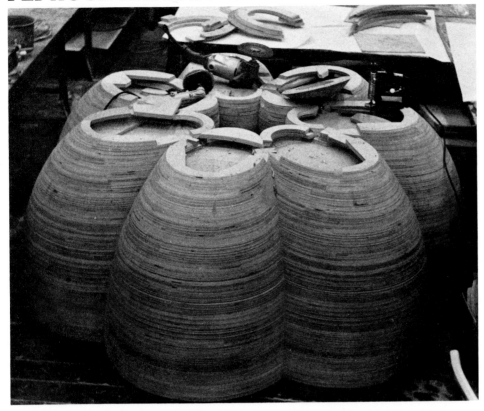

Stack Laminating the Plywood.
Raymond Sells stack laminates ¾″ (20 mm) plywood to build up volumetric forms. He selects shop-grade or cabinet-grade plywood of spruce, birch, fir, and other woods. Sells cuts out the component sections with a band saw, glues them together with Titebond adhesive, then nails them together. He fills the holes with the same kind and color of wood that's in the plywood. Because of the unique design, interior shapes are hollow.

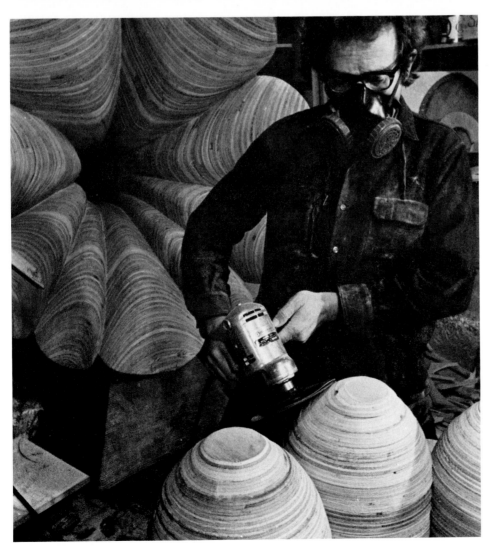

Machine Sanding. Sells rounds off the sculptural forms with a disc sander. A no. 50 grit abrasive disc is used first, followed by nos. 80 and 110 grit abrasive discs.

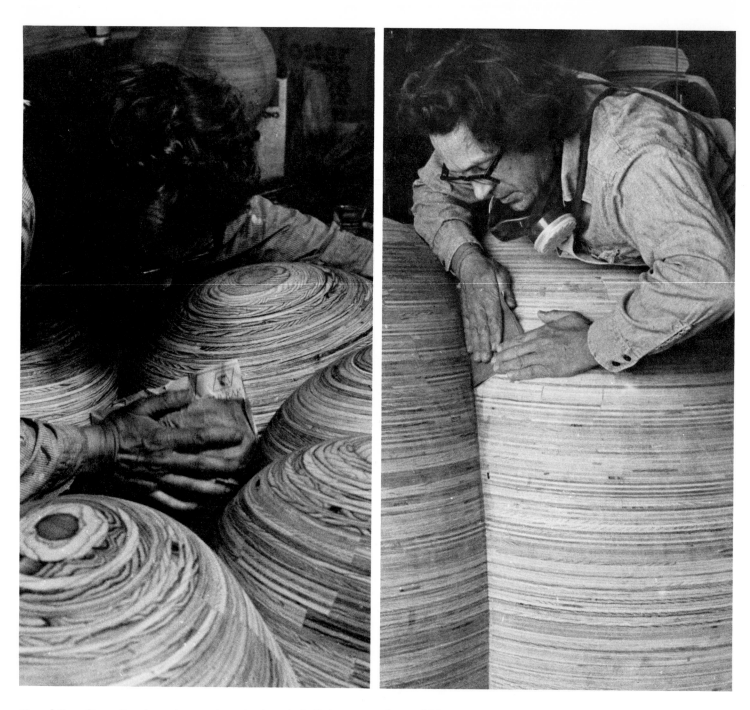

Hand Sanding. Final sanding is done by hand. Sells begins with no. 280 garnet paper, progresses through no. 400 grit, then finishes with no. 600 grit paper. Ironically, plywood laminates have a "woodier" character than natural wood laminates.

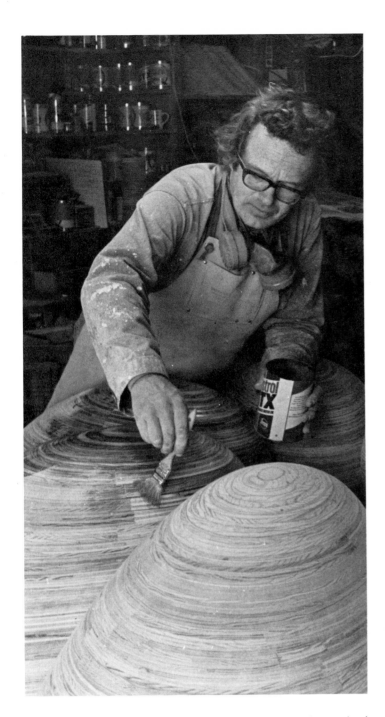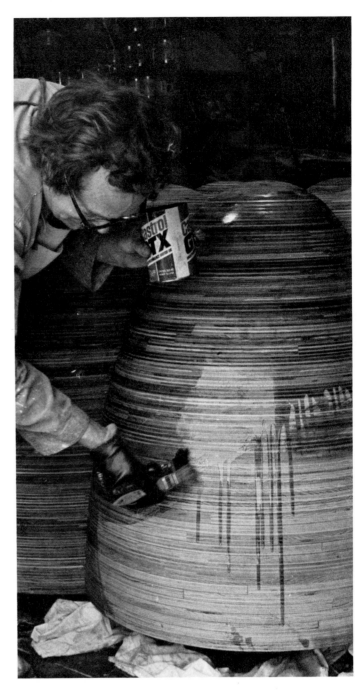

Finishing. Approximately 20 coats of unboiled linseed oil are applied over the surface of the plywood sculpture over a period of two months to achieve the final polish.

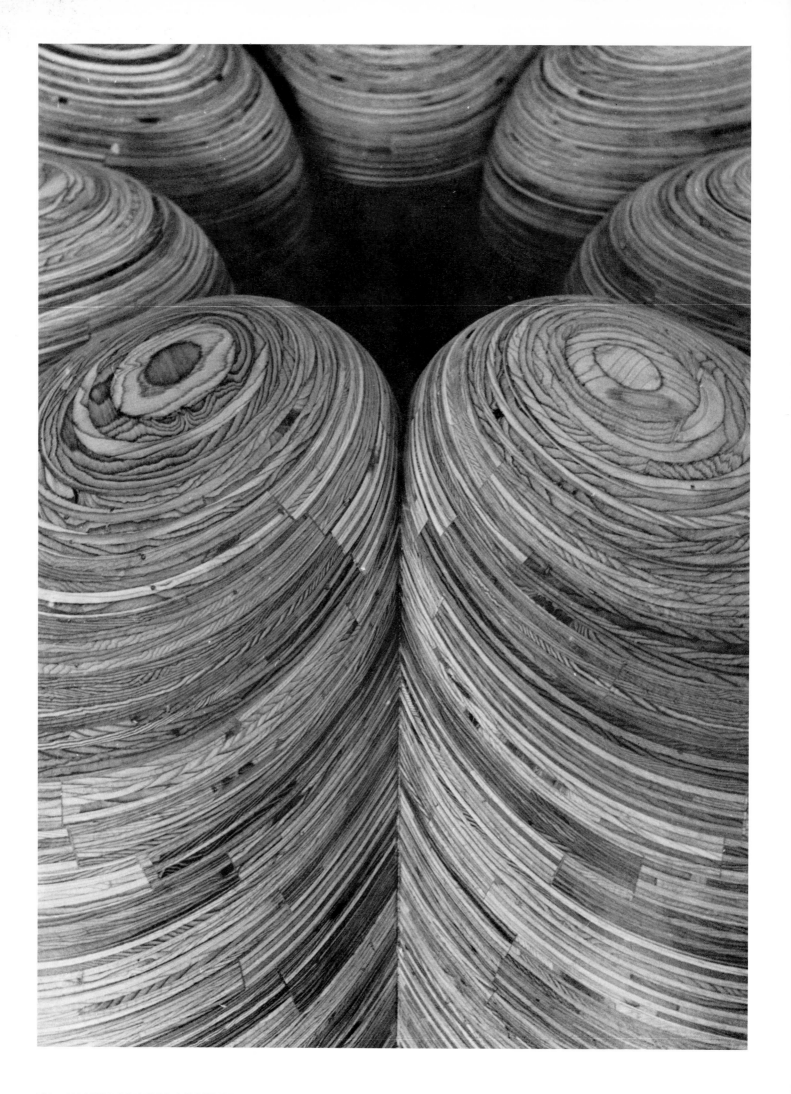

◄Detail of the Laminated Plywood. Sells chooses his plywood with an eye to their qualities of grain and color. The concentric rings that emerge during the shaping and sanding stages are dramatic reminders of the incredible number of veneer plies and glue lines that constitute the volumetric bulk of the plywood sculpture. For the top layer, Sells chooses a hard wood such as birch because it's easier to work with than plywood having a soft surface.

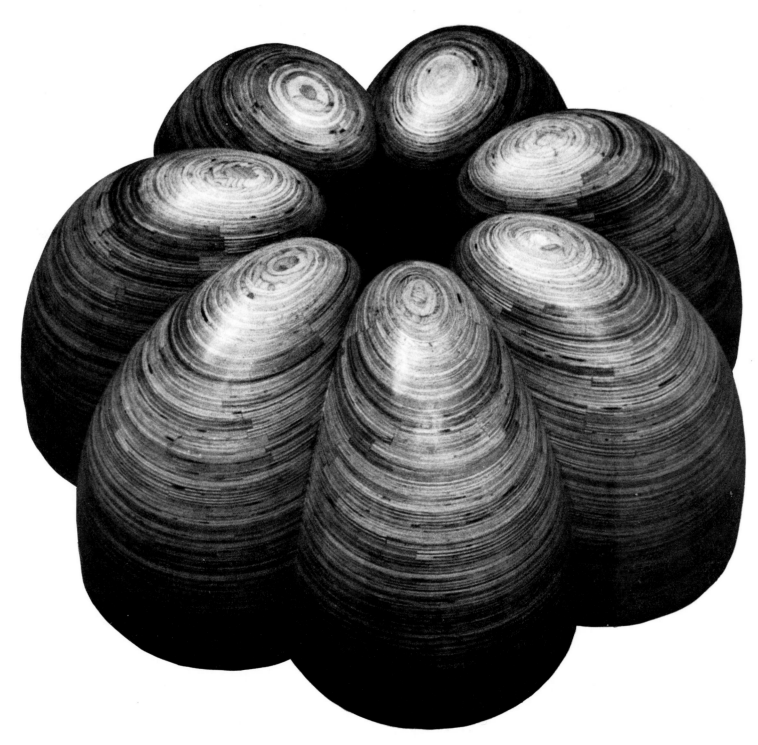

Untitled. Laminated plywood, 3′ × 7′ (1 × 2 m).

CARROLL BARNES

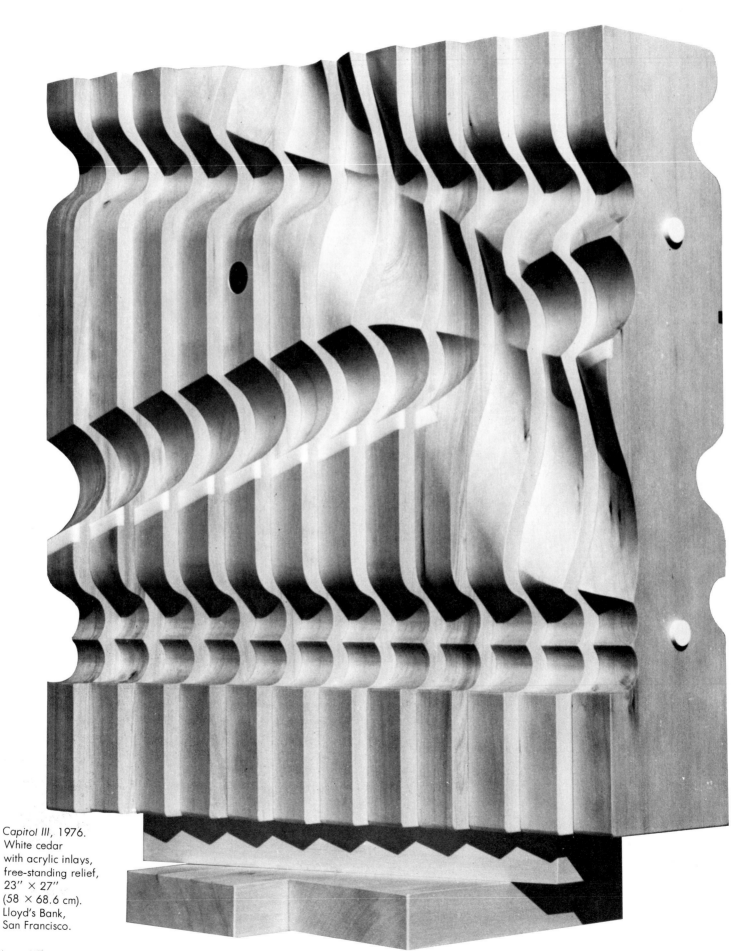

Capitol III, 1976.
White cedar
with acrylic inlays,
free-standing relief,
23" × 27"
(58 × 68.6 cm).
Lloyd's Bank,
San Francisco.

In earlier days, wood was easily acquired in massive forms, and Barnes took special delight in using a heroic scale to carve his favorite subjects, the American folk heroes. It was over thirty years ago that Carroll Barnes first attracted attention as a sculptor by carving a massive figure of Paul Bunyan from a single redwood log near Sequoia National Park in California. That particular log weighed 30 tons and measured 18½′ (5.5 cm) high by 9′ (2.7 m) wide.

Barnes' early training as a sculptor was with Carl Milles at the Cranbrook Academy of Art, Bloomfield Hills, Michigan, where he mastered the techniques of representational figure carving. Also while at Cranbrook, he made contacts with personalities from the Bauhaus, notable artists such as Gropius, Moholy-Nagy, and later Charles Eames and Harry Bertoia. As Barnes' work developed and eventually turned away from figurative carving, it was the influence of this latter group that inspired him toward his present interest in carving abstract sculptural forms.

THE MACHINE AESTHETIC

In 1969 Barnes moved to the San Francisco bay area and began making bas relief sculptures with power tools. As his experiments continued, he set aside his hand tools in favor of the portable power tools, especially favoring the portable circular saw, the router, power plane, and portable sander.

Most of the basic configurations of the bas reliefs from Carroll Barnes's studio are now dictated largely by the shapes that power tools are capable of producing. In this sense, he makes optimum use of power tools as form determinators.

THE TROLLEY TRACK SAW

With the help of a local tool and die maker, Barnes invented a unique power saw to use in making bas relief sculptures. He dubbed it the "Trolley Track Saw." This unusual device is simply an amalgamation of a Skilsaw (portable circular saw) to a metal trolley that rides along a bar track on steel rollers and can be adjusted to cut a variety of U-shaped channels.

Components of the Trolley Track Saw. The principal components of the Trolley Track Saw are shown in the first diagram opposite. A 10¼″ (26 cm) Skilsaw is mounted to a hinged metal bracket (B), which can be swung from 0° to 90° by loosening a set screw (C). The saw assembly is connected to the trolley (D), which has four stainless steel wheels that allow it to move along the bar track (E). C clamps are used to secure the Trolley Track assembly over the wood to be cut. Barnes has several lengths of bar track, which allows him to extend the length of the cut whenever necessary.

The sketches in the second diagram illustrate some of the various cuts that are possible with the Trolley Track Saw and its accessories, the portable belt sander, router, and conventional portable power saw.

The Slide-lams. Using the Trolley Track Saw, Barnes has created hundreds of bas relief sculptures, which he calls "slide-lams." His method of making these structures is quite unusual:

First, he carefully selects blemish-free Alaska white cedar, and cuts it in 1″ × 2″ (2.5 × 5 cm) strips about 4′ (120 cm) long. These strips are then clamped together (without glue) to the worktable. The Trolley Track Saw is then clamped over the wood and adjusted to make the cuts.

Making Channel (U-shaped) Cuts with the Trolley Track Saw. After the Trolley Track Saw is aligned and clamped over the work, a U-shaped channel is made by first roughing out the channel. Barnes does this by "walking" the saw down the length of the bar track, alternately raising and lowering the saw to make a series of cuts. He moves it ½″ (13 mm) each time and repeats the operation until he has transversed the length of the desired cut. This leaves a series of "fins" that stand ½″ (13 mm) apart along the length of the channel, which he later pops out with a hammer.

Next, in order to smooth out the channel, he lowers the saw back into position in the channel and moves it along the length of the cut, this time without raising it as he had done before.

After one cut is made, the clamps are removed, the boards shifted and reclamped, and the process continued. By angling the saw in different directions, the width of the channel is determined and can be changed from a semi-circular to an elliptical shape. The depth of the cut is determined by raising or lowering the saw blade in the Skilsaw.

As the work progresses, the position of the saw is changed many times and new cuts are made. The wood is also unclamped, realigned by shifting the wood strips, reclamped, and further modulated with additional cuts until the desired relief surface is achieved.

OTHER CUTS

The V-shaped cuts are not made with the Trolley Track Saw. Barnes has another portable circular saw for this purpose that he guides along a wooden plank that is clamped to the wood surface. The V-shaped channels are made by angling the saw and making two cuts, one of which is made in the reverse direction of the original cut.

Narrower channels are made with a router, also guided by a wooden plank that is clamped to the work.

SANDING AND FINISHING THE SLIDE-LAMS

The various channel cuts are further modulated with power belt sanders or power planes, drum sanders, and portable belt sanders to achieve the desired sculptural configuration. With the power belt sanders or power planes, he removes the corners of some of the channel cuts and smoothes the surfaces. To smooth smaller concave shapes, Barnes uses a flexible shaft machine with small drum sanders. With the portable belt sanders, he uses belt loops ranging from no. 60 grit to no. 120 grit.

When the work involving the use of power tools is completed, Barnes hand sands the surface with a fine grade of garnet paper. For the final finish, he applies a generous coat of Formby tung oil that is wiped clean after about twenty minutes.

ASSEMBLY

Finally, Barnes uses a "dry lamination" technique for assembly: The component elements of the bas relief are ultimately united by screwing a sheet of ¼″ (6 mm) tempered Masonite® sheet to the back side with wooden screws rather

than using an adhesive. (This allows him to easily disconnect and realign the wood should he desire to do so.) Special care is taken to avoid placing the screws behind concave areas in order to prevent them from coming through the surface.

The photographic sequence that follows visually describes Barnes's process of using the Trolley Track Saw to make slide-laminated bas reliefs.

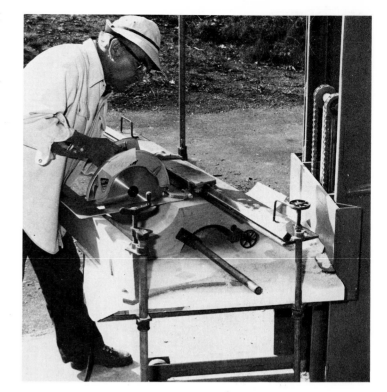

▶Barnes uses the Trolley Track Saw to make a deep elliptically shaped channel.

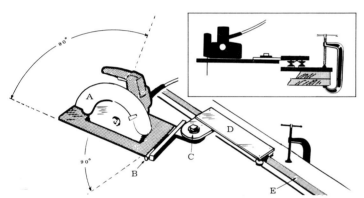

To make the Trolley Track Saw, a 10¼" (26 cm) Skilsaw (A) is hinged (B) to a trolley assembly (D). The saw can swing out 90° laterally, or can be raised up vertically to 90°. The assembly is guided along the length of the bar track with a diamond-shaped rail (E). An adjusting nut (C) allows the angle of the saw to be changed and determines the width of the U-shaped channel cut. The depth of the cut is determined by raising or lowering the saw blade in the Skilsaw. (The inset diagram shows how the trolley rides on the diamond-shaped rail, supported by four V-shaped steel wheels.) The entire unit is clamped over the wood to be cut, secured to the workbench with C-clamps.

This illustration shows the end views of some of the various cuts that are possible with the Trolley Track Saw and its accessories. (A) U-cut channel, medium depth and width. The saw is set for a medium angle (approximately 60°) and the blade set for a medium depth of cut. (B) U-cut channel, deeper elliptical cut. Here, the saw is set at approximately a 30° angle and the blade adjusted for a deeper cut. (C) U-cut channel, wider cut. Here, the saw is set at a wide angle (approximately 80°) and the saw blade set for a medium cut. (D) U-cut channel modified on the right edge. This is done by sanding with the portable belt sander. (E) U-cut channel modified on both edges. This is achieved by power sanding both edges. (F) Square channel. Another portable circular saw was used to make a series of cuts, guided by a plank that was clamped to the surface. (The Trolley Track Saw is not used for making this cut.) The channel is later cleaned out with a chisel or rabbet plane. Narrower square channels are made with the router, which is also guided by a wooden plank clamped to the wood's surface. (G) V-cut channel. A conventional portable circular saw is used for this cut, guided along a wooden plank that is clamped to the work. (The Trolley Track Saw is not used for this cut.) The angle of the saw is set at the desired angle within 45°, and two cuts are made to complete the channel. (H) Combination square channel and V-shaped cut. (I) Combination of modified U-cut channel and V-shaped cut.

THE SLIDING LAMINATION

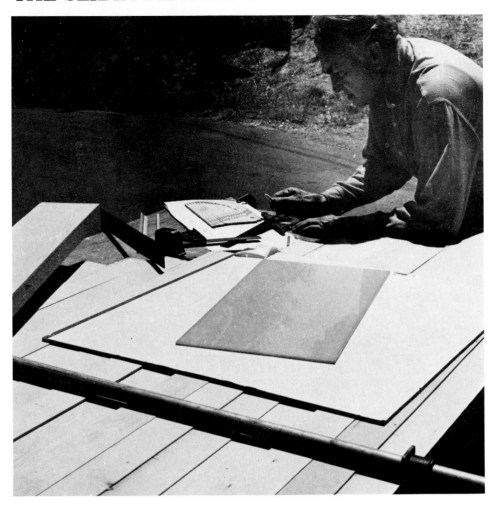

◄Preliminary Work. Carroll Barnes studies a small model of a proposed slide-laminated relief prior to starting work. Pipe clamps are used to secure the planks of wood to be cut to the workbench.

▼Clamping the Saw to the Wood. The Trolley Track Saw is clamped in position on the wood's surface with C-clamps. A proposed channel cut is first outlined in pencil, making careful measurements and adjustments on the saw to insure that the proper width and depth of the cut will be achieved.

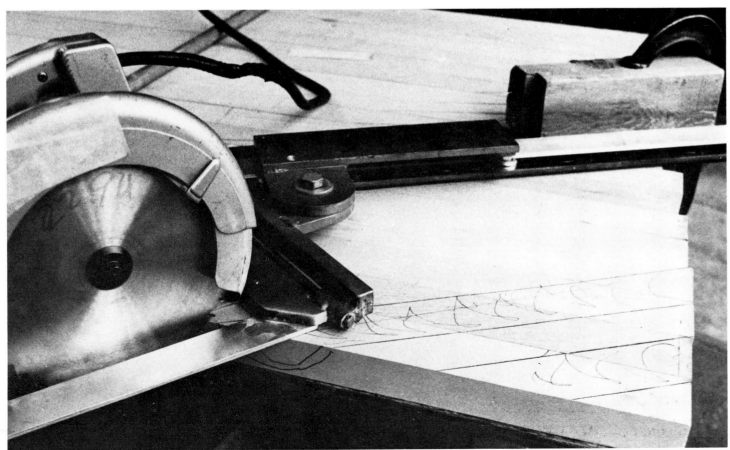

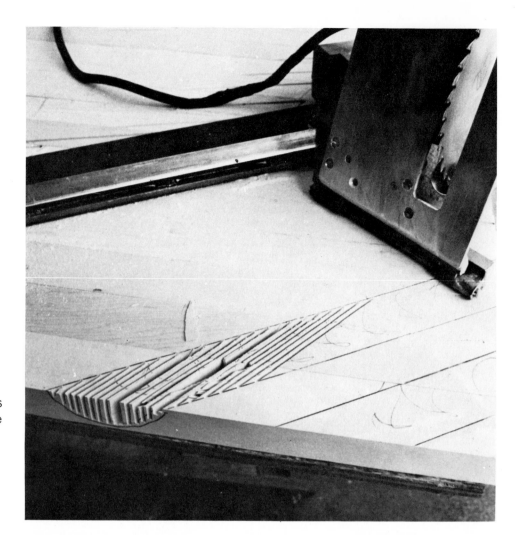

Roughing-out the Channel. Barnes first uses the Trolley Track Saw to make a series of "bites" on the wood as the saw is guided along the length of the bar track. In this stage, the saw is alternately raised and lowered to make a successive series of cuts, approximately ¼" (6 mm) apart.

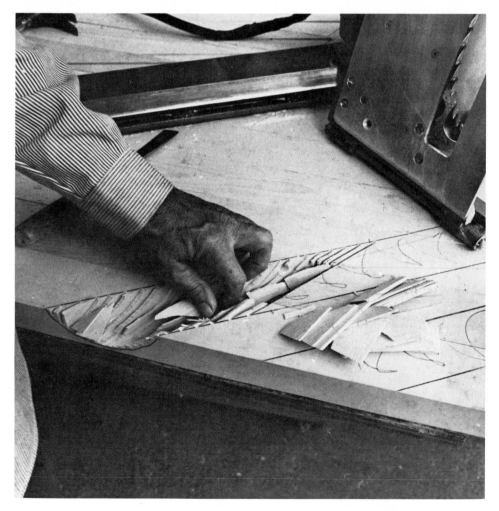

Removing the Excess Wood. The remaining wood "fins" are popped out with a hammer.

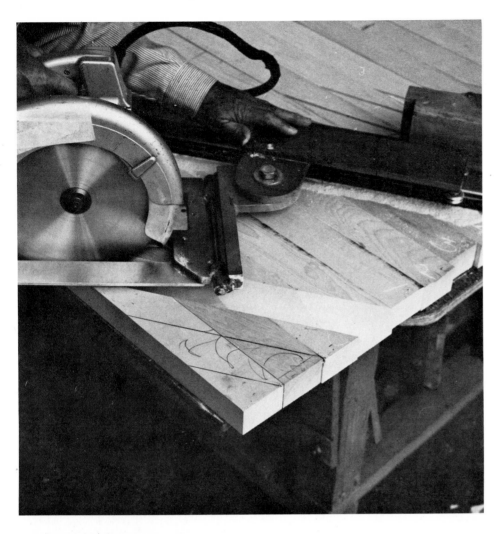

Planing the channel. The Trolley Track Saw is once again lowered into the channel and guided along the entire length of the channel. This time it is not raised and lowered, but kept down on the wood's surface and moved forward and backward to smooth out the *U*-shaped channel.

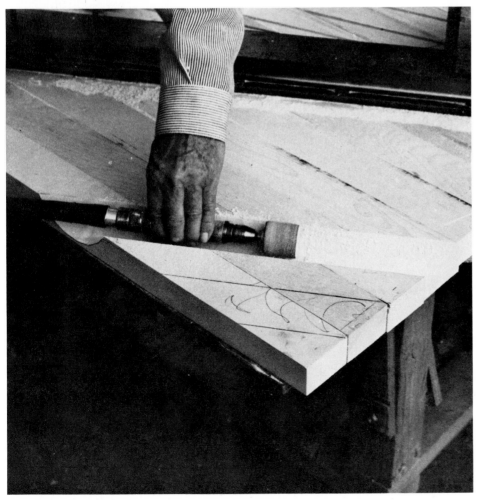

Sanding. A sanding drum attached to a flexible shaft machine is sometimes used to further refine the interior surfaces of the concave cut.

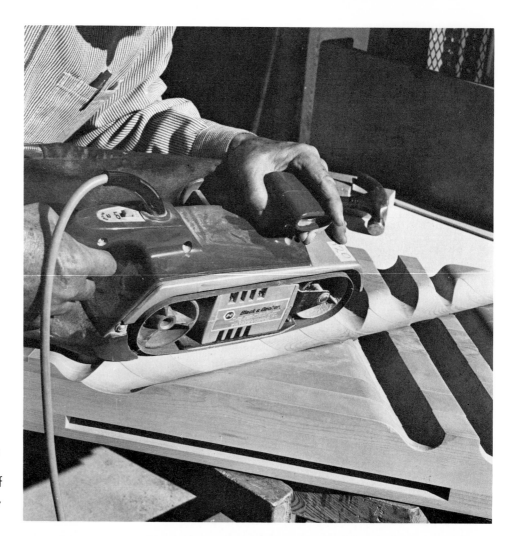

Modulating the *U*-shaped channels. Portable belt sanders, saddled with progressively finer abrasive belts (from no. 60 grit to no. 120 grit) are used to round off some of the edges of the channels, creating smooth-flowing, undulating surfaces.

Making a *V*-shaped Cut. Using a conventional portable circular saw (not the Trolley Track Saw), Barnes sets the saw blade to the desired angle and makes two cuts. The saw is reversed to make the second cut, which completes the *V*-cut channel. Wooden chips are removed with a screw driver and a mallet. The base is later cleaned out with a carpenter's chisel.

▸▸**Additional Cuts.** Pipe clamps are loosened and the boards are shifted to new juxtapositions, reclamped, and the operation continued until the desired surface forms are achieved. Here Barnes is using a portable router (guided by a plank of wood clamped to the work surface) to create a ¼" (6 mm) square channel cut that will be later used to inlay acrylic plastic strips.

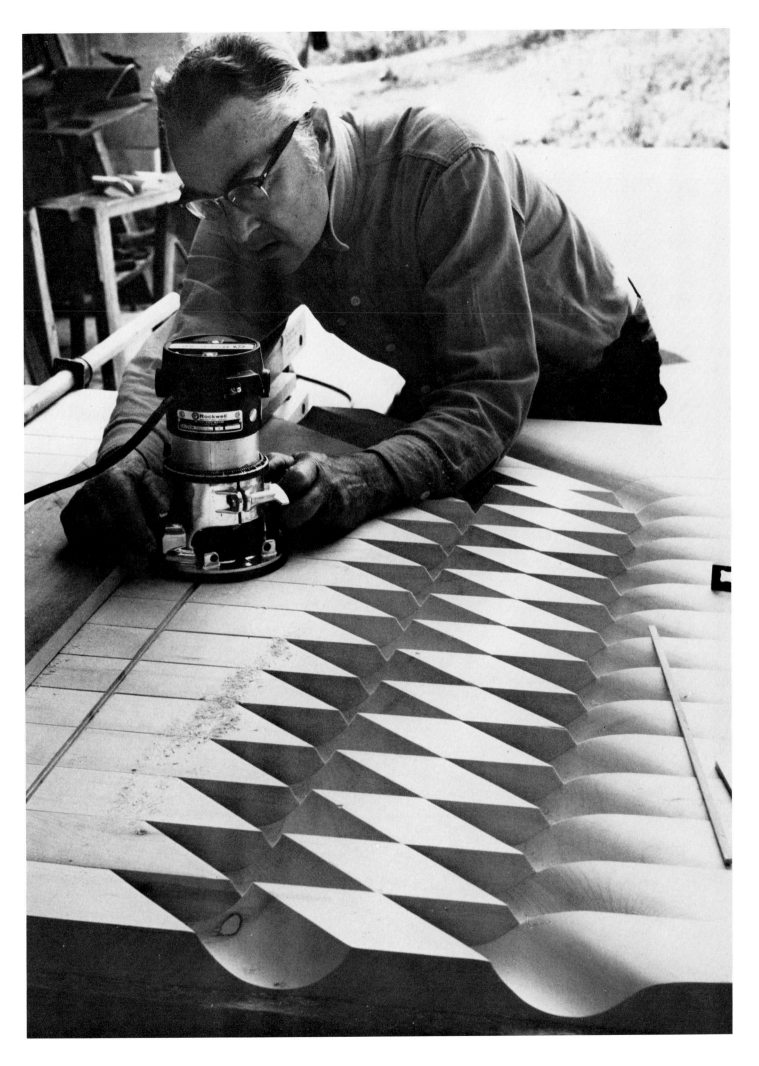

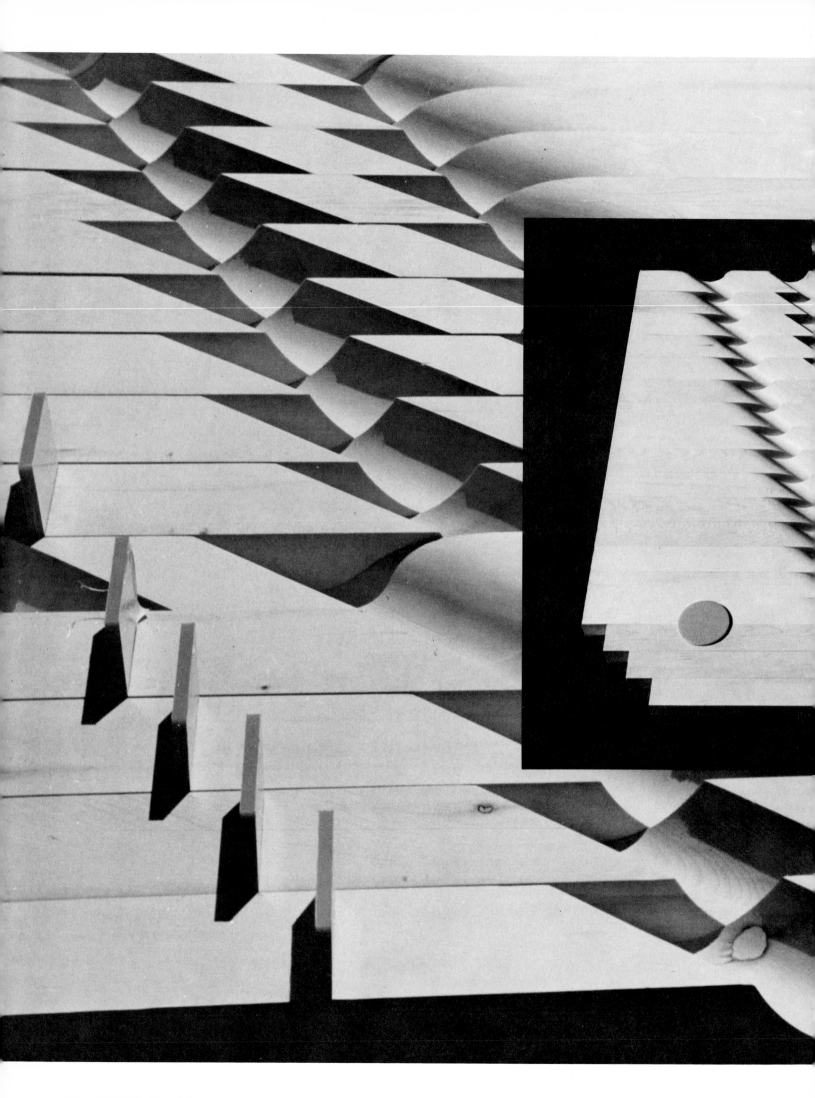

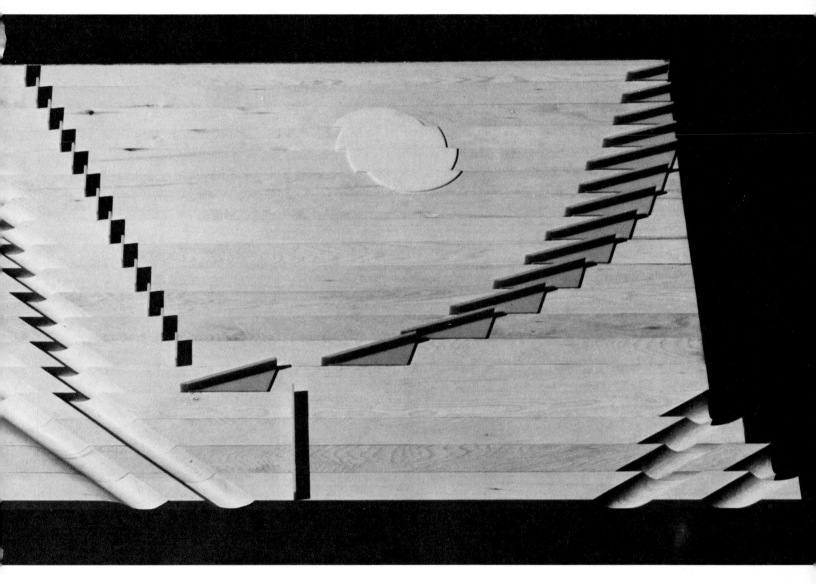

◄As the work progresses, the contrast of curvilinear and rectilinear forms produces a texture of dynamic light and dark surface undulations. In the work, ¼″ (6 mm) acrylic plastic strips are inlaid into some of the square channels.

▲**Sound Barrier.** White Alaskan cedar, 48″ × 91″ (122 × 231 cm). Although the components could be permanently bonded together with an adhesive, Barnes chooses to secure them mechanically. A sheet of tempered Masonite® is placed behind the components and wood screws are used to assemble the piece.

CONSTRUCTION AND LAMINATION

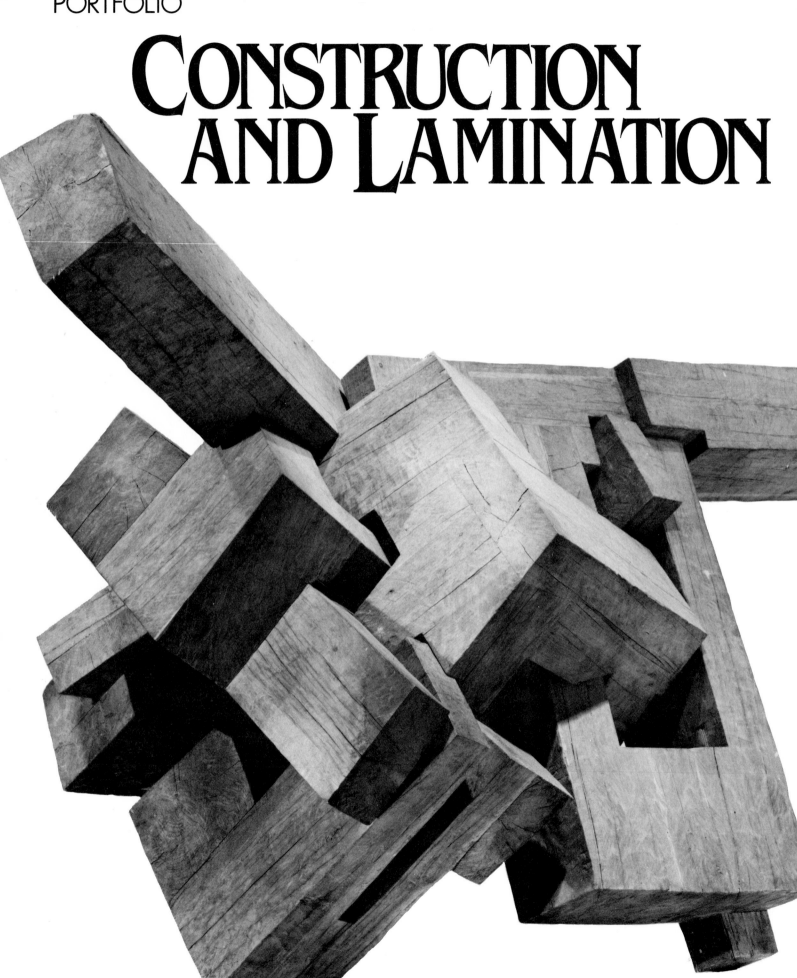

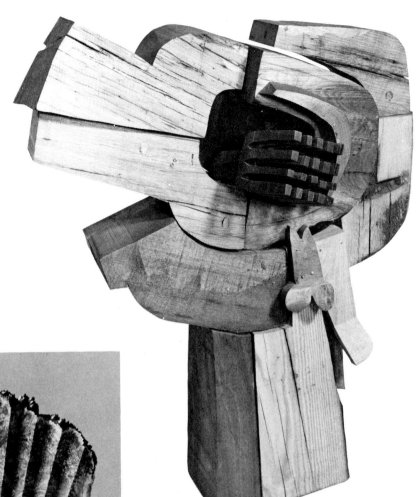

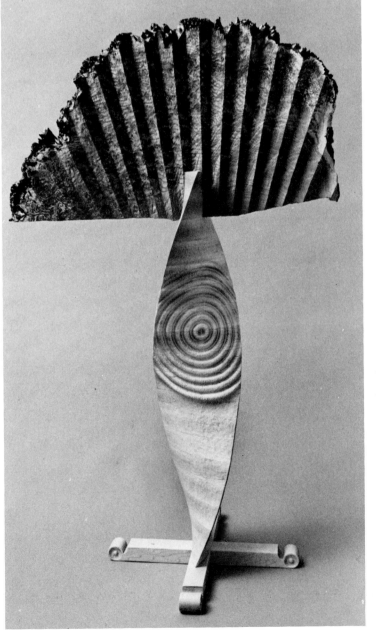

▲Hugh Townley, *The Shout* (Graves). Oak, mahogany, cherry, walnut, and lignum vitae, 41″ (104 cm) high.

◀Richard Graham, *The Zouave*, 1976. Maple and ash burl, 48″ × 28½″ × 18″ (122 × 72 × 46 cm).

◀◀Eduardo Chillida, *Abesti Gogora III*. Oak, 81⅝″ × 136⅜″ (33 × 54 cm). Collection The Art Institute of Chicago, Grant J. Pick Purchase Fund.

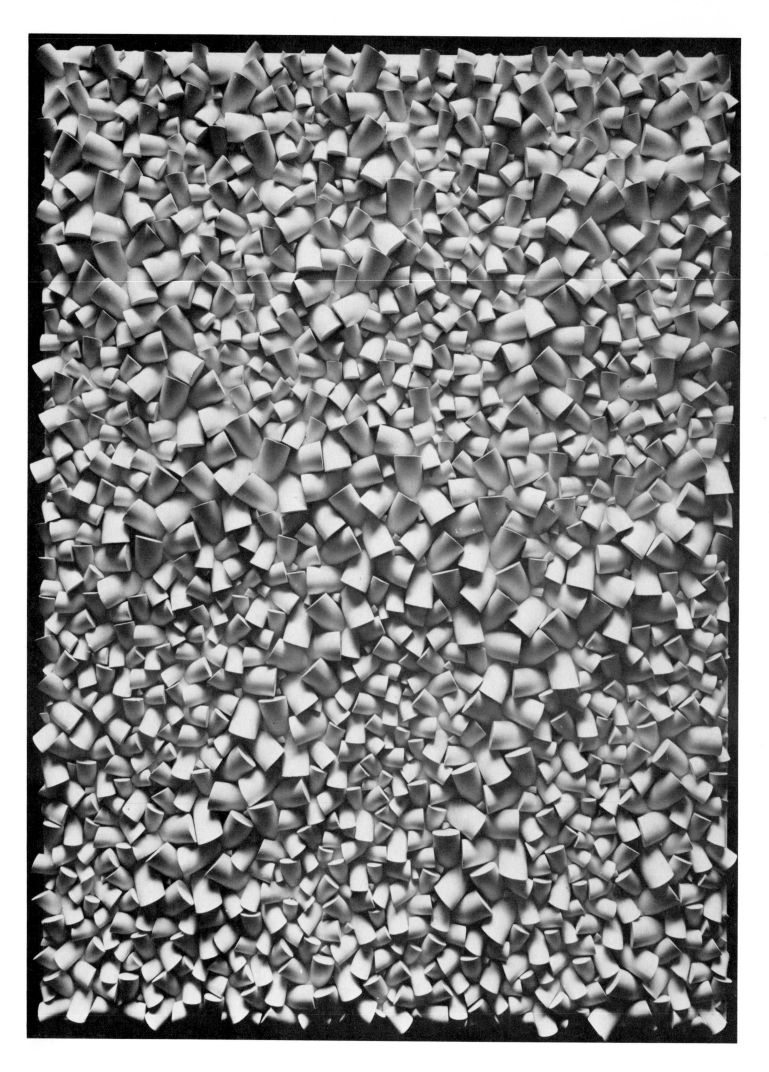

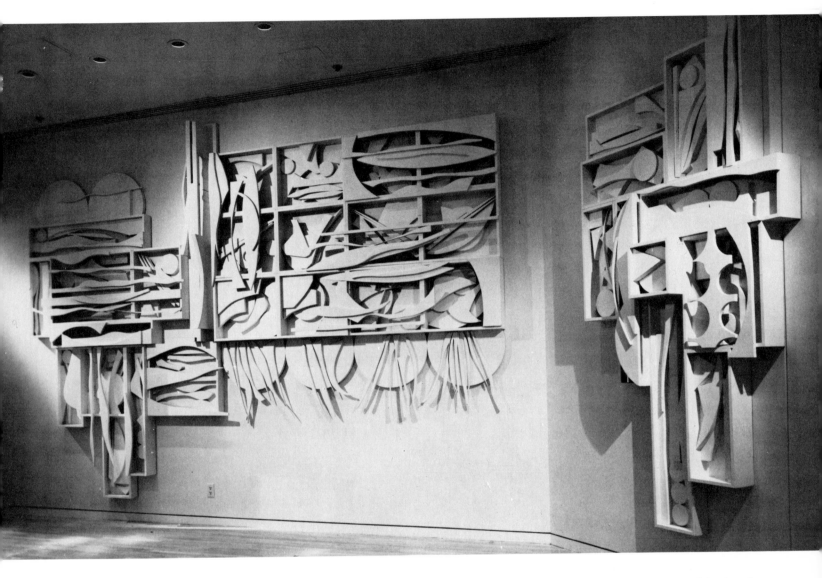

◄Camargo, *Relief Opus 141*, 1967. Wood, 47¼″ × 31½″ (119.4 × 80 cm). Courtesy Gimpel Fils Gallery, Ltd., London.

▲Louise Nevelson, *Chapel of the Good Shepherd: Frieze of the Apostles (left), and Cross of the Resurrection (right)*, 1977. Courtesy St. Peter's Church, New York. Photo: Tom Crane.

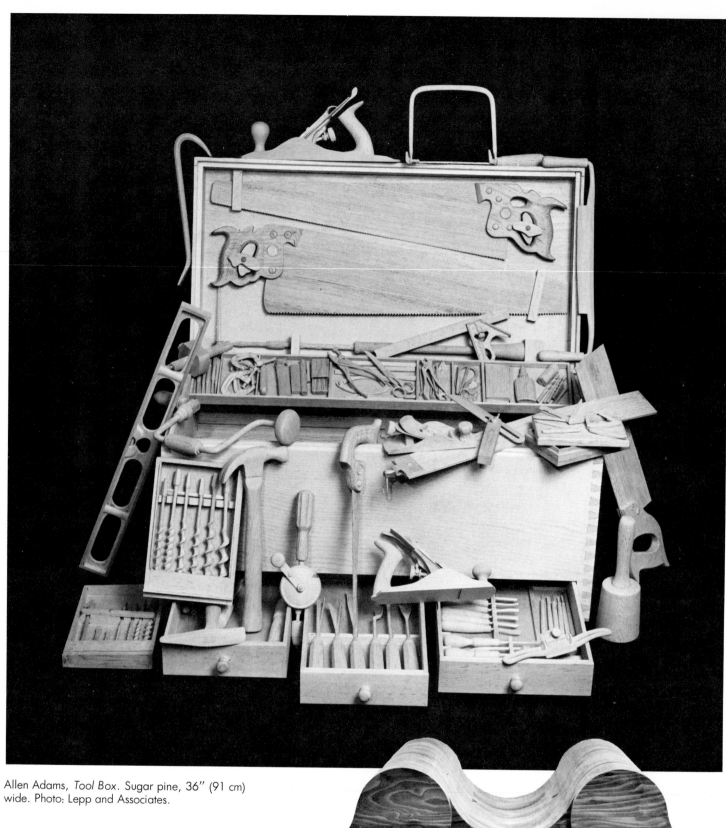

Allen Adams, *Tool Box*. Sugar pine, 36″ (91 cm)
wide. Photo: Lepp and Associates.

Hisayuki Mogami, *Naniga Nanishite Nantoyara*,
1976. Japanese katsura wood, 49″ × 60″ × 40″
(124.5 × 152 × 101.6 cm). Courtesy Tokyo
Gallery.

Michael Cooper, *Captain's Chair*, 1946. Laminated hardwood, 40″ ×
48″ × 48″ (102 × 122 × 122 cm). Courtesy of the artist. Photo:
Howard Photographics.

Lloyd Hamrol, *Log Ramps*, 1974. Cedar logs and steel cable, 9′ × 36′ × 36′1″ (2.7 × 10.8 × 10.8 m). Western Washington State College, Bellingham.

Manu Hartman, *Maamme I*, 1969. Wood.

Kenneth Fadeley, *Labor of Love*, 1974. Pine, 48″ × 18″
(122 × 46 cm).

◀Giuseppe Rivadossi, *Igloo*, 1973. Wood, 94″ × 46″ × 15″ (238 × 116 × 38 cm).

▶Guiseppe Rivadossi, *Grande Immagine di Fine Inverno*, 1972. Wood, 8′ × 32½″ × 11″ (242 × 82 × 29 cm). Courtesy of the artist.

▼Victor Colby, *Young Man with Legendary Chinese Birds*, 1960. Hemlock, 31″ (78.7 cm) high. Courtesy The Contemporaries, New York. Private collection. Photo: Walter Rosenblum.

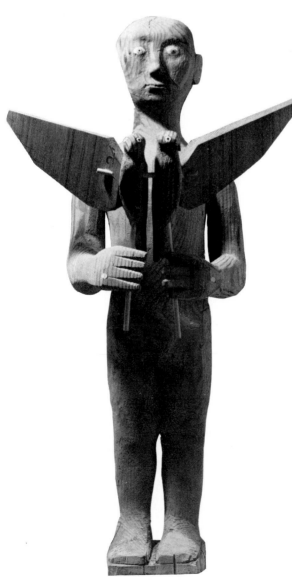

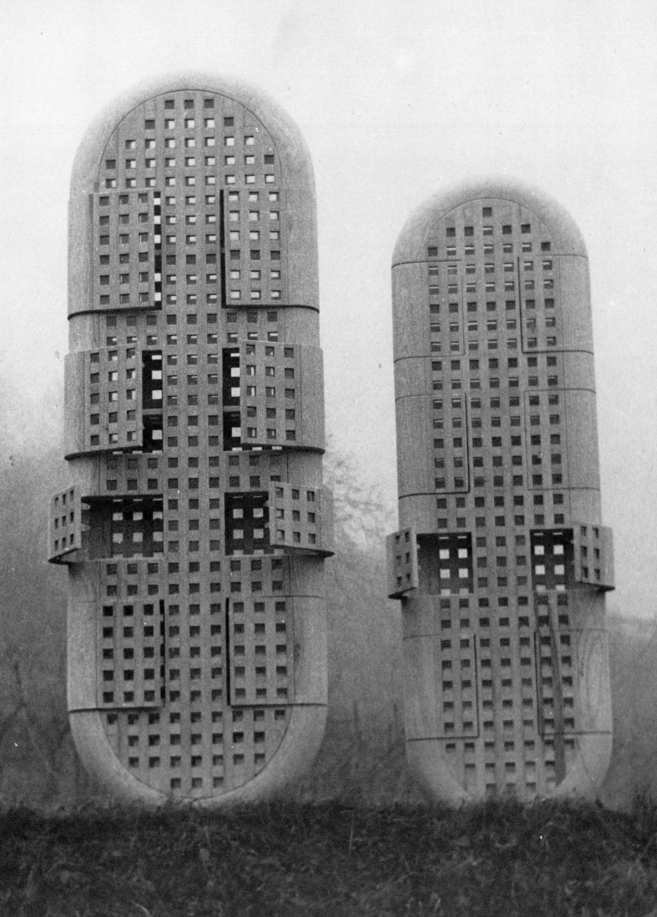

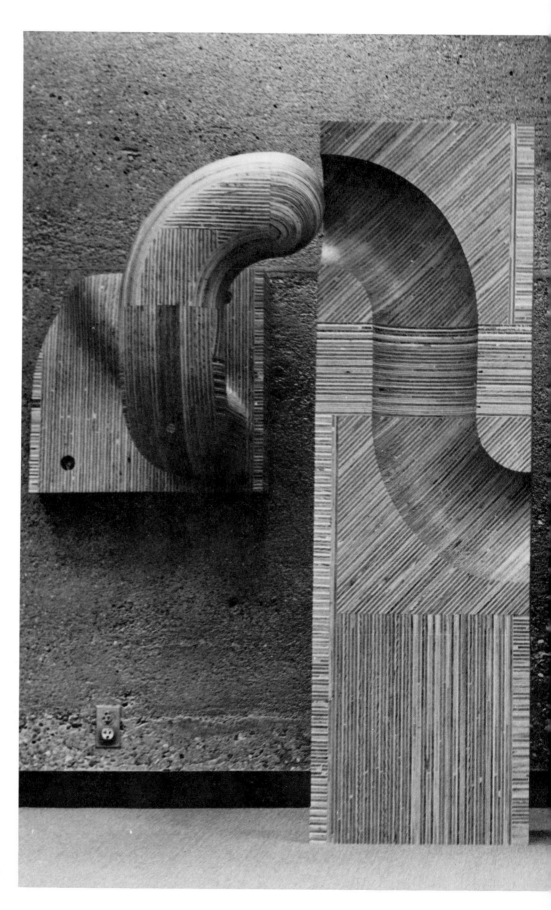

Alan Friedman, *Positive-Negative No. 2,*
1973. Laminated plywood, 6½' × 4' ×
20' (2 × 1.2 × 6 m). Cunningham Memo-
rial Library Commission.

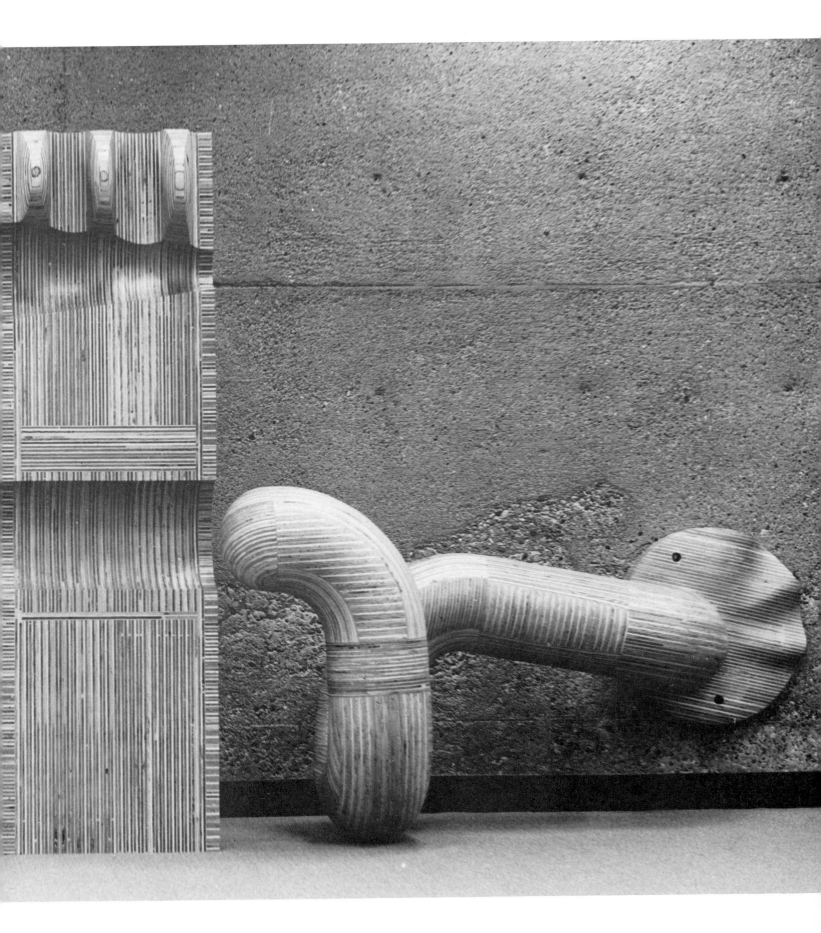

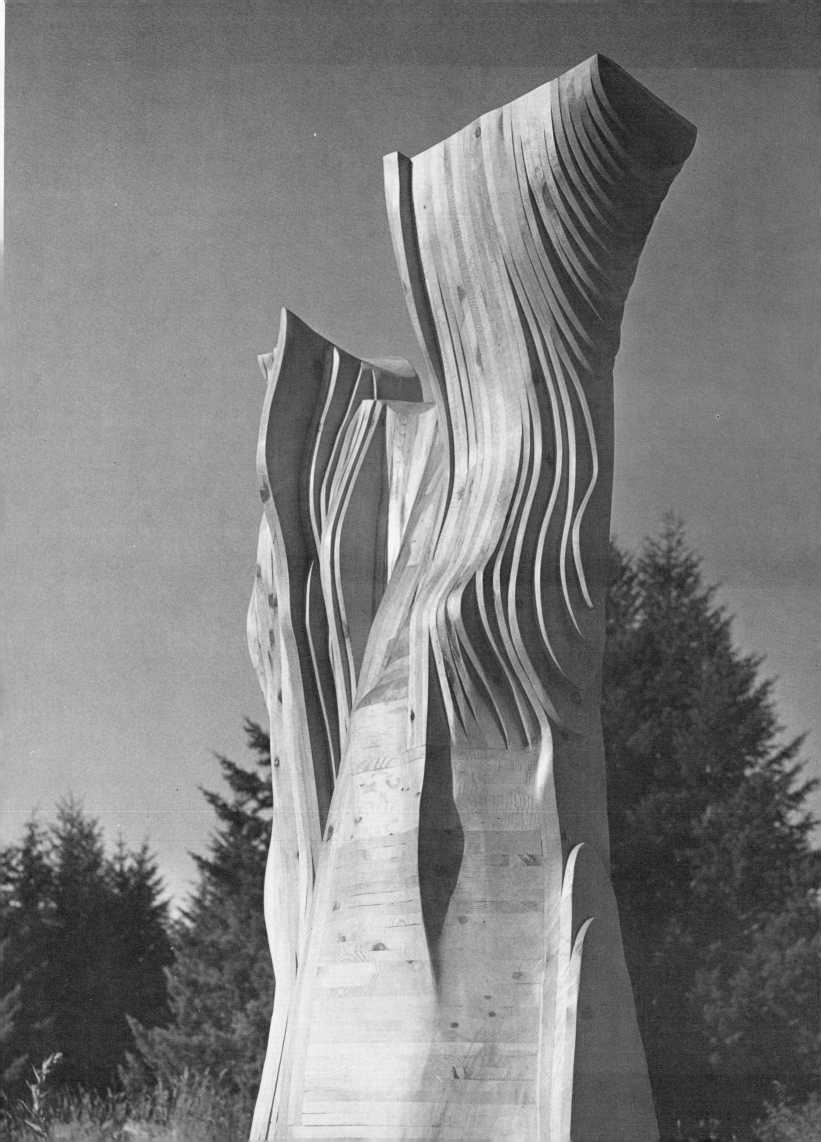

◄Jan Zach, *Drapery of Memory*, 1975. Laminated pinewood, 72″ × 63″ × 33″ (183 × 160 × 84 cm). University of Oregon, Eugene. Photo: Oscar Palmquist.

►Robert Bourden, *Table Land after the Rain*. Laminated wood. Courtesy of the artist.

▼Wendell Castle, *Sculptural Furniture*. Laminated wood. Courtesy of the artist.

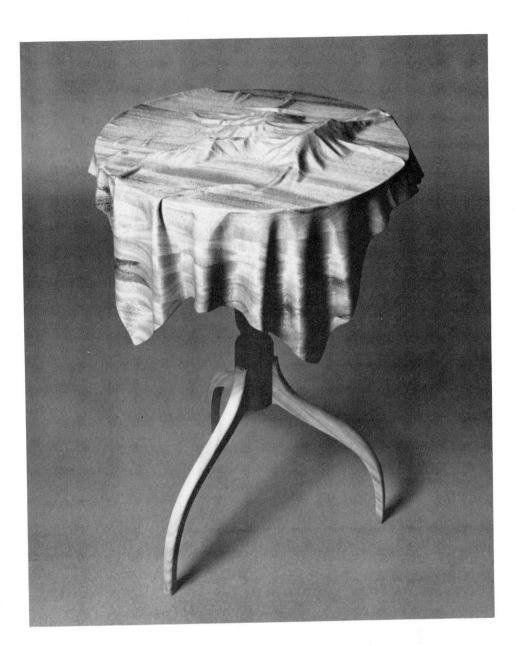

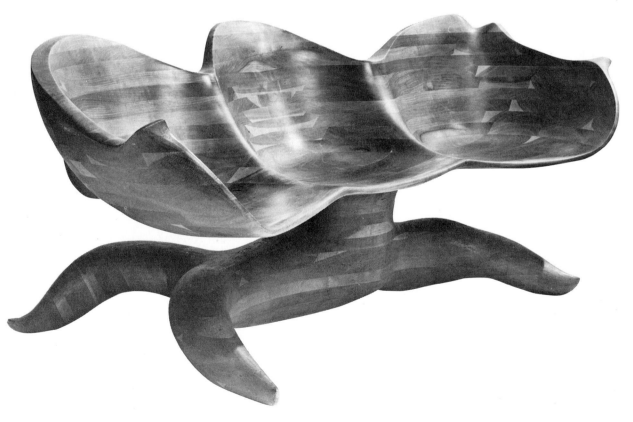

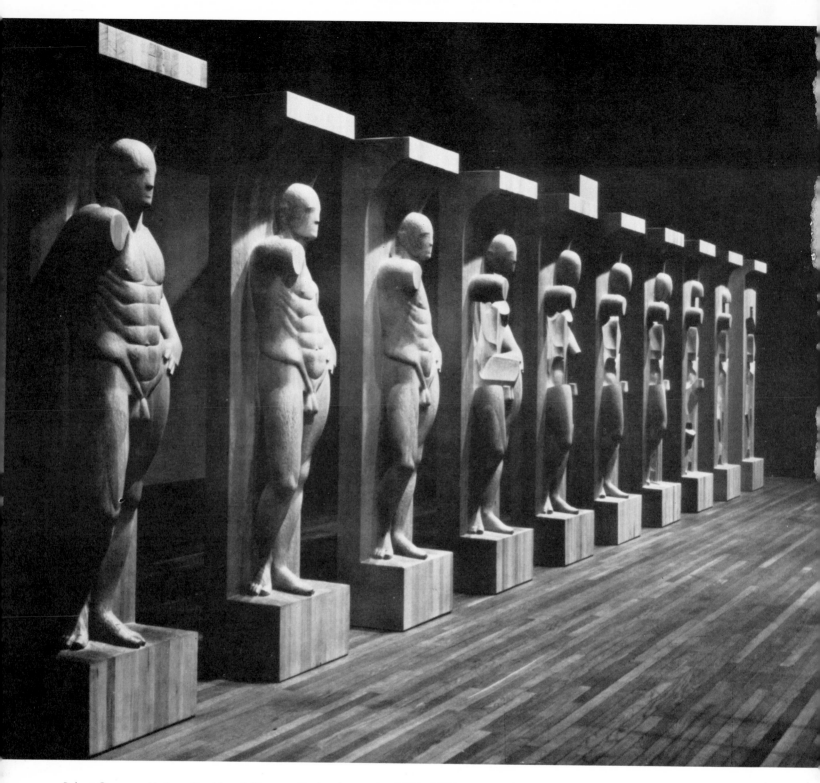

Robert Cremean, *Vatican Corridor, A Non-specific Autobiography*, 1974–1976. Laminated sugar pine, 20 carved figures, each 8′ × 16″ (2.4 m × 40.6 cm) deep. The figures are placed in two rows, 10′ (3 m) apart.

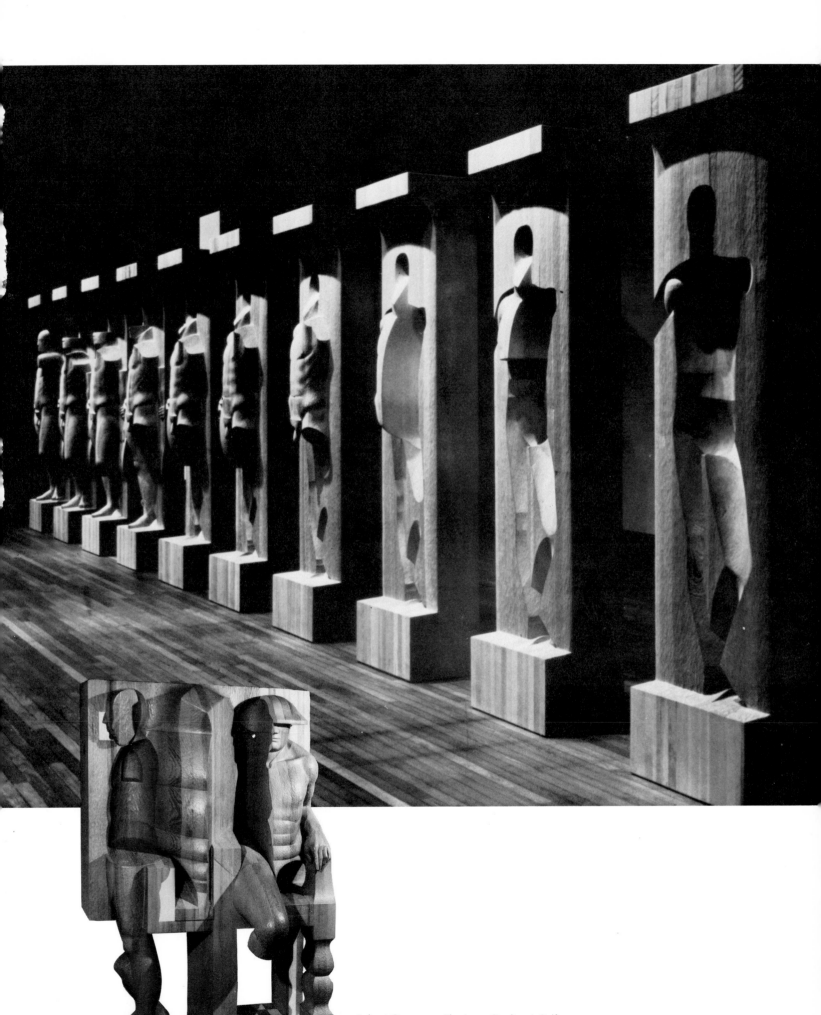

Robert Cremean, *The Inner Studio: A Self-portrait*, 1973. Laminated wood, 74″ × 48″ × 28″ (188 × 122 × 71 cm). Courtesy Esther Robles Gallery, Los Angeles.

◀H.C. Westerman, *Antimobile*, 1966. Laminated plywood, 67¼″ × 35½″ × 27½″ (171 × 89.5 × 70 cm). Collection Whitney Museum of Art, New York, Gift of the Howard and Jean Lipman Foundation, Inc. Photo: Geoffrey Clements.

▶Fumio Yoshimura, *Sewing Machine*, 1972. Wood, 31″ × 37″ (79 × 94 cm). Courtesy Nancy Hoffman Gallery, New York. Private Collection. Photo: Chie Nishio.

▼H.C. Westerman, *Phantom in a Wooden Garden*, 1970. Douglas fir, pine, redwood, and vermilion wood, 28″ × 36½″ × 18¾″ (71 × 93 × 48 cm). Collection Des Moines Art Center, Coffin Fine Arts Trust Fund.

▶Carroll Barnes, *Abacus II*, 1976. White cedar with acrylic inlays, 24″ × 45″ (61 × 114.3 cm). These three photographs show some of the endless possible design patterns of this bas relief. The components of this work were not permanently bonded together, but were designed to slide freely.

▼John Kapel, *Pressed Wood Sculpture*. Bleached particleboard. 52″ × 10″ (132 × 25 cm). Private Collection.

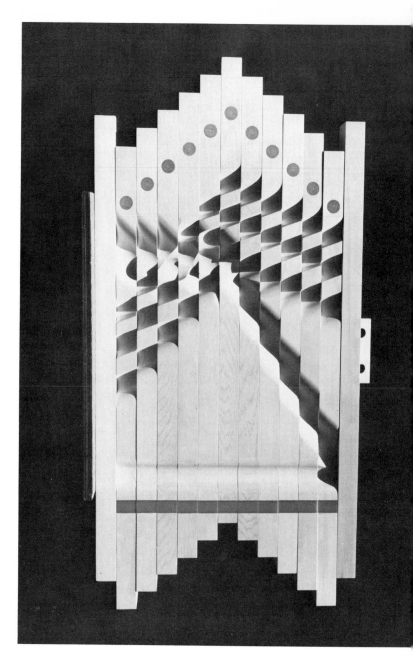

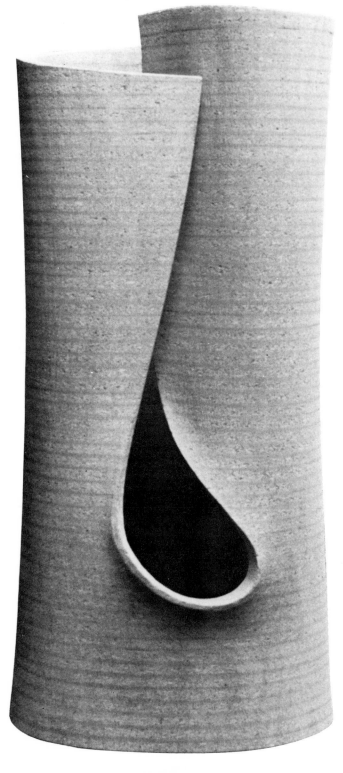

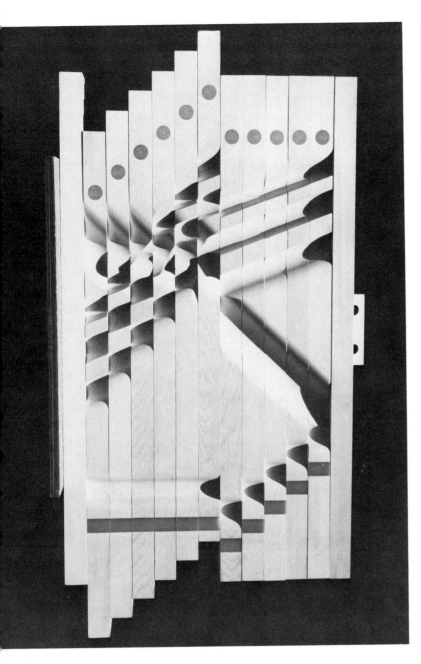

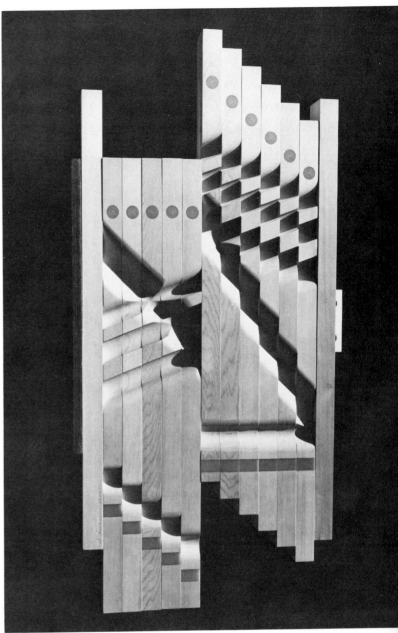

HAYDN DAVIES

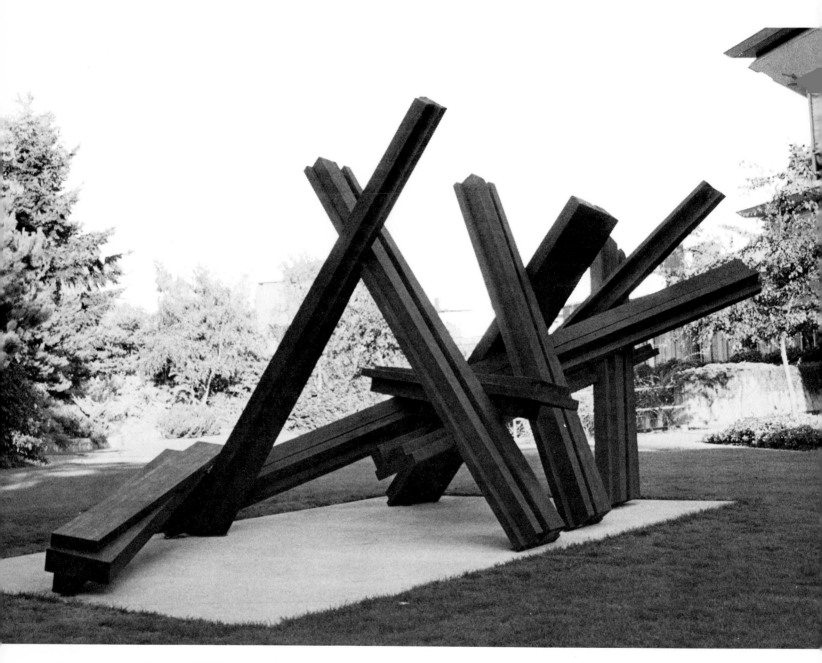

Symposium Piece (For Eva), 1977. Laminated red cedar,
scorched with a propane torch and oiled,
20′ × 12′ × 12′ (6 × 3.6 × 3.6 m).
Built during the 1977 Symposium,
Wood Sculpture of the Americas.
City Hall, West Vancouver, Canada.

> "Art has too often existed isolated like a tender plant, protected by aesthetics. Why not get it out in the open, away from artificial situations, where it has to be built from the ground up, so that it really becomes a living entity, part of the environment?"
>
> Ralph T. Coe

Although the psychological effects of our architectural environments are hard to assess, there's no question that the quality of the "spaces" around us strongly influences our behavior and emotional well-being. Just as landscaping serves to unite architecture with earth, architectural art unites architecture with *people*, serving as a "humanizing" link in its psychological function.

Architectural structures, both buildings and art forms, are four-dimensional in that they require *time* for their total perception. They are perceived in progressive stages as the spectator walks around and sometimes (as with Haydn's piece) *through* its spaces. Thus the sculptor, like the architect, writer, musician, or choreographer, builds a design structure that unfolds in time-space. In this way, architectural art can be thought of as being kinetic. Although nothing on the work itself may move, it offers constantly changing compositions and new juxtapositions of forms and spaces through spectator movement.

HAYDN DAVIES

Haydn Davies has his studio in Toronto, Ontario. Treks to Stonehenge, as well as his trips to the Orient, intensified his interest in architectural art and design. The magnificent edifices and gardens of Japan and the oriental sensibility of modulating exterior space has had a significant effect in his development as an architectural sculptor.

In creating *Homage*, Davies linked the spirit of Stonehenge with the present-day urban environment. His architectural sculpture was made of laminated red cedar, and measures 31' × 11' × 12' (9.3 × 3.3 × 3.6 m). It stands on a causeway by a reflecting pool on the campus of Lambton College of Arts and Technology at Sarnia, Ontario. In this chapter, Davies describes the evolution of *Homage* from its initial concept on the drawing board through the progressive stages of fabrication, assembly, and installation.

VISUALIZING THE IDEA

"In visiting the site that was allocated for my commissioned work, the concept for its ultimate form didn't grow so much from "sudden inspiration" (although there was a point at which I knew the idea was "right"), but more from the dictates of the site itself.

"I believe that establishment of a "working relationship" with the environmental setting is the first priority of the architectural artist. For me, it's a very personal requirement that I become totally familiar with every aspect of the site on which my sculpture will be located; not only in terms of the architecture of existing buildings, but I must also be aware of textures, possible reflective surfaces, and differences in backgrounds from one viewpoint of the proposed sculpture to another.

"In surveying the space allocated for this particular sculpture, it occurred to me that the appropriate form of the sculpture should be one that would complement the expanse of glass and concrete of the buildings that surrounded the area. This thought led me to the concept of using wood as the structural material, since wood has a softer character and would act as a successful "buffer."

"I also decided to use an "open" structure whereby the spectator could walk through the interior spaces of the sculpture. The sculpture was to be placed within a reflecting pool, which offered a mirror image of the structure, an additional bonus.

PRELIMINARY WORK

"I began to visualize the concept by making a series of sketches and drawings, trying many different approaches. Sketches were done principally to capture the basic "feeling" of the architectural idea. As the drawings progressed, the concept for *Homage* grew clearer and I decided to develop it further in the form of a three-dimensional model.

The Scale Model. "I used balsa wood to make the scale model, using a scale of ½" to 1' (13 mm to 30 cm). I made the scale model exactly as the larger proposed sculpture was to be done, carefully constructing volumetric forms from sheets of ⅛" (3 mm) balsa wood.

Working Model. "After the scale model was completed, additional detailed working drawings were made for the fabricators, showing precise details and final dimensions.

Selection of Lumber. "Kiln-dried red cedar was selected for fabricating *Homage*. I was particularly fortunate in obtaining a portion of a lumber shipment that was originally intended for swimming pool decking that I got at a fair price. This timber proved to be the ideal choice, as the dressed-down 4" × 5" (10 × 12.5 cm) planks were perfectly suited for the lamination demands of the sculpture.

CONTRACTING A FABRICATOR

"Because the scale of the project was larger than I could handle in my own studio, I had to contract a special fabricator to help in the production of the final work. The selection of a suitable firm was fairly easy, as only two of the many firms that I contacted were even willing to bid on the job. I was particularly pleased to use the services of Woodway Structural Components Ltd. of Burlington, Ontario, who have a special interest in architectural sculpture and are specialists in laminated wood structures. They not only had the craftsmen and the equipment to do the job, but took an uncommon interest in the project, demonstrating high professional skills and patient cooperation, traits that aided immensely in the establishment of a "hassle-free" collaboration.

LAMINATING THE BOARDS

"The first stage of work at the factory involved the lamination of the cedar boards to make larger components that would subsequently be used to make the various elements of the sculpture. The lamination procedure was initiated by passing the lumber through steel rollers that simultaneously coated

the two sides of the wood with a thin layer of resorcinol-phenol adhesive. The boards were then clamped to insure a perfect interface between the laminated members.

CURING AND DRESSING THE LUMBER
"Because resorcinol-phenol adhesive requires heat to cure, a plywood enclosure was assembled over the laminated lumber. Flexible ducts from a furnace were connected to special openings in the enclosure and provided warm air to accelerate the cure. (A temperature of 70° F for eight hours is considered adequate to cure the adhesive.) Then the laminated boards were cleaned of imperfections and excessive glue "squeeze-out" was removed by passing them through the planer.

THE COMPONENTS OF *HOMAGE*
"*Homage* is composed of two basic sculptural units. Each unit is comprised of many contributing elements which form its overall compositions; these include horizontal wing sections, supporting columns, and arches.

The Wings. "The curvilinear elements of the wing sections were cut on the band saw. Each wing section had three curved beams on the top and three underneath. The top beams were connected to the wing sections with glued dowels, while the lower ones were connected with steel tie rods.

"The wing assemblies were supported by the columns, both sections united by careful morticing and fitting. Mortices were marked on the columns with the aid of plywood templates. Portions of the columns were routed out, allowing the wing assemblies to fit snugly in place. These were further secured with metal tie-rods.

The Columns. "The columns of *Homage* are hollow, with walls measuring 4½″ (11.5 cm) thick. The process of beveling and joining the lumber to make the columns was somewhat complicated because each "wall" of the columns was attached to its adjoining section at angles other than 90°. Because of the complex angles, each component had to be glued and clamped individually. After the columns were assembled, excess wood was trimmed off with a portable circular saw and then sanded smooth with a power sander.

The Arches. "There are three arches in the sculpture. These were constructed exactly the same way as the columns, but were joined together with tie-rods.

FINISHING
"As the individual components of the sculpture were completed, they were sanded and oiled. A commercial bleaching oil was used as a finish, serving to protect the wood and dramatize its natural color. I added some carbon black and burnt umber to the preparation to provide a richer tone to the finish.

"Holes and slots were drilled and routed to the underside of the columns to accommodate *T*-shaped steel plates which were to be used to anchor the wood sculpture to the concrete base at the site of installation.

TRANSPORTATION AND INSTALLATION
"The distance from the factory to the site exceeded 200 miles. It had been carefully checked prior to loading the work to insure that there would be proper clearance of bridges, wires, and other possible obstructions. Two flat-bed trucks were hired to transport the sculpture.

"At the site, a crane was hired to lift the two sections from the trucks and place them on their allocated positions on the concrete base. The sculpture was then secured to the concrete base with steel bolts. The lighting had been previously designed and installed in the concrete base."

ART IN ARCHITECTURE

Making a Model. A small model of *Homage* is made of ⅛″ (3 mm) balsa wood to a scale of ½″ to 1′ (13 mm to 30 cm). It is painted with gesso for additional strength.

Preparing the Working Drawings. Haydn Davies (left) discusses details of *Homage* with an architectural draftsman in the preparation of working drawings for the architectural sculpture.

Lamination, Stage One. Dressed red cedar boards are passed through rollers that coat the two sides of the wood with resorcinol-phenol adhesive.

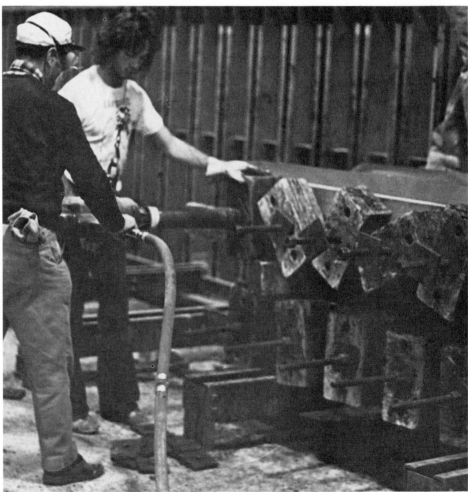

Lamination, Stage Two. The adhesive-coated lumber is then clamped together. Pressure is applied with a pneumatic impact wrench to 90 psi.

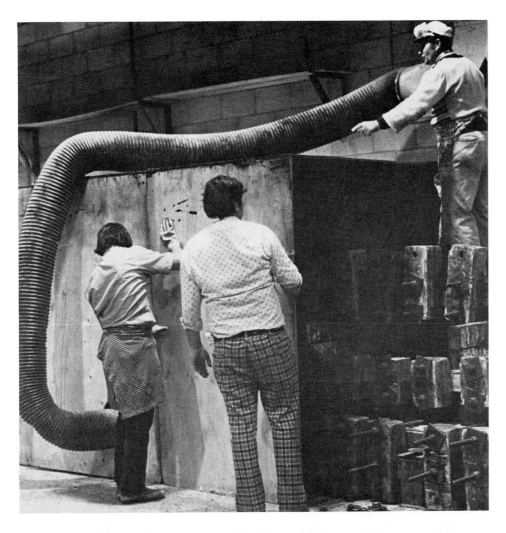

Lamination, Stage Three. A plywood "tent" is assembled around the clamped lumber to create a warmer atmosphere in order to cure the adhesive. Flexible heat ducts are inserted into openings to allow heat to enter the enclosure. (A temperature of 70° F, maintained for eight hours is sufficient to cure the adhesive.)

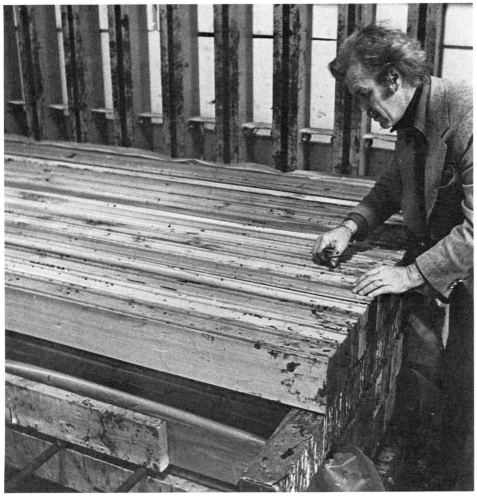

Inspection. Here Davies is shown examining the laminated lumber after the removal of the clamps.

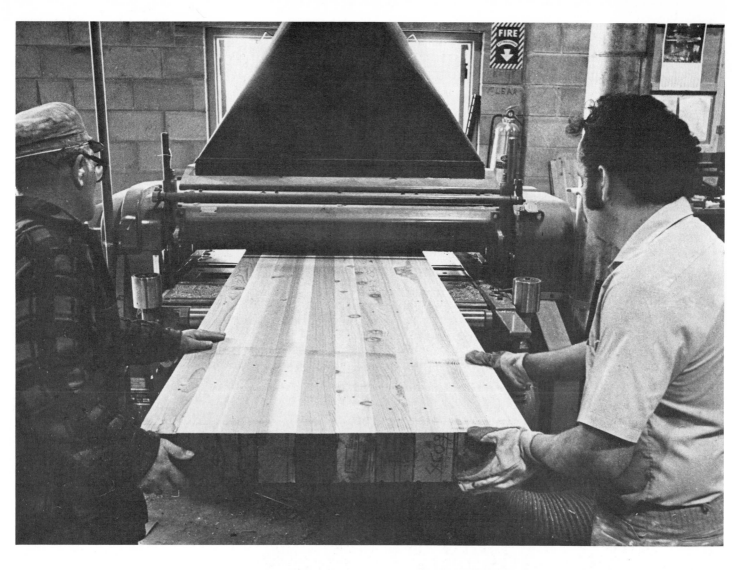

▲Dressing the Laminated Sheets.
Wood surfaces are cleaned of imperfections and surplus adhesive by passing the laminated wood through the planer.

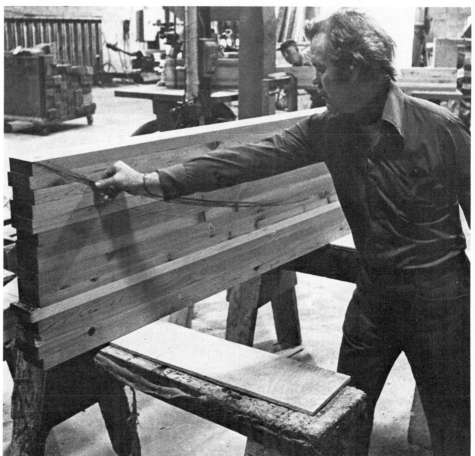

▶The Wing Sections. Here Davies draws the curve for a wing element.

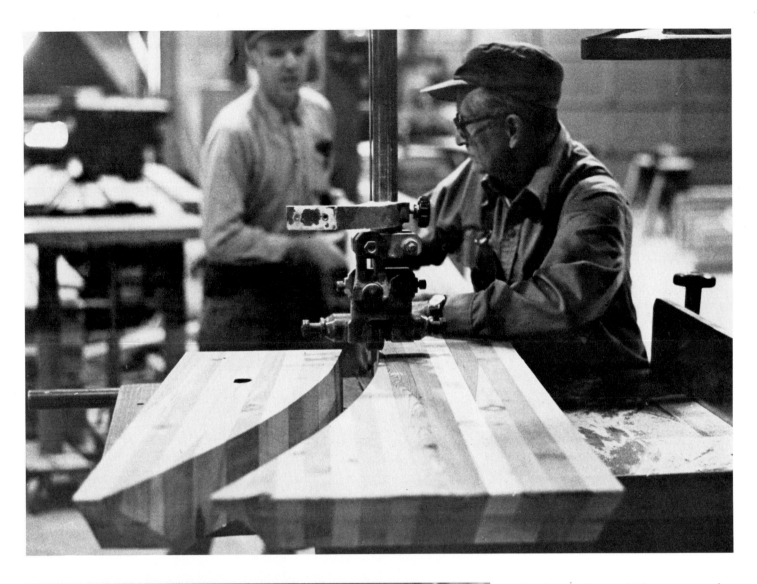

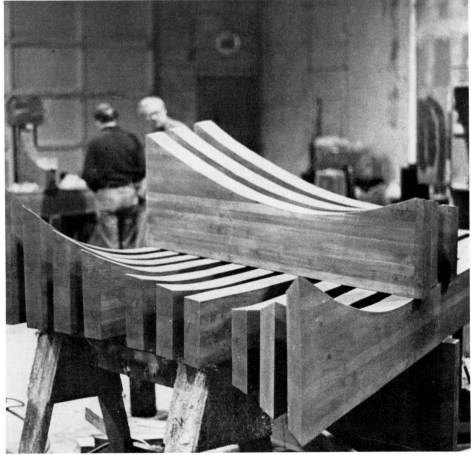

▲Cutting a Curved Element on the Band Saw. This operation is repeated many times to create the numerous curved elements that constituted the design of the wing sections.

◄The Wing Sections. The cut-out curved elements for the wing sections are shown here.

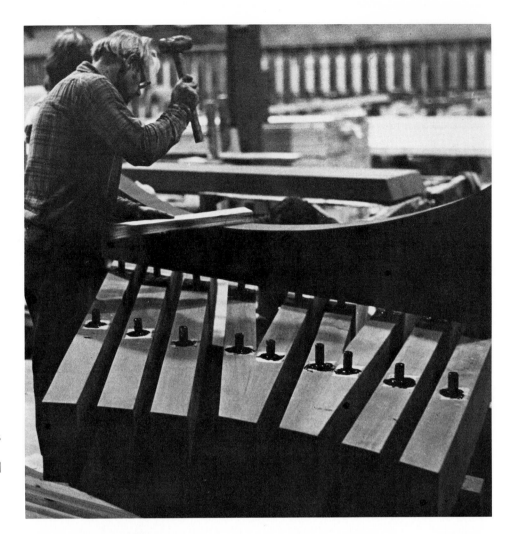

Assembly of the Wing Sections.
The smallest of the two wing sections is shown being assembled. The curved cross members on the top are attached with glued dowels, while the lower components are attached with steel tie-rods.

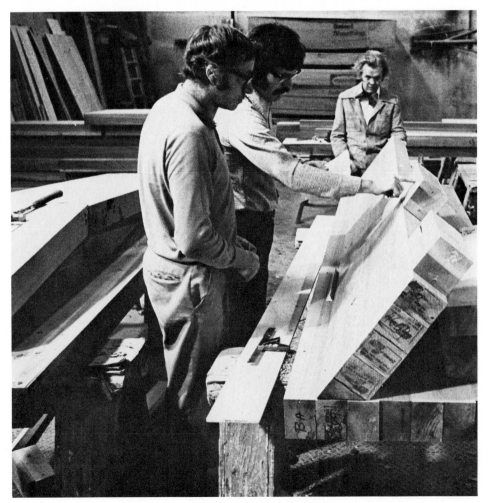

Fabricating the Support Columns.
The beveled laminates are positioned prior to gluing and clamping. The columns are hollow, with walls 4½″ (11 cm) thick.

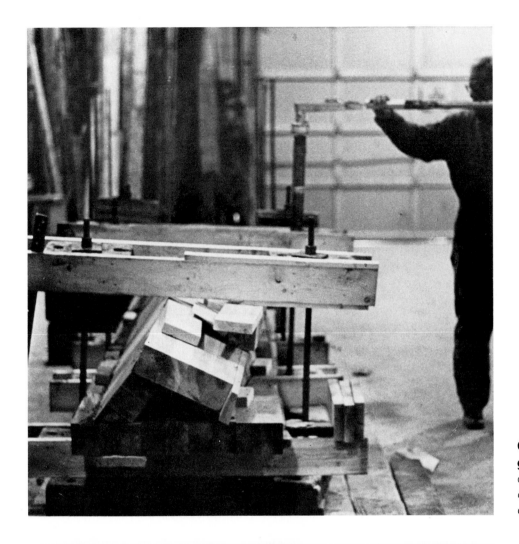

Clamping the Column Walls Together. Because of the oblique angles of the design of the columns, each component member is glued and clamped sequentially.

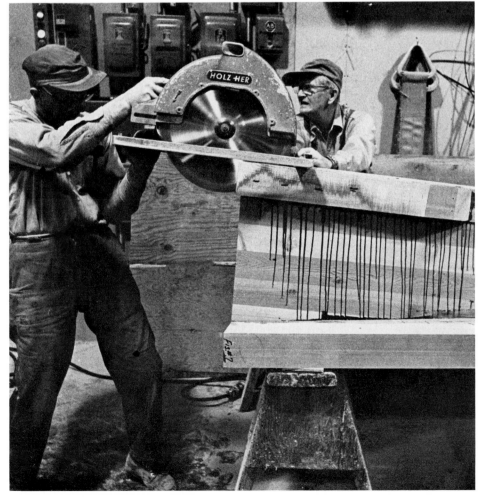

Trimming off Excess Wood. Wood is trimmed from the assembled columns with a portable circular saw.

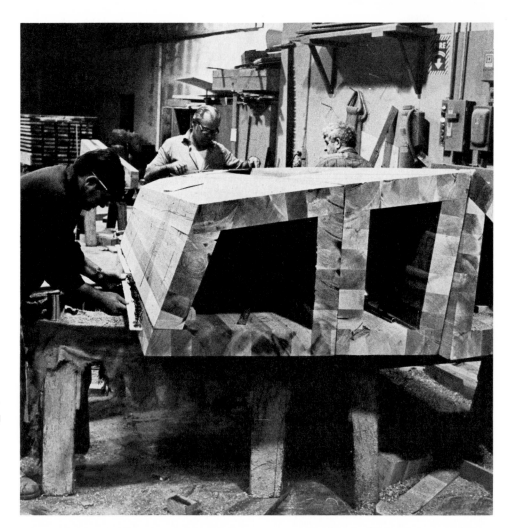

Fabricating the Arches. This photograph shows the method of fabricating the arches for *Homage*. The arches are constructed exactly like the columns, except for several of the completed units, which are subsequently joined with steel tie-rods to make larger structures.

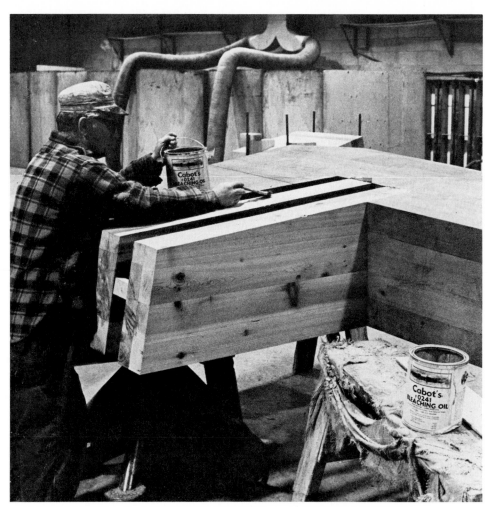

Finishing the Wood. As each component for *Homage* is completed, it's given a finishing coat of bleaching oil. (A small amount of carbon black and burnt umber is added to the bleaching oil.)

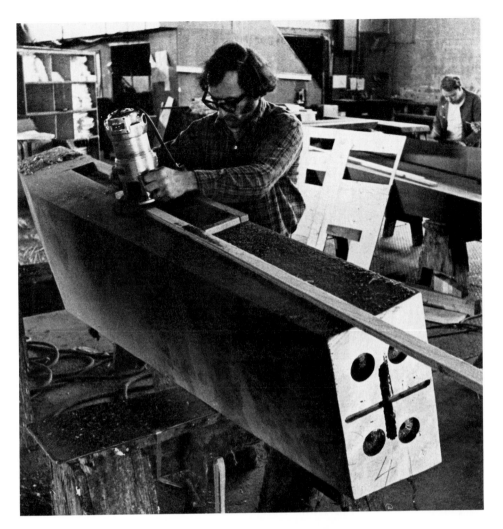

Morticing. Here a worker cuts mortice into one of the support columns with a router. The wing sections of the sculpture are fitted into these mortices. Precise positioning of the cuts is aided by using plywood templates (shown in the background). The countersunk holes and slots at the foot of each column are made to anchor the completed sculpture to its concrete base.

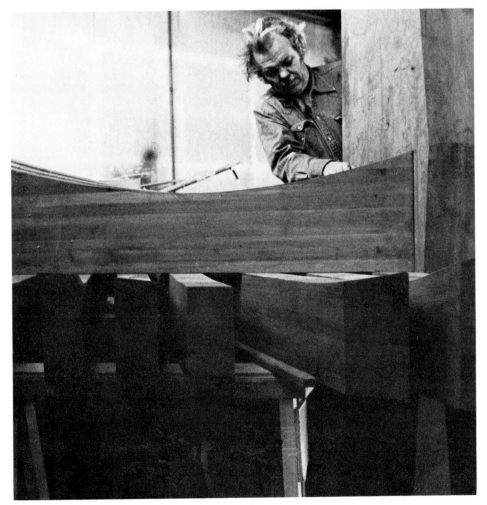

Assembly. The wing sections are carefully fitted into the morticed columns. These are further secured by using galvanized steel tie-rods which ran through the length of the horizontal units.

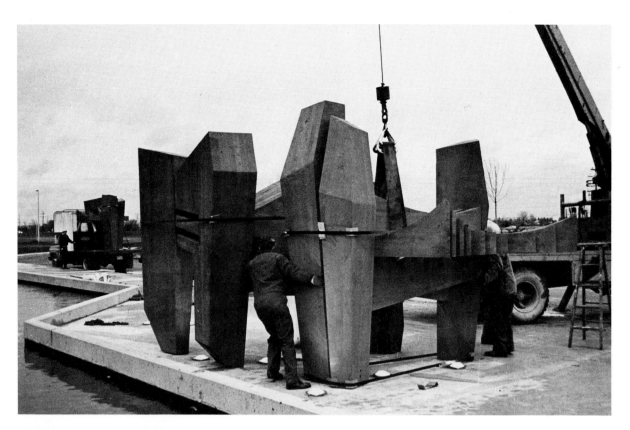

Transportation, Installation, and Final Touch-up. The completed units are lifted by crane to a flat-bed truck and transported to the site, some 200 miles away. The two sculptural units are carefully lowered in place. The sculpture is anchored with steel bolts which pass through steel *T* plates at the base of the sculpture. Floodlights are previously inset into the concrete base. Some local areas require sanding and patching. Additional bleaching oil is applied to areas requiring it.

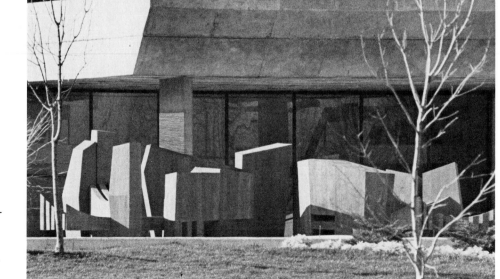

Homage, 1974. Laminated western red cedar, 31′ × 11′ × 12′ (9.3 × 3.3 × 3.6m). Collection Lambton College of Arts and Technology, Sarnia, Ontario. The sculpture was finished just one day prior to the official dedication.

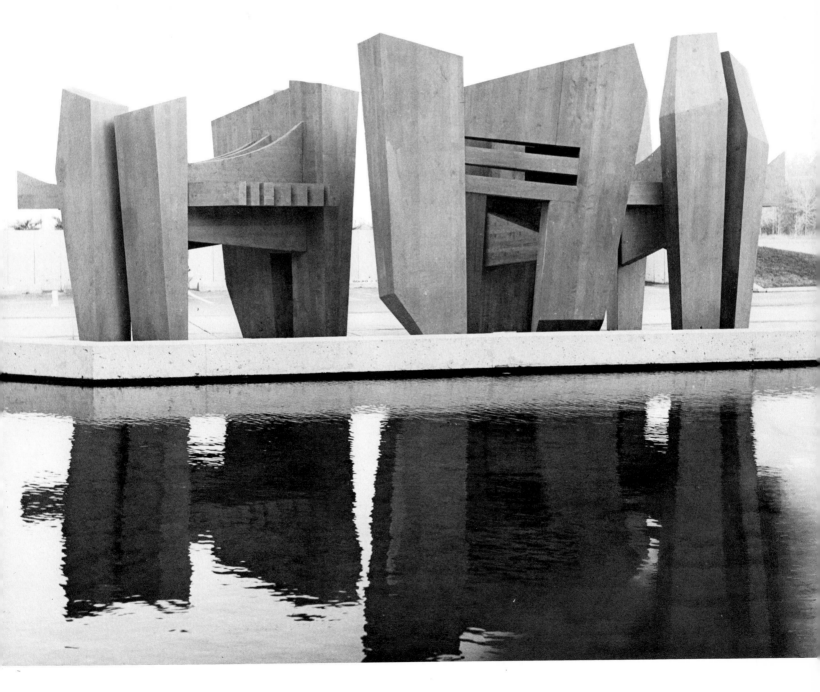

MICHAEL COOPER

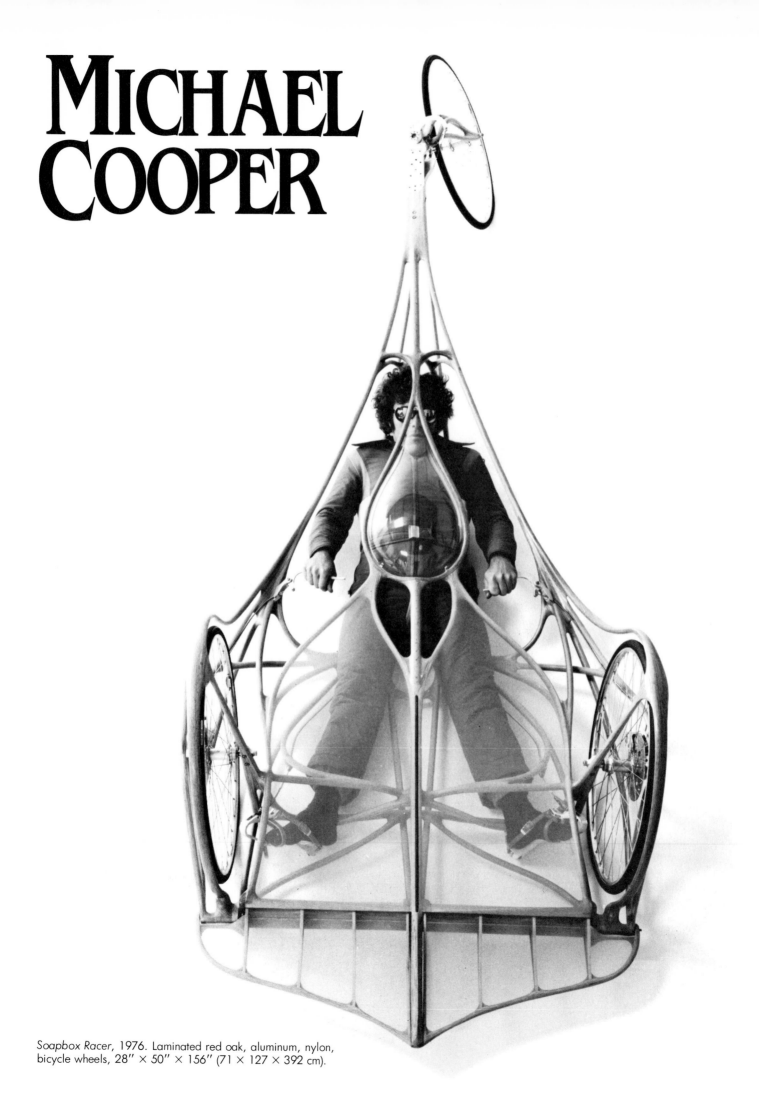

Soapbox Racer, 1976. Laminated red oak, aluminum, nylon, bicycle wheels, 28″ × 50″ × 156″ (71 × 127 × 392 cm).

Michael Cooper of San Jose, California, is a wood wizard who takes commonplace objects and transforms them into remarkable fantasy structures. At first glance, *Turbo*, the work demonstrated in this chapter, appears to be a competently executed three-dimensional sculpture of a typical motorcycle. It's the second glance, however, that "double-take," that suddenly reveals that this creation is *not* your typical everyday chopper.

Upon the close inspection we perceive this actual-size motorcycle to be constructed of over twenty-two different species of hardwoods, with over 5000 parts, each meticulously shaped and integrated. Also, mysterious transfigurations from within the motorcycle's mechanical components are suddenly perceived; guns for example, substitute for engines. What events led Cooper to create work like this?

CHILDHOOD EXPERIENCES

Michael Cooper gained rudimentary shop skills at an early age. In those years, he made more than his share of coaster cars, downhill racers, modified hot rods, sail boats, and a host of childhood inventions. Now, he realizes how positive those early childhood experiences had been and that they eventually led him back to the realm of the three-dimensional craftsman after being trained as a commercial artist.

He recalls, "I always enjoyed drawing and putting things together. My grandfather's cabinet shop was a block away from my house and I used to go over there quite often as a youngster. I learned a lot from my grandfather about wood just by watching and getting in the way a lot. Finally, as a teenager, he let me help with some of the cabinet work.

"There's a special joy that one experiences when ideas begin to develop and dovetail with the constructed objects. For me, the *process* is the major key. First come the thoughts, then maybe some sketches, lots more thinking, and finally a start, usually at an important area that is fairly clear in my mind. This then becomes a *reality* that serves to develop and clear up the foggy areas of the "non-piece." Finally, I feel that the process becomes a lifestyle. It becomes part of you and begins to stretch and push your own personal boundaries as it takes its own shape."

THE CREATION OF *TURBO*

"*Turbo* was a complicated piece that required eight months to produce," Cooper recalls. "I worked an average of 11 to 18 hours a day, six and a half days a week. Power tools, milling machines, and lots of handsanding went into the production of this piece. The basic procedure in creating this work involved the following steps:

PRELIMINARY SKETCHES

"After getting the idea of "substituting guns for an engine" on a chopperlike bike with a *V*-shaped design, I started to make drawings. Sketches were made on vellum graph paper to the scale of 1″ to 1′ (2.5 to 30 cm). These were made principally to establish overall proportions and placement of the major parts. To get the correct measurements, I had to measure parts on a variety of motorcycle hardware, such as wheels, tires, and frames. When this was established, a full-size working drawing, much like a crude blueprint, was started. It was especially useful for making the tires and wheels.

SELECTING THE WOOD

"Wood was chosen for colors that related to those of an actual motorcycle: maple for the chromed steel; rosewood for cylinder chamber, tires, and rubber; mahogany and poplar strips for the tank and fenders; boxwood for the brass plating; maple for the frame; oak for the first exhaust stage; walnut for the second exhaust stage and intake from the carburetor; vermilion for the tail light and rubber; wenge for black oxidized steel; purple heart for the cylinder chamber turbocharger; ash for the seat; aircraft plywood and dowels for the no. 60 chain; and so forth. The base of the sculpture was carefully crafted of maple, cherry, and oak. In all, over 22 hardwood varieties were used.

MAKING THE FRAME

"The frame of the motorcycle was made of mahogany strips that were laminated and clamped to rigid plywood jigs. A plastic resin glue was used to glue the wood together.

The forks and handlebars of the motorcycle were made of maple strips that were laminated and clamped in plywood jigs. Resorcinol glue was used to laminate the handlebar.

MAKING THE TIRES

"The tire was constructed of rosewood. The rear tire was made with 17 wedge-shaped pieces of rosewood, seven layers thick. Each layer was carefully fitted and glued together. Then the entire structure was milled flat on an electric rotary table, turning on a Millrite vertical milling machine.

"I then turned the "tire/wheel" on a very large metal lathe, renting work time from a friend's machine shop. (Just the rear tire turning alone took a day and a half of careful work.) I used a Rockwell 7″ (18 cm) body grinder to grind the contour of the wheel while it was on the lathe. This relieved the tendency of the end grain to chip.

"A special ball mill bit was used along with a jig to shape the zigzag threads on each tire. This procedure involved 2990 operations, taking about three days. Hand deburring took another 12 hours. Total time spent to make the rear wheel with spoke assembly and three-piece split hub, wood sprocket, and brake disc was approximately one month.

"All accurate drilling was done on the milling machine. I also used the machine to rough out special parts, such as the turbocharger, disc brakes, underside of the fenders, and gas tank.

FINISHES

"For the final finish of the completed wood surfaces, I used flattened clear automotive acrylic lacquer, DuraSeal, Watco oil, and Deft lacquer."

WOOD WIZARDRY

Constructing the Frame. Using the bentwood lamination technique, maple is cut into strips and then glued and clamped within a plywood jig. Plastic resin glue is used to make the lamination.

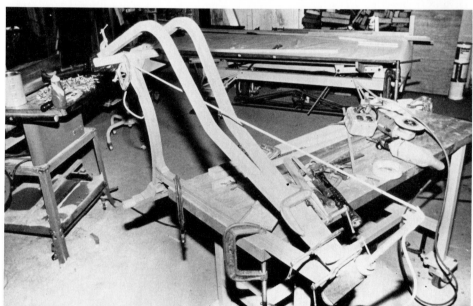

Basic Structure. The laminated forms are removed from the jig and assembled to create the basic structure of the motorcycle's frame.

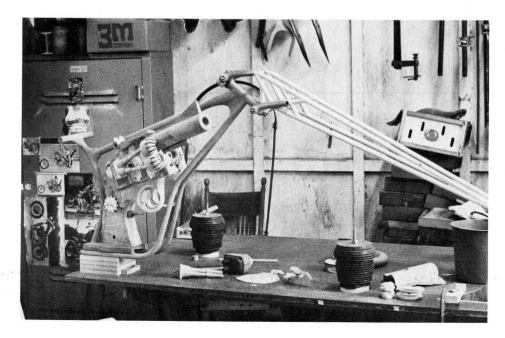

Shaping and Sanding. The frame is shaped and sanded smooth. A gun substitutes for an engine in Cooper's design. Most of the components of the "engine/gun" are constructed of curly and hard maple.

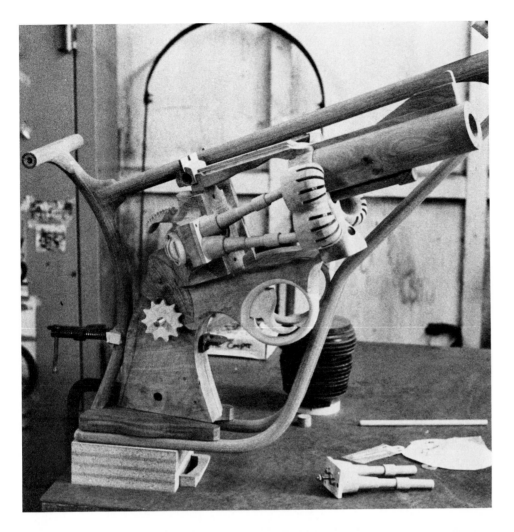

Detail of the "Engine/Gun." The engine/gun a half-and-half blend of a Smith and Wesson pistol with a Harley-Davidson engine. Most of the shaping of these parts is done on a small metal lathe or the vertical mill. Contour work is done with a band saw, a 12" (30 cm) disc sander, a Rockwell 7" (18 cm) and Bosh 4½" (11 cm) angle grinder, and a Rodac pneumatic die grinder, as well as through extensive handsanding and filing.

Rear Sprocket. The three-piece hub and brake disc is made of maple. These components are turned on a Rahn and Larmond 16" (41 cm) metal lathe. The chain is made of aircraft plywood and maple dowels. (Jigs are first made in aluminum to provide accurate tolerances for the final wood construction of most of these shapes.)

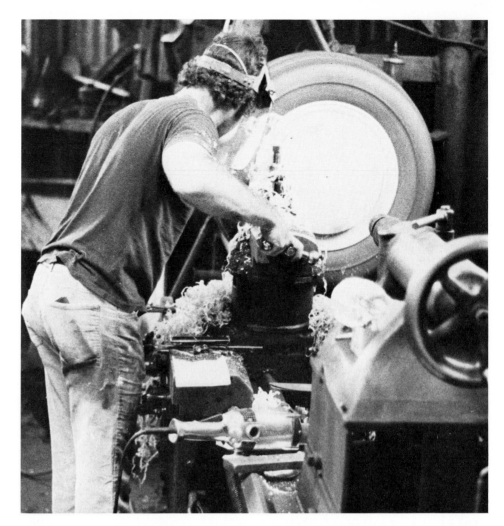

Tire Construction. The tires are made of rosewood. The rear tire consists of many pieces of wedge-shaped rosewood carefully fitted and glued together. They are then milled flat on an electric rotary table, which turns on a Millrite vertical milling machine. Here, Cooper is turning the tire on a large metal lathe.

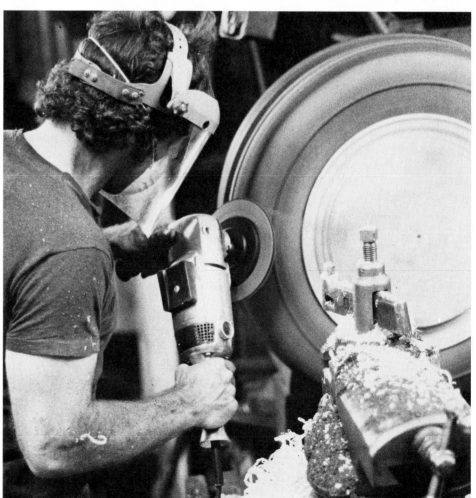

Grinding the Contour of the Tire. A 7" (18 cm) Rockwell body grinder is used. This procedure insures that the end grain is smoothly contoured without chipping.

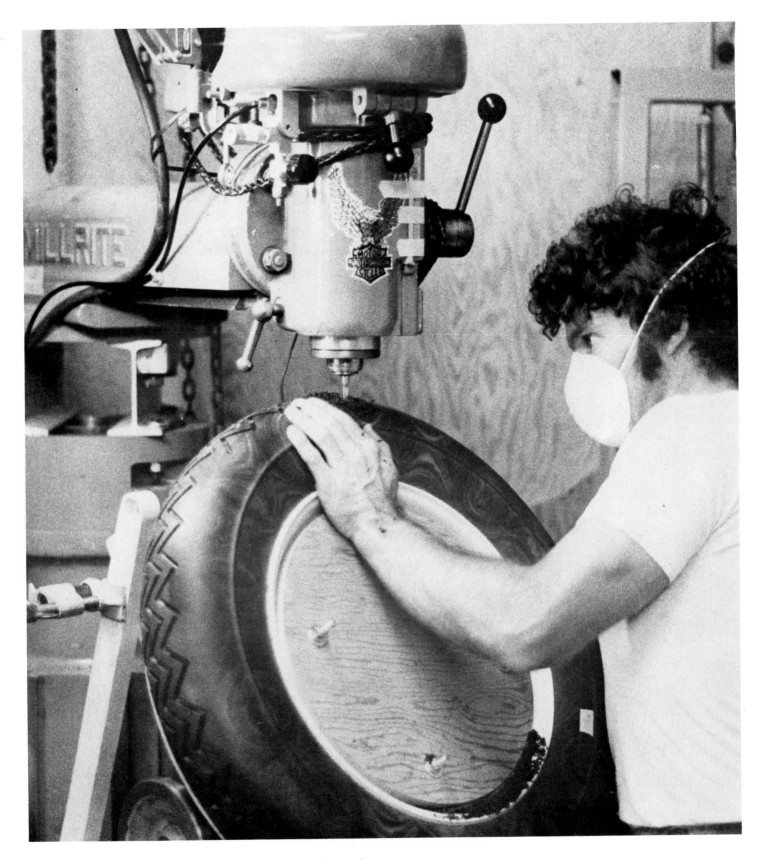

Milling the Tire Thread. The rosewood tire is clamped to a rotary table. This is bolted to a homemade, heavy angling table, which, in turn, is bolted to the mill bed with 10° stops on the X and Y axis. A ball mill bit was used to create the zigzag cuts, involving 2990 operations.

Making the Tank. Mahogany and poplar planks are alternately stacked and laminated to build up the required volume for the tank. The 7″ (18 cm) Rockwell body grinder is used to shape the basic outside form. The underside of the tank is roughed out on the milling machine.

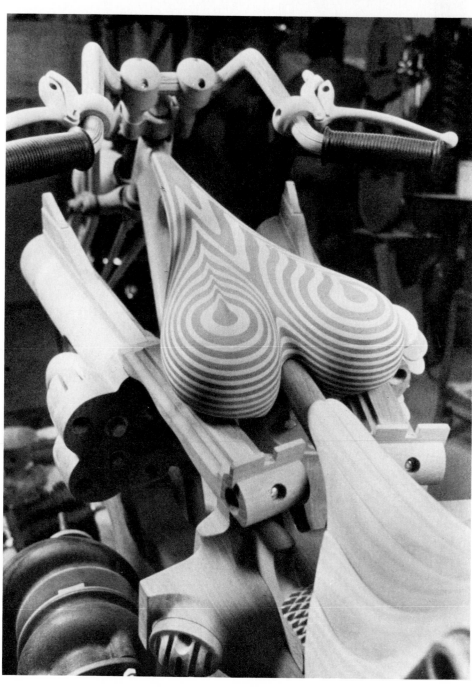

Tank in Place. Through progressive sanding and smoothing, the grain and color of the contrasting woods present dramatic accents.

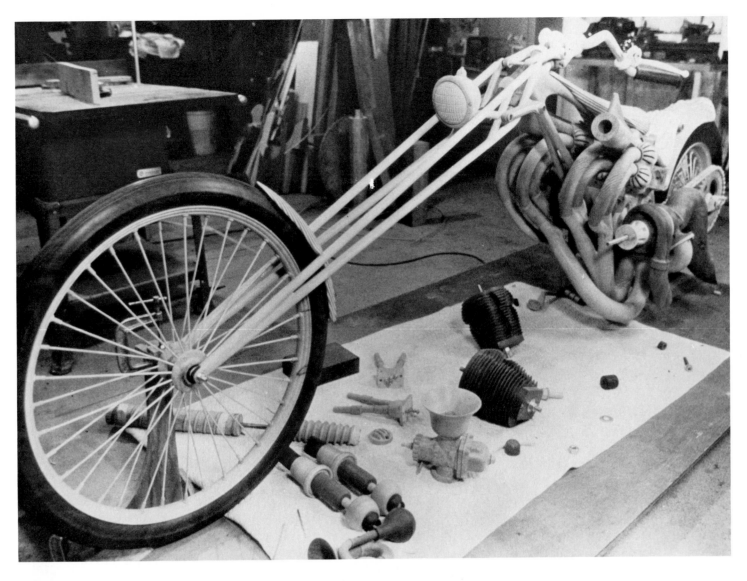

▲**Assembly.** Over 22 hardwood species are used in the construction of *Turbo*. The first exhaust stage is constructed of oak, and the second exhaust stage and intake from walnut. Much of the roughing out of the intricate parts is done on the milling machine.

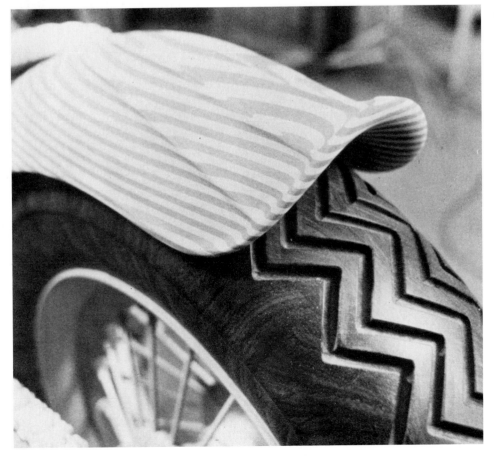

◄**Rear Tire and Fender Detail.** Mahogany and poplar strips are laminated and shaped to create the fender. The underside of the fender is milled to achieve the required contour. Rosewood and maple are used for tire construction, with maple dowels serving as spokes for the wheels.

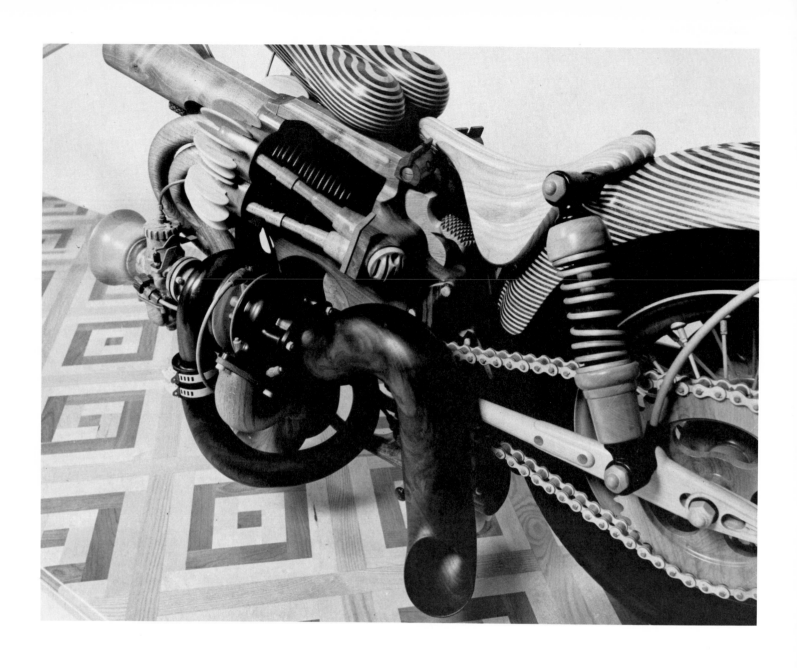

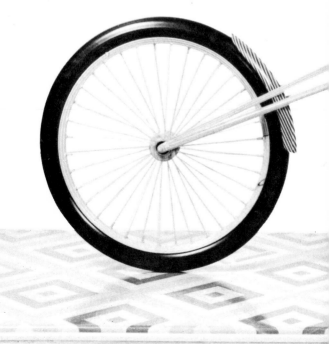

Turbo, 1977. Twenty-two mixed hardwoods, lifesize. Collection of the artist. A special base of maple, cherry, and oak was made for *Turbo*. Cooper's skillfully executed design is a tribute to his craftsmanship and use of hand and power tools.

◄Closeup of the Completed Work.
After countless hours of meticulous hand sanding, the components are finished with flattened automotive lacquer, Watco oil, Dura Seal, and Deft lacquer, depending on the surface requirements of each wood.

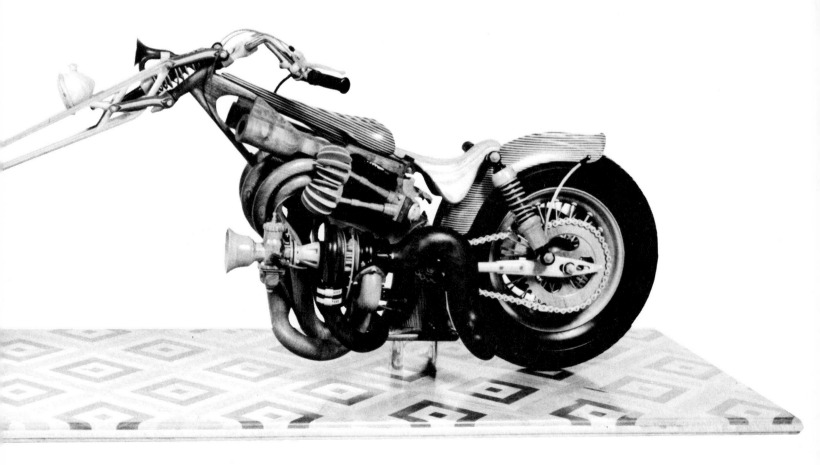

ACROSS BOUNDARIES

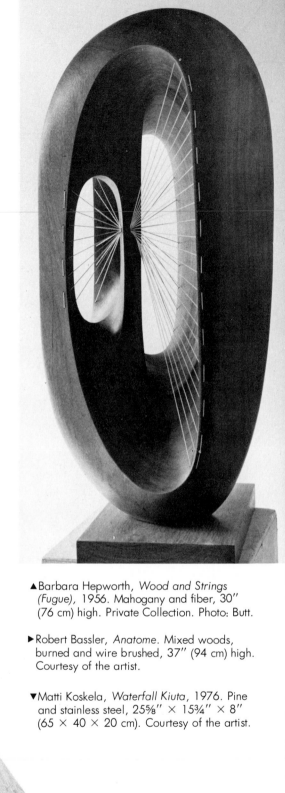

▲Barbara Hepworth, *Wood and Strings (Fugue)*, 1956. Mahogany and fiber, 30" (76 cm) high. Private Collection. Photo: Butt.

▶Robert Bassler, *Anatome*. Mixed woods, burned and wire brushed, 37" (94 cm) high. Courtesy of the artist.

▼Matti Koskela, *Waterfall Kiuta*, 1976. Pine and stainless steel, 25⅝" × 15¾" × 8" (65 × 40 × 20 cm). Courtesy of the artist.

Tommy Simpson, *Climbing the Success Ladder* or
Rung Out, 1976. Wood, wire, metal, and mixed
media; unpainted, 45″ × 24″ (114 × 61 cm).
Courtesy of the artist.

H.C. Westermann, *Little Egypt*, 1969. Fir and
pine, 68″ × 31″ × 31″ (172.7 × 78.7 × 78.7
cm). Courtesy Allan Frumkin Gallery, New York.
Photo: Eric Pollitzer.

Tom Fawkes, *Devices and Chart for the Isles of Langerhans*, 1977.
Wood and acrylic, 12″ × 16″ × 16″ (53 × 41 × 41 cm). Courtesy of the artist.

John Okulick, *Masque of Dryads*, 1973. Wood and twigs, 62″ × 29″
(158 × 74 cm). Courtesy Nancy Hoffman Gallery, New York. Private
Collection. Photo: Robert E. Mates and Paul Katz.

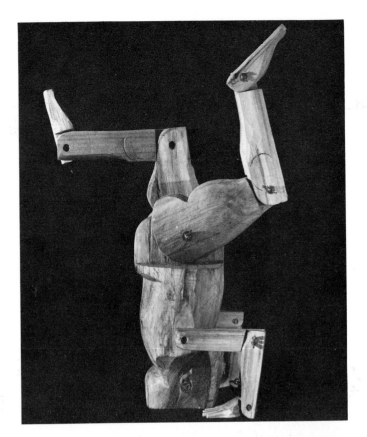

◄Red Grooms, *City of Chicago*, 1968. Plywood, beaver board, and acrylic, two tons. Courtesy The Art Institute of Chicago. Anonymous gift.

▼◄Bernard Langlais, *Football*. Wood and mixed media, 18' (5.4 m) high. Courtesy of the artist.

▶Louise Kruger, *Man Standing on Head*, 1977. Cedar with brass hardware, 27" (68.6 cm) high. Courtesy Landmark Gallery, New York. Photo: Bob Brooks.

▼Mario Ceroli, *The Brownstone*, 1966. Wood and mixed media. Courtesy Galeria Bonino, New York. Photo: Peter Moore.

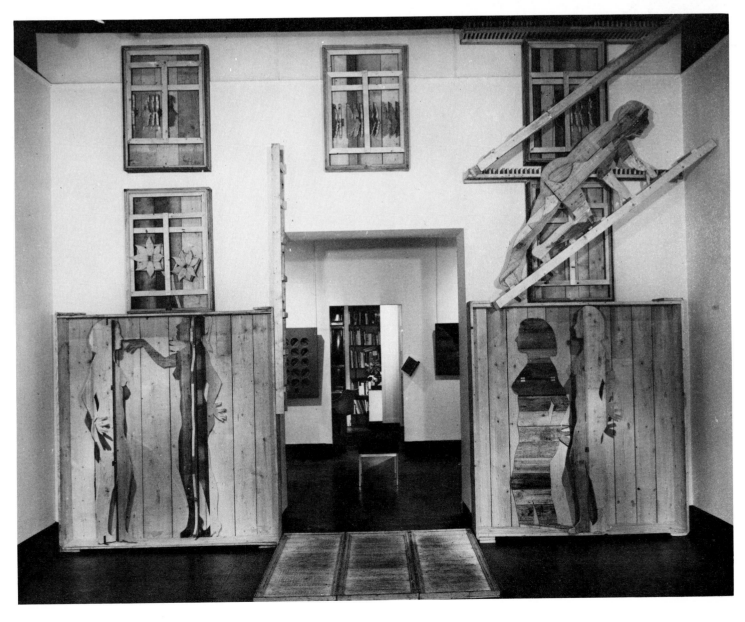

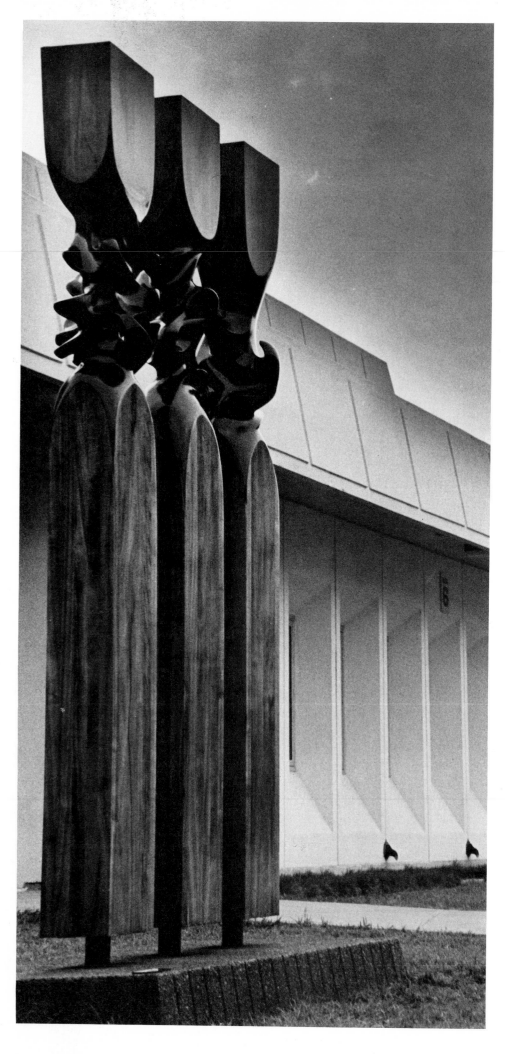

◄Donald Harvey, *Nā Aumakua* (Family of Guardian Spirits). Wood and polyester, 14' (4.2 m) high. Honolulu Community College, Hawaii. Photo: Joeann Edmonds.

▶David E. Davis, *Walking Together*, 1972. Redwood and anodized aluminum, 22' × 4' × 20' (6.6 × 1.2 × 6 m). Kent State University, James Michener Collection. Photo: Martin Linsey.

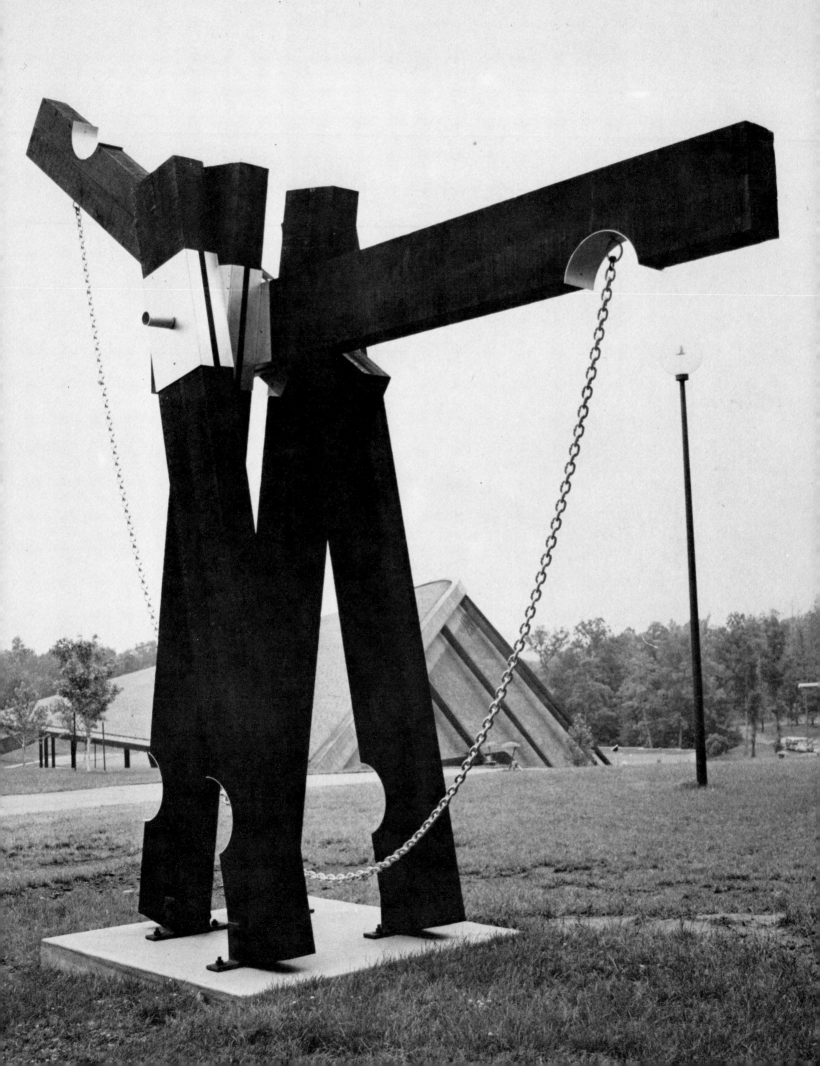

▼Alexander Calder, *Constellation with Bomb*, 1943. Steel wire and wood, 31″ × 30″ × 18″ (79 × 76 × 46 cm). Courtesy Perls Galleries, New York.

▶Jeremy Anderson, *The Lotus Eaters*, 1965. Redwood and enamel, 36″ × 86″ × 14″ (91 × 218 × 35.5 cm). Courtesy Quay Gallery, San Francisco.

▶▼Louise Nevelson, *Black Light I*, 1970. Black wood and formica, 36½″ × 47″ × 5½″ (93 × 119 × 14 cm). Courtesy Pace Gallery, New York. Photo: Ferdinand Boesch.

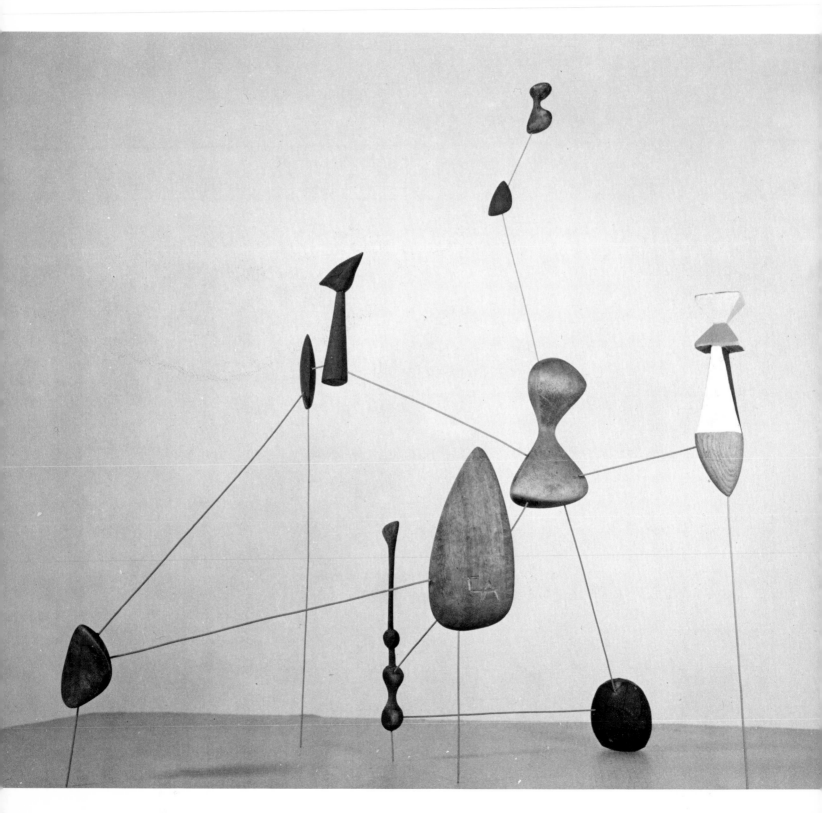

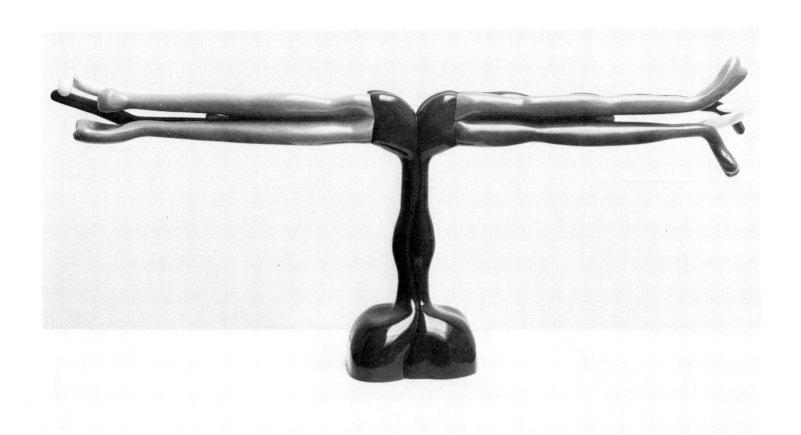

H. Nosti, *Trojan Horse*, 1974. Walnut, oak, hardwood dowels, stoneware, and red formica, 6′ × 4′ (1.8 × 1.2 m). Courtesy of the artist.

Marisol (Escobar), *Portrait of Sidney Janis Selling Portrait of Sidney Janis by Marisol*, 1967–68. Painted construction: wood, plaster, bow tie, carpet, and eyeglass rims, 69″ × 61½″ × 21⅝″ (175 × 156 × 55 cm). Courtesy of Sidney Janis Gallery, New York.

BIBLIOGRAPHY

Anderson, Eric A., and Earle, George F. (Editor), *Design and Aesthetics in Wood*. Syracuse, New York: State University of New York (College of Environmental Science and Forestry), 1972.

Beekman, W. B., *Elsevier's Wood Dictionary*, 3 volumes. Amsterdam, London, New York: Elsevier Publishing Company, 1964.

Berry, James Berthold, *Wood Identification*. New York: Dover Publications, 1966.

Campbell, Robert, *How to Work with Tools and Wood*. New York: Pocket Books, 1975 (28th printing).

Christensen, Erwin O., *Early American Wood Carvings*. New York: Dover Publications, 1952.

Coleman, Donald G., *Woodworking Factbook: Basic Information on Wood for Woodcarvers, Home Woodshop Craftsmen, Tradesmen, and Instructors*. New York: Robert Speller and Sons.

Collingswood, G. H., and Brush, Warren D., *Knowing Your Trees*. American Forestry Association, Washington D.C., 1955.

Constantine, Albert, Jr., *Know Your Woods*, revised edition. New York: Charles Scribner's Sons, 1975.

De Cristoforo, R. J., *Complete Book of Power Tools*. Times Mirror Magazines Inc., Book Division, 1976.

Edlin, Herbert T., *What Wood is That?* New York: Viking Press, 1969.

Elsen, Alberte, *Origins of Modern Sculpture*. New York: George Braziller, 1974.

Feirer, John, *Bench Woodwork*. New York: Charles Scribner's Sons, 1973.

Gibbia, S. W., *Wood Finishing and Refinishing*. New York: Van Nostrand Reinhold, 1971.

Gross, Chaim, *The Techniques of Wood Sculpture*. New York: ARCO Publishing Company Inc., 1977 (4th printing).

Hackett, Donald F., and Spielman, Patrick E., *Modern Wood Technology*. Glencoe, Illinois: Bruce Publishing Company, 1968.

Haines, Ray E., et al, *The Wood-Turning Lathe*. New York: Van Nostrand Reinhold, 1952.

Hammacher, A.M., *Evolution of Modern Sculpture*. New York: Harry Abrams, 1969.

Hammond, James J., et al, *A Woodworking Technology*. Bloomington, Illinois: McKnight and McKnight Publishing Company, 1972.

Harrar, E. S., *Hough's Encyclopedia of American Woods*, 13 volumes. New York: Robert Speller and Sons, 1957.

Hayes, Vincent, *Artistry in Wood*. New York: Drake Publishers Inc., 1972.

Hayward, Charles H. (Editor), *Carpentry for Beginners*. New York: Buchanan, Emerson Books Inc., 1969.

Hayward, Charles H., *The Complete Book of Woodwork*, revised edition. New York: Drake Publications, 1974.

Howard, Alexander L., *A Manual of the Timbers of the World*. London: Macmillan and Company Ltd., 1920.

Hunt, George M., and Garratt, George A., *Wood Preservations*, 3rd edition. New York: McGraw-Hill Company, 1967.

Jackson, Frank, *Woodworking*. New York: International Publication Service, 1966.

James, Philip (Editor), *Henry Moore on Sculpture*. London: MacDonald, 1966.

Joyce, Ernest, *The Techniques of Furniture Making*. London: B. T. Batsford Ltd., 1970.

Laliberte, Norman, *Wooden Images*. New York: Reinhold Publishing Corporation, 1966.

Maguire, Byron C., *The Complete Book of Woodworking and Cabinetmaking*. Englewood Cliffs, New Jersey: Prentice-Hall, 1974.

Maillard, Robert, *New Dictionary of Modern Sculpture*. New York: Tudor Publishing Company, 1970.

Mason, Bernard S., *Woodcraft*. New Jersey: A. S. Barnes, 1973. (Also published in paperback by Barnes and Noble Division, Harper and Row, New York.)

Matthews, John and Kerr, J. D., *Pictorial Woodwork*, 3 volumes. New York: St. Martin's Press, 1971. (Book 1: *Background to Wood Construction and Finishes*. Book 2: *Tools and Their Uses*. Book 3: *Guide to Practical Work*.)

Meilach, Dona Z., *Contemporary Art with Wood*. New York: Crown Publishers, 1968.

Nish, Dale L., *Creative Wood Turning*. Provo, Utah: Brigham Young University Press, 1977.

Pain, F., *Practical Wood Turner*. New York: Drake Publications, 1970.

Rich, Jack C., *Sculpture in Wood*. New York: Da Capo Press, Inc., 1977.

Rickey, George, *Constructivism: Origins and Evolutions*. New York: George Braziller, 1967.

Shea, John G., *Woodworking for Everybody*, 4th revised edition. New York: Van Nostrand Reinhold, 1970.

Sloane, Eric, *A Reverence for Wood*. New York: Harper and Row, 1965.

Teller, Raphael, *Woodwork: A Basic Manual*. Boston: Little, Brown, and Company, 1974.

The International Book of Wood. New York: Simon and Schuster, 1976.

Wagner, Willis H., *Modern Woodworking*. South Holland, Illinois: Goodheart-Willcox Company, 1974.

Walton, Harry, *Home and Workshop Guide to Sharpening*. New York: Times Mirror Magazines, Inc., Book Division, 1976.

Weygers, Alexander G., *The Making of Tools*. New York: Van Nostrand Reinhold, 1973.

PERIODICALS AND SPECIAL PUBLICATIONS

Adhesive Reference Series. USM Corporation, Chemical Division, Middleton, Mass., 1970.

Fine Wood Working (magazine published quarterly). Taunton Press, Inc., 52 Church Hill Road, Newton, Ct.

Wood Handbook: Wood as an Engineering Material. Agriculture Handbook No. 72. U.S. Department of Agriculture, Forest Products Laboratory, 1974.

Mitchell, H. L., "How PEG Helps the Hobbyist Who Works with Wood." U.S. Forest Products Laboratory, Box 5130, Madison Wisc., 53705, 1972.

INDEX

Adams, Allen, *Tool Box, 138*
African tribal art, *20*
Air drying, 37, 45
"American Woman Series"
 (Hostetler), 37
American woodcarving. *See also*
 specific sculptors
 early, *23*
 Northwest Coast Indian, *21*
Anderson, Jeremy, *The Lotus
 Eaters, 187*
Aniline dye, with polyurethane
 varnish, 37–38, *42*
Architectural art
 assembly, 156, *162, 165*
 environmental setting, 155
 fabrication, 155–156, *162, 164*
 installation, 156, *166*
 kinetic quality, 155
 lamination, 155–156, *158–159*
 psychological function, 155
 scale model, 155, *157*

Band saw, 110, 111, 118, 119
Baney, Ralph R., *Cathedral, 76*
Barlach, Ernst
 Man in the Stocks, 26
 Die Vision, 10
Barnes, Carroll
 Abacus II, 152–153
 Capitol III, 124
 demonstration by, *126–132*
 influences on, 125
 slide lamination by, 125–126
 Sound Barrier, 133
 Trolley Track Saw of, 125, *126*
Baskin, Leonard, *Oppressed Man,
 78*
Bas relief
 basic steps, 65
 carving technique, 65–66, *67–70*
 design transfer, 65, *67*
 finish, 66, *70, 71*
 lamination, 65
 sliding, *124,* 125, *127–133*
 wood selection, 65, 125
Bassler, Robert, *Anatome, 179*
Basswood, 65
Behl, Wolfgang
 carving technique, 89–90, *92*
 demonstration by, *91–101*
 Frog Hollow, 89–90, *91–101*
 gluing and joining, 90, *91, 92, 93,
 95, 100*
 Godgame, 82
 influences on, 89
 preliminary study, 89, *90*
 symbolism, 89
 Two Faces of Eve, 88
 wax finish, 90
 wood selection, 89
Bellamy, John, 23
Bentwood lamination, 109–110,
 111–113
Bicycles (Yoshimura), 109–110
 demonstration, *111–115*
 wheels and spokes, 110, *111, 112*
Blemish, repair of, 33
Blunk, J. B., *Continuum, 74*
Boiger, Peter
 carving technique, 45–46, *46–52*
 demonstration by, *46–52*
 design themes, 45

Eye Sculpture 11, *44,* 45
 Standing Figure, 45–46, *46–53*
 wood selection, 45
Bourden, Robert, *Table Land after
 the Rain, 147*
Bow saw, 45, *46,* 49
Buddha figures
 Chinese, *16*
 Japanese, *14*

Calder, Alexander, *Constellation with
 Bomb, 186*
Camargo, *Relief Opus, 141, 136*
Carving
 crossgrain, 29, *31, 32, 50*
 diagonal, 30, *32, 50*
 direct, *72–87*
 on green wood, 37, *38, 41,* 56, *57*
 from lengthwise-cut log, 45
Carving an abstract figure
 finish, 45–46, *51, 52*
 intermediate stage, 45, *51*
 preliminary study, 45
 roughing-out stage, 45, *47, 48, 49,
 50*
Carving a bas relief
 background removal, 65–66, *69*
 finish, 66, *70, 71*
 modeling relief forms, 66, *70*
 with power tools, 125–126,
 126–132
 outlining design, 65, *67*
 setting in design, 65, *68*
Carving a figure
 intermediate stages, 30, *33, 34*
 preliminary study, 29
 roughing-out stage, 29–30, *31*
 surface finish, 30, *34*
Carving a figure group
 finish, 90
 gluing and joining, 90, *91–93, 95,
 100*
 gouges in, 90
 preliminary study, 89, *90*
 roughing-out stage, 90, *93*
Carving laminated wood, 103, *105*
 bentwood, 110, *112*
 plywood, *116,* 118, *119–120, 123*
Carving a monumental figure
 intermediate stage, 56
 open spaces in, 55
 preliminary study, 55, *56*
 roughing-out stage, 56, *62*
Carving a torso
 blocking out, 37, *39*
 finish, 37–38
 intermediate stage, 37
 preliminary study, 37
 roughing out, 37, *39*
Carving tools, 29, *30,* 45, *46,* 103,
 110
 power, 37, 103, *104, 106,* 110,
 125, *126–132,* 169, 171
 sharpening, 29
Castle, Wendell, *Sculptural Furniture,
 147*
Ceroli, Mario, *The Brownstone, 183*
Chain saw, 37, *39,* 45, *47,* 84, 103,
 104
Checking, 29–30, 90
 prevention of, 45
Cherry wood, 29

Chillida, Eduardo, *Abesti Gogora
 111, 134*
China (ancient), woodcarving of, *16*
Chipping, repair of, 118
Chisel, *31, 68, 69,* 90, *94*
Colby, Victor, *Young Man with
 Legendary Chinese Birds, 142*
Color correction, 30
Cooper, Michael
 Captain's Chair, 139
 childhood influences on, 169
 demonstration by, *170–176*
 motorcycle construction, 169,
 170–176
 Soapbox Racer, 168
 Turbo, 169, *177*
Cracks, repair of, 30, 46, 56, 90
Cremean, Robert
 *The Inner Studio: A Self-portrait,
 149*
 *Vatican Corridor, A Non-specific
 Autobiography, 148–149*
Crossgrain carving, 29, *32*

Davies, Hayden
 architectural art, 155–156,
 157–166
 demonstration by, *157–166*
 Homage, 167
 Symposium Piece (for Eva), 154
Davis, David E., *Walking Together,
 185*
Driesbach, Walter, Jr.
 artistic philosophy, 29
 carving technique, 29–30, *30–35*
 demonstration by, *30–35*
 Interval, 28
 Seated Woman, 72
 A Short Stirring, 29–30, *30–35*

Egypt (ancient), woodcarving in, *12,
 13*

Fadeley, Kenneth, *Labor of Love,
 141*
Fawkes, Tom, *Devices and Chart for
 the Isles of Langerhans, 181*
Finish
 aniline dye over polyurethane,
 37–38, *42*
 lacquer, 169
 oil, 30, 34, 46, 66, 125
 bleaching, 156, *164*
 linseed, 118, *121*
 plastic resin spray, 110
 wax, 30, 90, 103, 107
Friedman, Alan, *Positive-Negative
 No. 2, 144–145*
Frog Hollow (Behl), 89–90
 completed sculpture, *101*
 demonstration, *91–101*

Gauguin, Paul, wood relief, *24*
German woodcarving, gothic period,
 18
Glickman, Maurice, *Construction, 87*
Gluing and joining, 90, *91–93, 95,
 100, 152–153,* 156, *163*
 seasoned wood for, 90
 in wood lamination, 103, 109,
 110, *113,* 118, 125–126, 169
Gouges, 29, *30,* 90
 in intermediate stage, 30, *33,* 37,

 40, 45, 56, *93, 96, 98,* 103,
 104, 106
 in relief carving, 65–66, *68,* 69
 in roughing-out stage, 29, *31,* 37,
 39, 48, 49, 56
 for surface texture, 37, *40*
Graham, Richard, *The Zouave, 135*
Green wood
 carving, *38, 57*
 drying under polyurethane, 37
 precautions, 56
 seasoning, 90
 wet-wrapping of, 37, *41*
Grinders, 90, *92*
 power, 103, *104, 169, 171, 173*
Grooms, Red, *City of Chicago, 182*
Gross, Chaim, *Sisters, 75*

Hamrol, Lloyd, *Log Ramps, 140*
Hartman, Manu, *Maamme I, 141*
Harvey, Donald, *Na Aumakua, 184*
Hepworth, Barbara
 Icon, 27
 Wood and Strings, 178
Herreria, Jose Inez, *Death Cart, 22*
Hokanson, Hans, *Hat No. 3, 85*
Homage (Davies), 155–156
 completed sculpture, *167*
 demonstration, *157–166*
Hoptner, Richard,
 Repression/Escape, 77
Hostetler, David
 carving techniques, 37–38, *39–42*
 demonstration by, *39–42*
 influences on, 37
 Sassafras Lady, 37–38, *39–43*
 Seated Woman, 36
 Young Woman, 82
Hueter, James, *Rising Figure, 79*

Indians, Northwest, totemic art of, *21*
Internal and External Forms (Moore),
 56
 demonstration, *62–63*

Japanese woodcarving
 Buddha figures, *14*
 Gigaku masks, *16*
 Kamakura period, *15*
Jig making, for bentwood lamination,
 109
Joining. *See* Gluing and joining

Kapel, John, *Pressed wood
 sculpture, 152*
Kassoy, Hortense, *Adam, 73*
Koskela, Matti, *Waterfall Kiuta, 178*
Kruger, Louise
 Man Standing on Head, 183
 Man Wearing Vest, 83

Lamination, 155–156, *158–159,*
 169
 bas relief, 65
 bentwood, 109–110, *111–113*
 and construction, *135–153*
 sliding, *124,* 125–126, *126–133*
 stacking, *102,* 103, *105*
Langlais, Bernard, *Football, 182*
Lathe, 110, 169
Lekakis, Michael, *Rythmisis, 77*
Linseed oil finish, 118, *121*

Marisol (Escobar), *Portrait of Sidney Janis Selling Portrait of Sidney Janis by Marisol*, 189
Milling machine, 169, *173*
Mogami, Hisayuki, *Naniga Nanishite Nantoyara*, 138
Montanes, Juan Martinez, *Maddona of Sorrows*, 19
Moore, Henry, *54*
 carving techniques, 55–56, *57–63*
 Composition, 26
 pre-Columbian influence on, 55
 Reclining figure (1959–1964), 56, *57–63*
 reclining figures of, 55

Nadelman, Elie, *The Pianiste*, 25
Nevelson, Louise
 Black Light I, 187
 Chapel of the Good Shepherd: Frieze of the Apostles, 137
 Cross of the Resurrection, 137
Nosti, H., *Trojan Horse, 188–189*

Oil finish, 30, *34,* 46, 66, *71,* 125
 bleaching, 156, *164*
 linseed, 118, *121*
Okulick, John, *Masque of Dryads, 181*
Oseberg ship, *17*

Phoenix (Roukes), 65–66
 demonstration, *67–71*
Plywood sculpture, 117–118, *119–123*
Polyethlene glycol (PEG), 37
Polyurethane varnish
 application of, 37–38, *42*
 clouding, 37
 residue, 37
 wood drying under, 37
Power arm, 37
Power tools, 37, 103, *104, 106,* 110, 169, *171, 174*
 for bas reliefs, 125, *126–133*
 sanders, 46, *51,* 103, *104, 106,* 118, *119,* 125, *129–130*
 saws, 37, 103, *104,* 125, *126–129, 130–131*
Preliminary study(s)
 clay model, 29, *31*
 paper silhouette, 37
 plasticene, 29, *31*
 scale model, 155, *157*

sketches, 29, 45, 55–56, *56,* 65, 89, *90,* 103, 169

Rasps, 30, *30, 34*
Reclining figure, 1959–1964 (Moore), 56
 demonstration, *57–63*
Relief sculpture. *See* Bas relief
Repairs
 blemishes, *33*
 chips, 118
 cracks, 30, 46, 56, 90
Riemenschneider, Tilman, *Saint Bérnard of Wurzburg, 18*
Riffler rasp, 30, *34, 104, 106*
Rivadossi, Giuseppe
 Grande Immagine di Fine Inverno, 143
 Igloo, 142
Robb, Samuel A., 23
Robbie, Peter
 demonstration by, *104–107*
 lamination and carving methods, *102,* 103, *105*
 power and hand tools, 103, *104, 106*
 Seed, 103, *104–107*
Roukes, Nicholas
 demonstration by, 67–71
 Montreux Cluster, 64
 Phoenix, 65–66, 67–71
 relief carving methods, 65–66, *67–71*
Rush, William, 23
Russell, John, 55

Sanders and sanding
 air sander, *46, 52*
 garnet paper, *34, 52,* 66, *70,* 103, *120*
 grit paper, 38, *42,* 46, 103, *120*
 on oiled wood, 30
 power, 46, *51,* 103, *104, 106,* 118, *119,* 125, *129–130*
 surform tool, 45–46
 wet/dry paper, 66
Sassafras Lady (Hostetler), 37–38
 demonstration, *39–43*
Scale model, 155, *157*
Scaravaglione, Concetta, *Floating Woman, 81*
Seasoned wood
 for figure groups, 90
 lengthwise-cut, 45, 47

storage, 45, 47
 time period, 57
Seed (Robbie), 103
 demonstration, *104–107*
Sells, Raymond
 demonstration by, *119–123*
 plywood sculpture, *116,* 118, *119–123*
 wood selection, 117–118
Setziol, Leroy, *Bas relief, 86*
Short Stirring, A (Driesbach), 29–30
 demonstration, *31–35*
Simon, Sidney, *Oedipus as a Young Man, 80*
Simpson, Tommy, *Climbing the Success Ladder or Rung Out, 180*
Skillon, John and Simeon, 23
Sliding lamination (slide-lams), 125–126, *124, 126–133*
Smullin, Frank, *Bystanders, 84*
Spalting, 37, *41*
Splitting, 30
Stack lamination, *102,* 103, *105*
 plywood, 117, 118, *119*
Stains, 90
 aniline dye with polyurethane, 37–38, *42*
Standing Figure (Boiger), 45–46
 demonstration, *46–53*
Surform rasp, 29, *30,* 30, *34,* 45–46, *46, 51, 104*

Toltec-Mayan sculpture, 55
Tomb figures, 16
Totemic art, *21*
Townley, Hugh, *The Shout, 135*
Tribal art, African, *20*
Trolley Track Saw, 125, *126–132*
Trough, V-shaped, 29
Turbo (Cooper), 169
 demonstration, *170–177*

Unkei, 15

Varnish
 clouding, 37
 polyurethane with aniline dye, 37–38, *42*
 residue, 37
Viking wood carving, *17*
V-tool, in relief sculpture, 65, 66, *67*

Walnut, 29
Warping, 31

Wax finish, 30, 90, 103, 107
Westerman, H.C.
 Antimobile, 150
 Little Egypt, 180
 Phantom in a Wooden Garden, 150
Wood
 atmospheric changes and, 29–30
 chalk outlines on, 29, *31, 33*
 checking for obstructions in, 29
 color correction, 30
 curing and dressing, 156, *160*
 finish. *See* Finish
 lamination. *See* Lamination
 resources, 11
 seasoning, 45, *47,* 56, 90
 storage, 29
Woodcarving. *See also* Carving, Carving process, Green wood carving
 African tribal, *20*
 architectural. *See* Architectural art
 Chinese, *16*
 early American, 23
 Egyptian, *12, 13*
 German gothic, *18*
 history, 11
 Japanese, *14–16*
 Northwest Coast Indian, *21*
 revival, 11
 Viking, *17*
Wood drying
 by air, 37, 45
 under polyurethane coating, 37
Woodgrain
 design alignment, 29
 and sculptural form, 29
Wood putty, 118
Wood selection, 29, 45, 65, 89, 155,169
 for bentwood lamination, 109
 for plywood, 119

Yoshimura, Fumio
 bentwood lamination method, 109–110, *111–114*
 bicycle interpretations, 109
 Bicycle with Parking Meter, 114–15
 Sewing Machine, 151
 Typewriter, 108

Zach, Jan, *Drapery of Memory, 146*
Zadkine, Ossip, *Homo Sapiens, 87*

Edited by Bonnie Silverstein
Designed by Jay Anning
Graphic Production by Hector Campbell
Set in 11-point souvenir light

Roukes

(5) Sculpture. Wood.